Put any picture you want on any state book cover. Makes a great gift. Go to www.america24-7.com/customcover

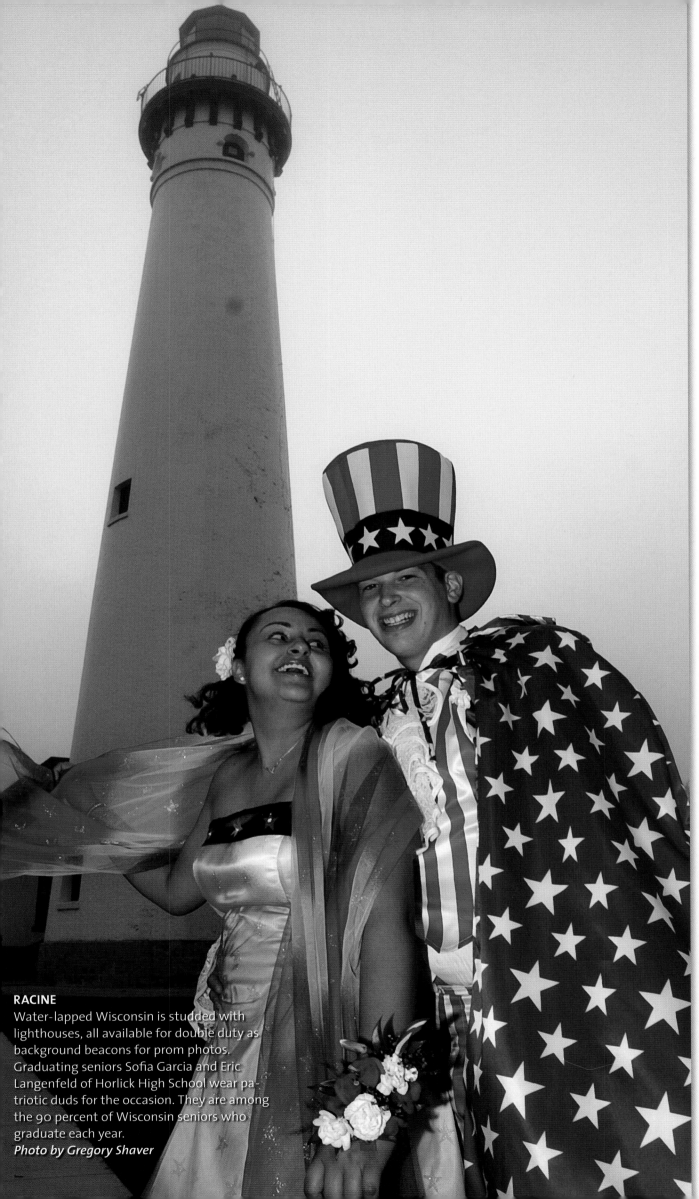

RACINE
Water-lapped Wisconsin is studded with lighthouses, all available for double duty as background beacons for prom photos. Graduating seniors Sofia Garcia and Eric Langenfeld of Horlick High School wear patriotic duds for the occasion. They are among the 90 percent of Wisconsin seniors who graduate each year.
Photo by Gregory Shaver

Wisconsin 24/7 is the sequel to *The New York Times* bestseller *America 24/7* shot by tens of thousands of digital photographers across America over the course of a single week. We would like to thank the following sponsors, the wonderful people of Wisconsin, and the talented photojournalists who made this book possible.

LONDON, NEW YORK, MUNICH, MELBOURNE, and DELHI

Created by Rick Smolan and David Elliot Cohen

24/7 Media, LLC
PO Box 1189
Sausalito, CA 94966-1189
www.america24-7.com

First Edition, 2004
04 05 06 07 08 10 9 8 7 6 5 4 3 2 1

Published in the United States by
DK Publishing, Inc.
375 Hudson Street
New York, NY 10014

DK Publishing, Inc. offers special discounts for bulk purchases for sales promo-
tions or premiums. Specific, large-quantity needs can be met with special edi-
tions, personalized covers, excerpts of existing guides, and corporate imprints.
For more information, contact:

Special Markets Department
DK Publishing, Inc.
375 Hudson Street
New York, NY 10014
Fax: 212-689-5254

Cataloging-in-Publication data is available
from the Library of Congress
ISBN 0-7566-0090-1

Printed in the UK by Butler & Tanner Limited

First printing, October 2004

SISTER BAY

After the maypole raising, cakewalk, family
bingo, and ice cream social, patrons of the
Sister Bay Festival of Blossoms settle into a

WISCONSIN 24/7

24 Hours. 7 Days.
Extraordinary Images of
One Week in Wisconsin.

Created by Rick Smolan and David Elliot Cohen

DK Publishing

About the America 24/7 Project

A hundred years hence, historians may pose questions such as: What was America like at the beginning of the third millennium? How did life change after 9/11 and the ensuing war on terrorism? How was America affected by its corporate scandals and the high-tech boom and bust? Could Americans still express themselves freely?

To address these questions, we created *America 24/7*, the largest collaborative photography event in history. We invited Americans to tell their stories with digital pictures. We asked them to shoot a visual memoir of their lives, families, and communities.

During one week in May 2003, more than 25,000 professionals and amateurs shot more than a million pictures. These images, sent to us via the Internet, compose a panoramic yet highly intimate view of Americans in celebration and sadness; in action and contemplation; at work, home, and school. The best of these photographs, more than 6,000, are collected in 51 volumes that make up the *America 24/7* series: the landmark national volume *America 24/7*, published to critical acclaim in 2003, and the 50 state books published in 2004.

Our decision to make *America 24/7* an all-digital project was prompted by the fact that in 2003 digital camera sales overtook film camera sales. This techno-logical evolution allowed us to extend the project to a huge pool of photographers. We were thrilled by the response to our challenge and moved by the insight offered into American life. Sometimes, the amateurs outshot the pros—even the Pulitzer Prize winners.

The exuberant democracy of images visible throughout these books is a revela-tion. The message that emerges is that now, more than ever, America is a supersized idea. A dreamspace, where individuals and families from around the world are free to govern themselves, worship, read, and speak as they wish. Within its wide margins, the polyglot American nation manages to encompass an inexplicably complex yet workable whole. The pictures in this book are dedicated to that idea.

—*Rick Smolan and David Elliot Cohen*

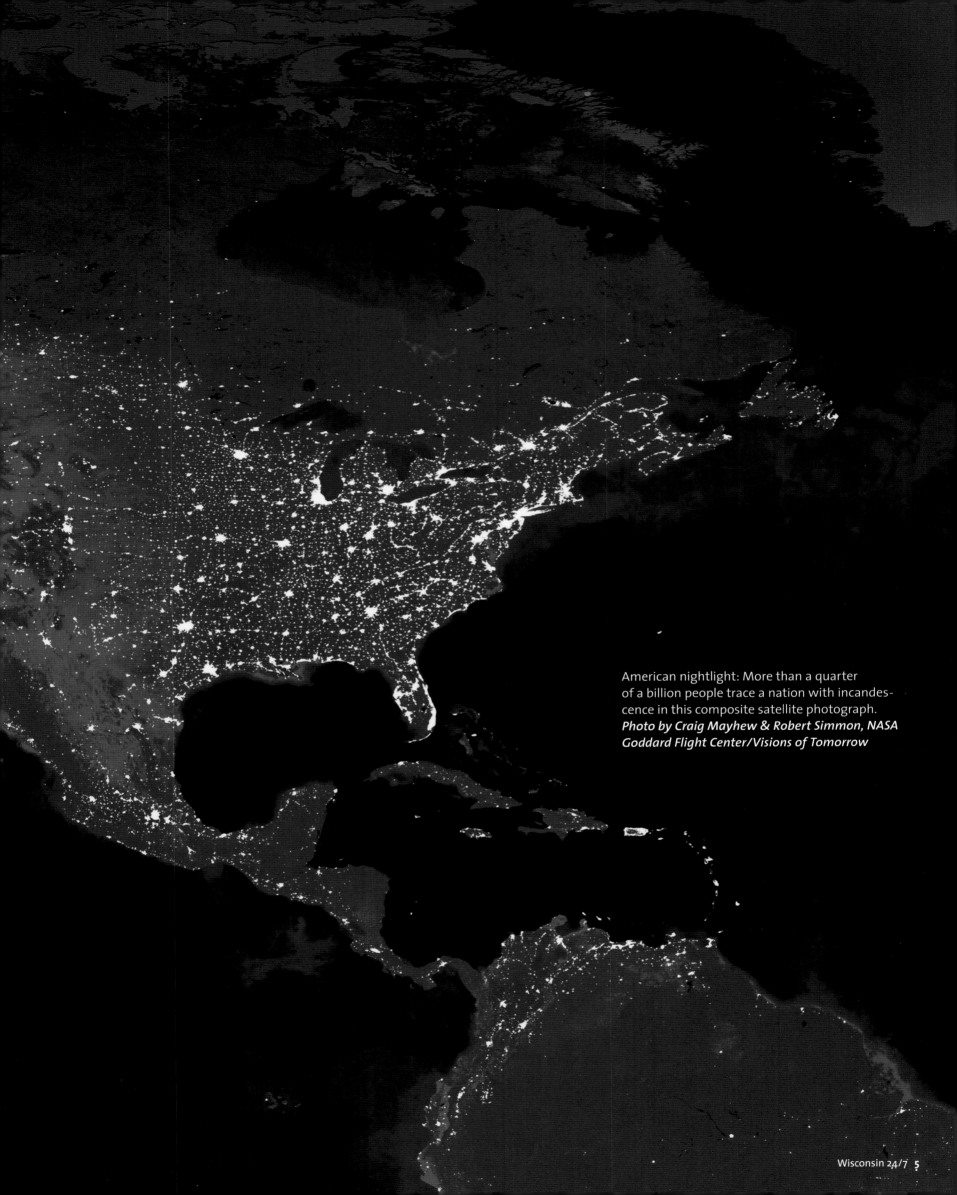

American nightlight: More than a quarter
of a billion people trace a nation with incandes-
cence in this composite satellite photograph.
Photo by Craig Mayhew & Robert Simmon, NASA
Goddard Flight Center/Visions of Tomorrow

Wisconsin in May

By Susan Lampert Smith

Wisconsin is a work hard, play hard kind of state. We know we're not the center of the universe, but we don't like people who think they are better than we are. Our Progressive tradition in politics means we like candidates who are looking out for the little guy. We tend to root for the underdog. We're proud of being America's Dairyland and the home of Harley Davidson, but we're worried about all the dairy farms and manufacturing jobs we've been losing. You can't work hard if there's no work.

We don't put on airs here, but we're not as slow as our accents make us sound. Wisconsin students regularly top the ACT college tests, and we're proud of our schools. You'll hear guys with thick Wisconsin accents calling in from North Woods to ask questions about astrophysics or genetic engineering when there's an interesting professor on a public radio talk show.

Wisconsin bursts wide open in May. Oh, sure, we're tough enough to survive our long, cold winters. But after March's mud and April's cruelty (it always snows one last time, just when you can't take it anymore), the month of May blossoms like a party. Boots are tossed to the back of the closet, and even the bachelor farmers finally take off their long underwear. We feel we've earned our playtime.

Ice loosens its grip on our 15,000 lakes, just in time for opening day of the fishing season. The state's walleye warriors and trout tormenters clog the highways heading north to the lakes and west to the trout streams. Skies fill with Sandhill cranes returning from the South. Prehistoric paddlefish begin

SISTER BAY
When the weather is a balmy 60 degrees at sunset, who wants to be inside? Not this crowd, savoring the day's last rays on the dock.
Photo by Jeffery Foss Davis

their ancient migration up the Mississippi. The summer cottage people aren't far behind.

The hayfields of Wisconsin turn instantly emerald, making the hilly southwestern part of the state greener than Ireland. That vigorous first crop of alfalfa is what puts the butterfat into the milk, just in time for the ice cream sundaes of June Dairy Days. In central Wisconsin's Sand Country, groves of lilac blossoms are gaudy memorials to the farmsteads that stood, and failed, during the Great Depression.

In May, you can smell Wisconsin thawing. There's the yeasty beer breath of Milwaukee's Red Star yeast factory mixing with the smoke of bratwursts grilling at tailgate parties around Miller Park. It's an aroma that can almost convince you that maybe this year the Brewers won't disappoint.

At the farmers' market around the Capitol in Madison, spring smells like frying bacon and Amish donuts. May smells like perfume in the pink and white apple orchards above the Kickapoo Valley and in Door County's cherry orchards. Everywhere else, May smells like freshly cut grass and the laundry that dried on the line in the cool sunshine.

Having such drastic seasonal changes is like going to sleep in Siberia and waking up in Tahiti. Winter in Wisconsin is like the black-and-white beginning of *The Wizard of Oz*—all mean schoolteachers and weird relatives and bad, scary weather. May in Wisconsin is like walking out the door and finding that you've landed in a bright new country.

Milwaukee native Susan Lampert Smith *writes the "On Wisconsin" column for the* Wisconsin State Journal.

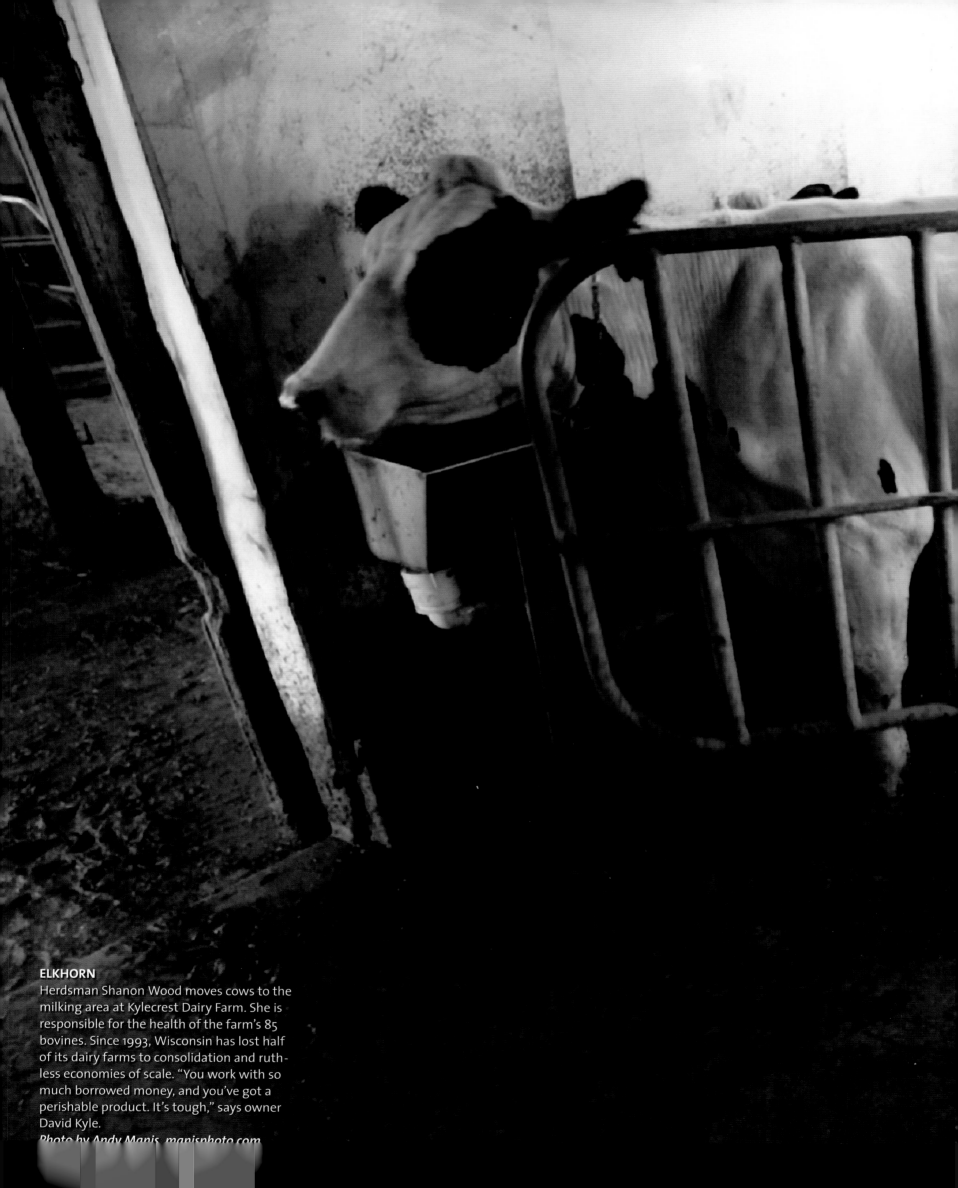

ELKHORN

Herdsman Shanon Wood moves cows to the milking area at Kylecrest Dairy Farm. She is responsible for the health of the farm's 85 bovines. Since 1993, Wisconsin has lost half of its dairy farms to consolidation and ruthless economies of scale. "You work with so much borrowed money, and you've got a perishable product. It's tough," says owner David Kyle.

Photo by Andy Manis, manisphoto.com

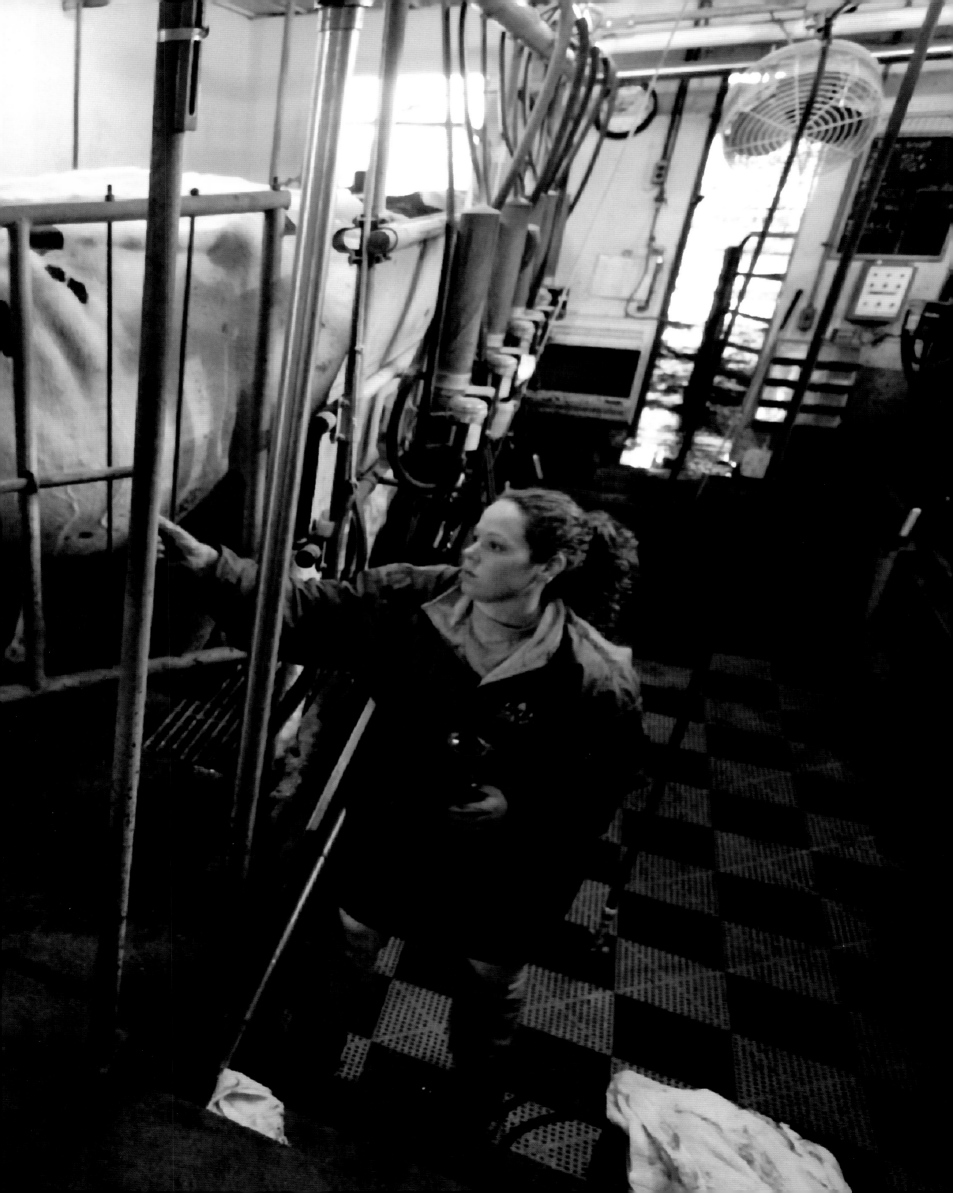

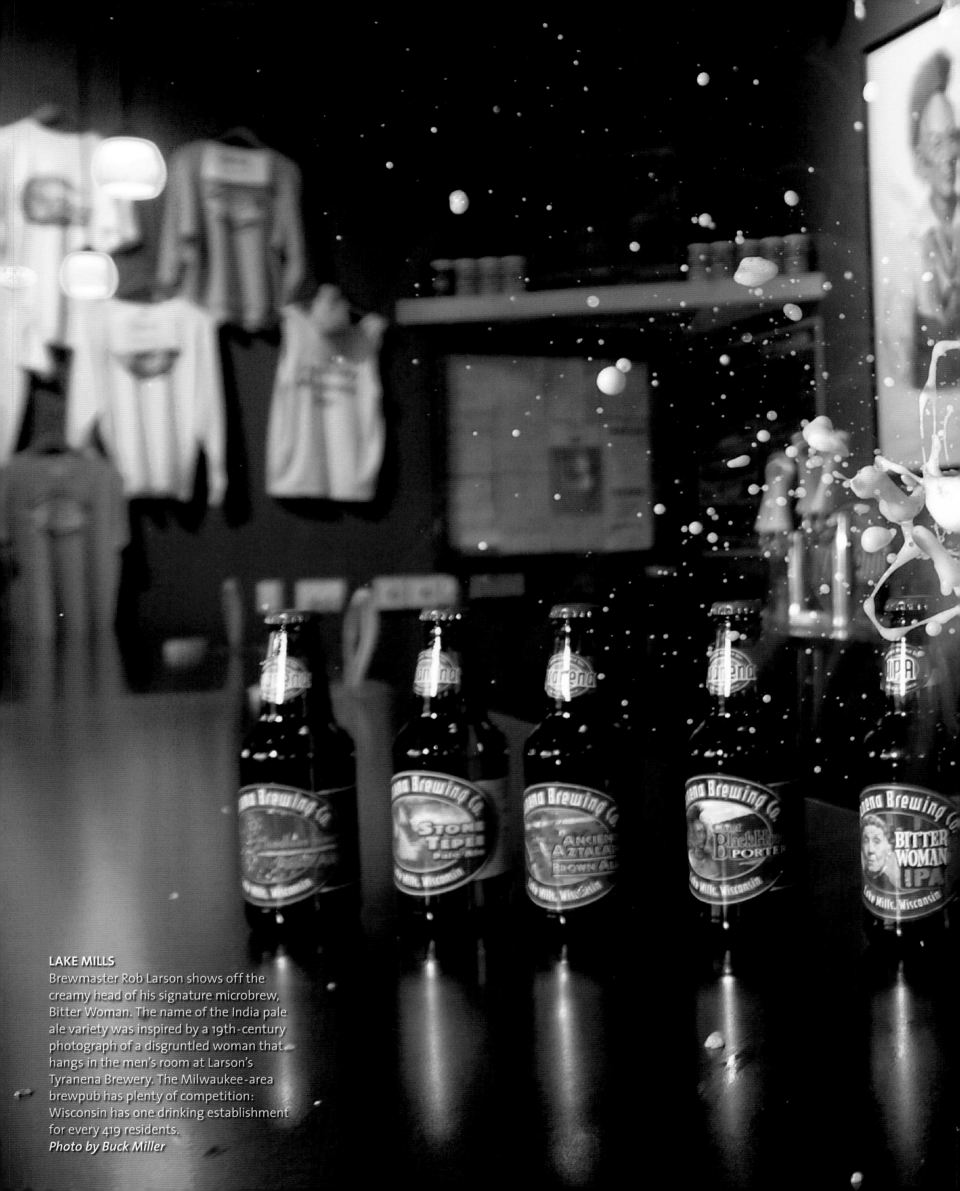

LAKE MILLS
Brewmaster Rob Larson shows off the creamy head of his signature microbrew, Bitter Woman. The name of the India pale ale variety was inspired by a 19th-century photograph of a disgruntled woman that hangs in the men's room at Larson's Tyranena Brewery. The Milwaukee-area brewpub has plenty of competition: Wisconsin has one drinking establishment for every 419 residents.
Photo by Buck Miller

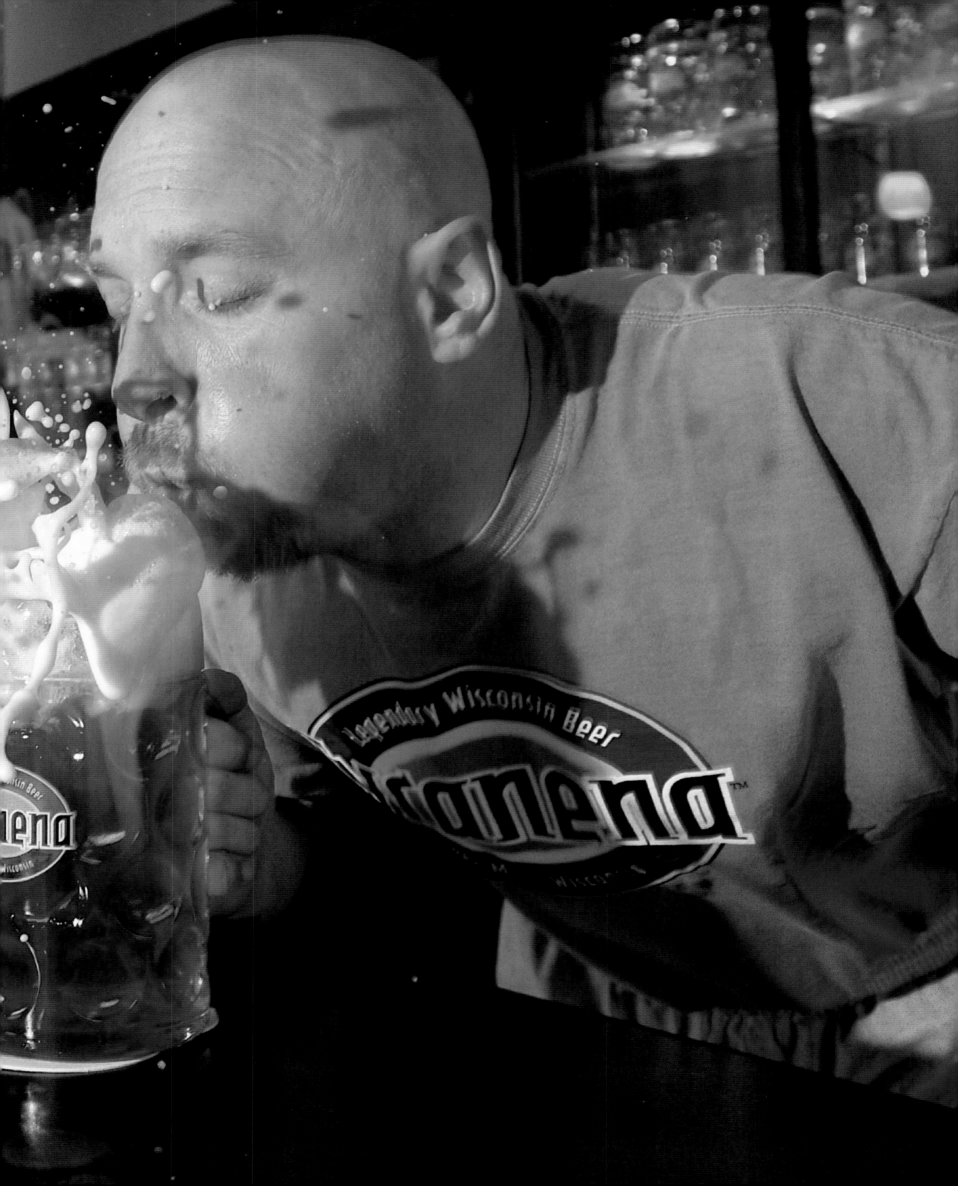

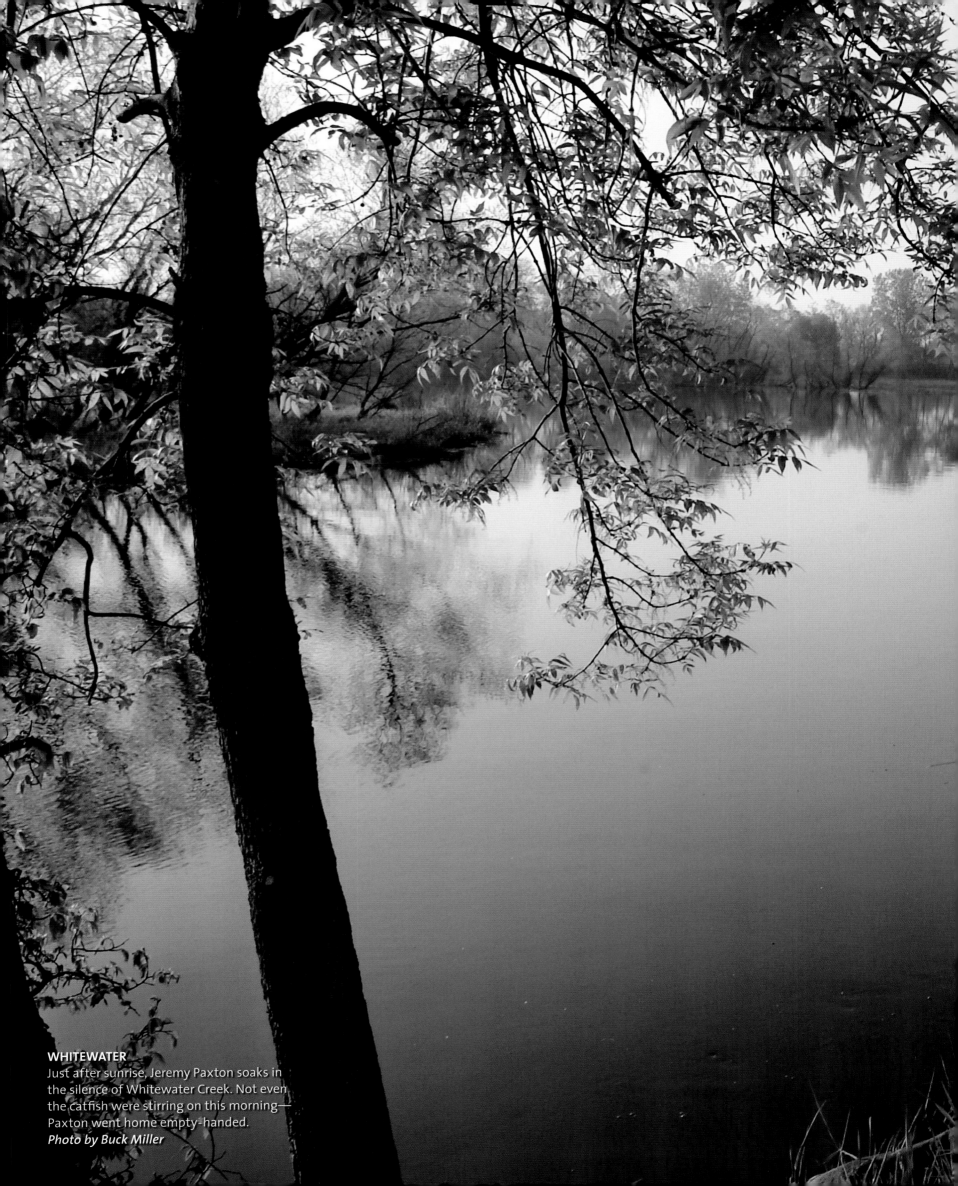

WHITEWATER
Just after sunrise, Jeremy Paxton soaks in the silence of Whitewater Creek. Not even the catfish were stirring on this morning— Paxton went home empty-handed.
Photo by Buck Miller

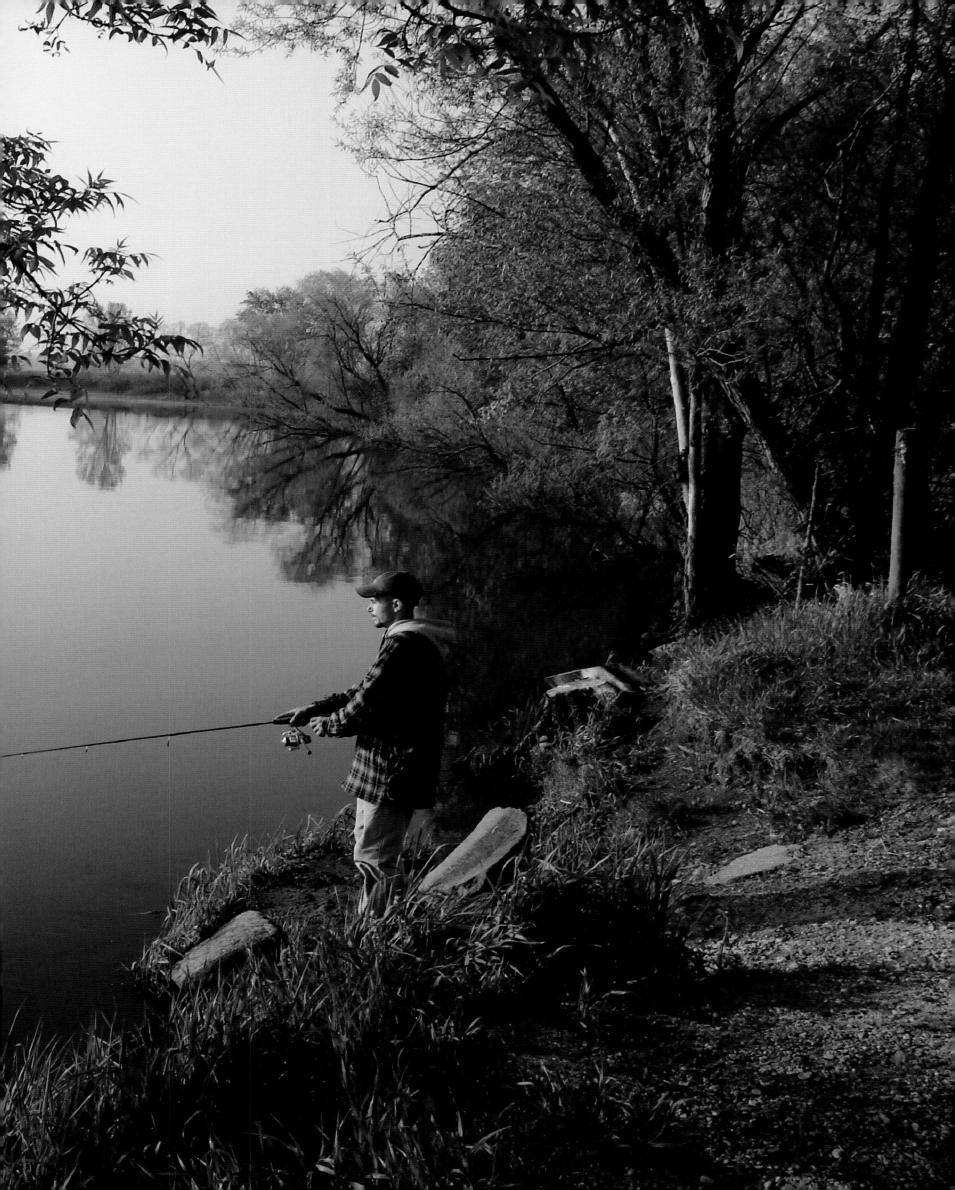

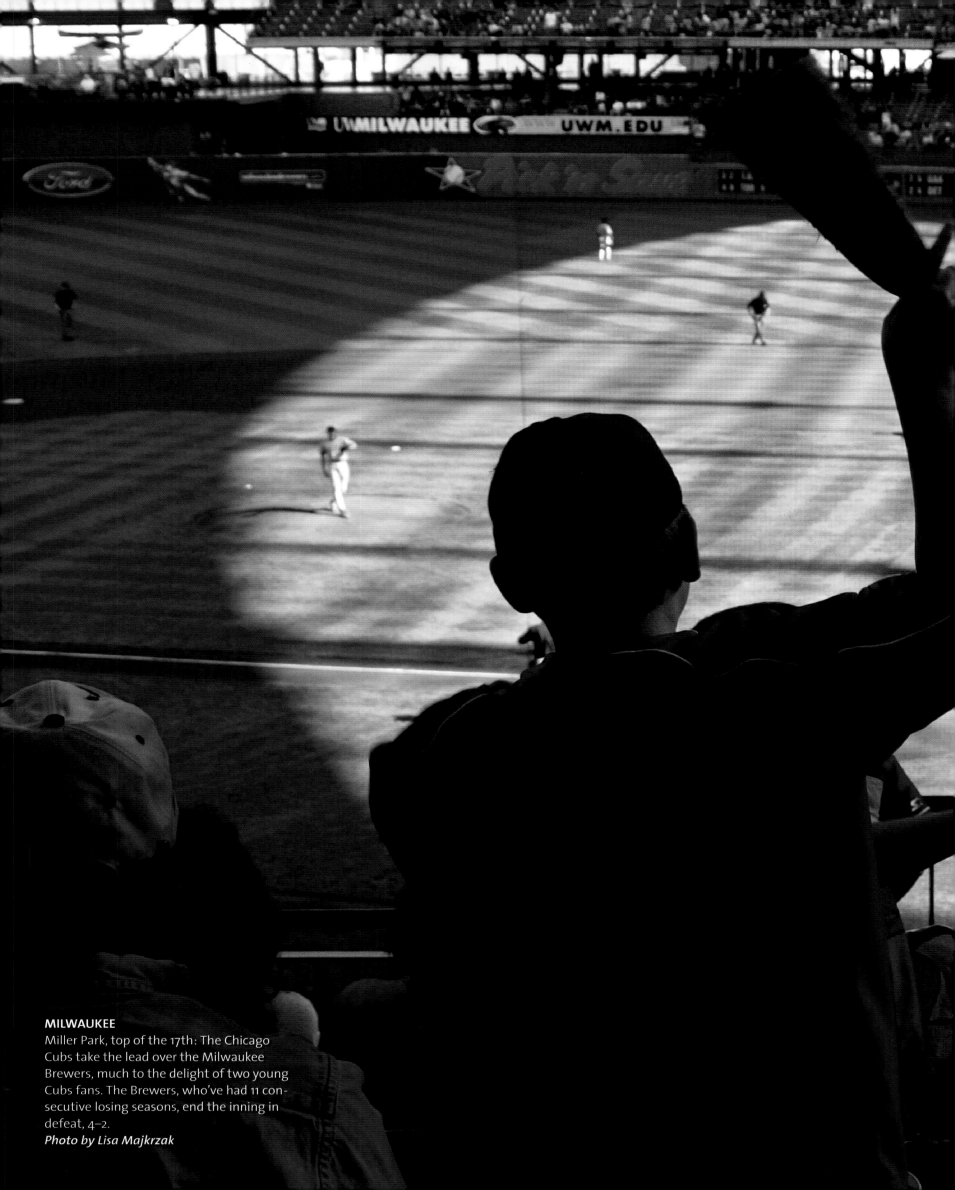

MILWAUKEE

Miller Park, top of the 17th: The Chicago Cubs take the lead over the Milwaukee Brewers, much to the delight of two young Cubs fans. The Brewers, who've had 11 consecutive losing seasons, end the inning in defeat, 4–2.

Photo by Lisa Majkrzak

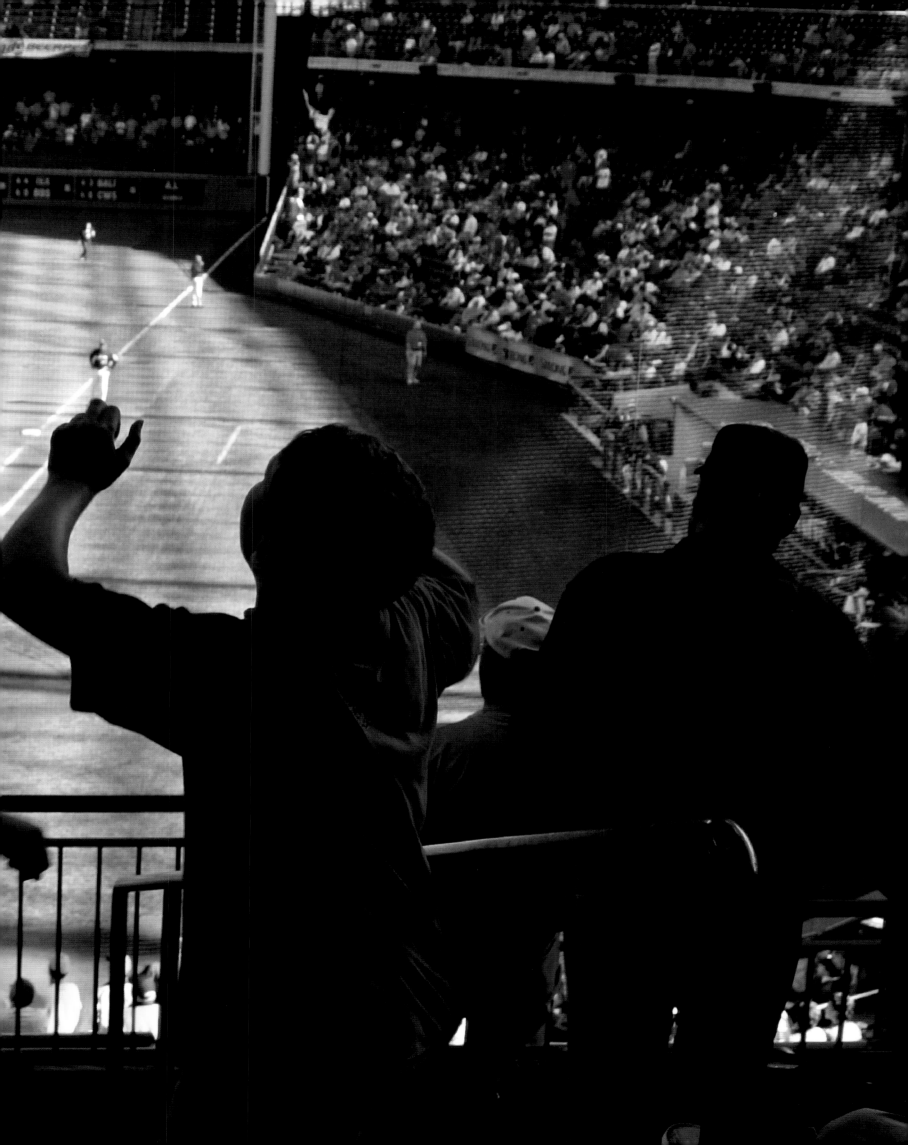

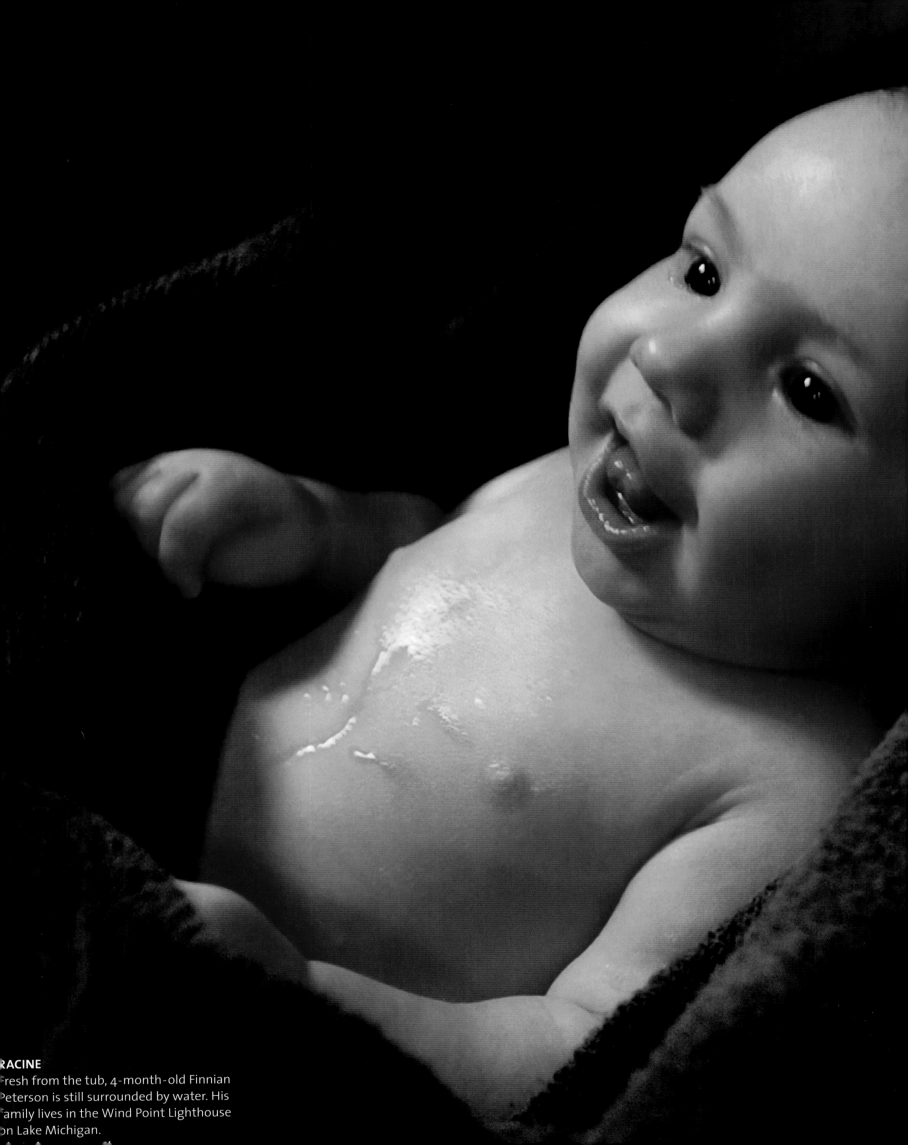

RACINE
Fresh from the tub, 4-month-old Finnian
Peterson is still surrounded by water. His
family lives in the Wind Point Lighthouse
on Lake Michigan.

Hearth & Home

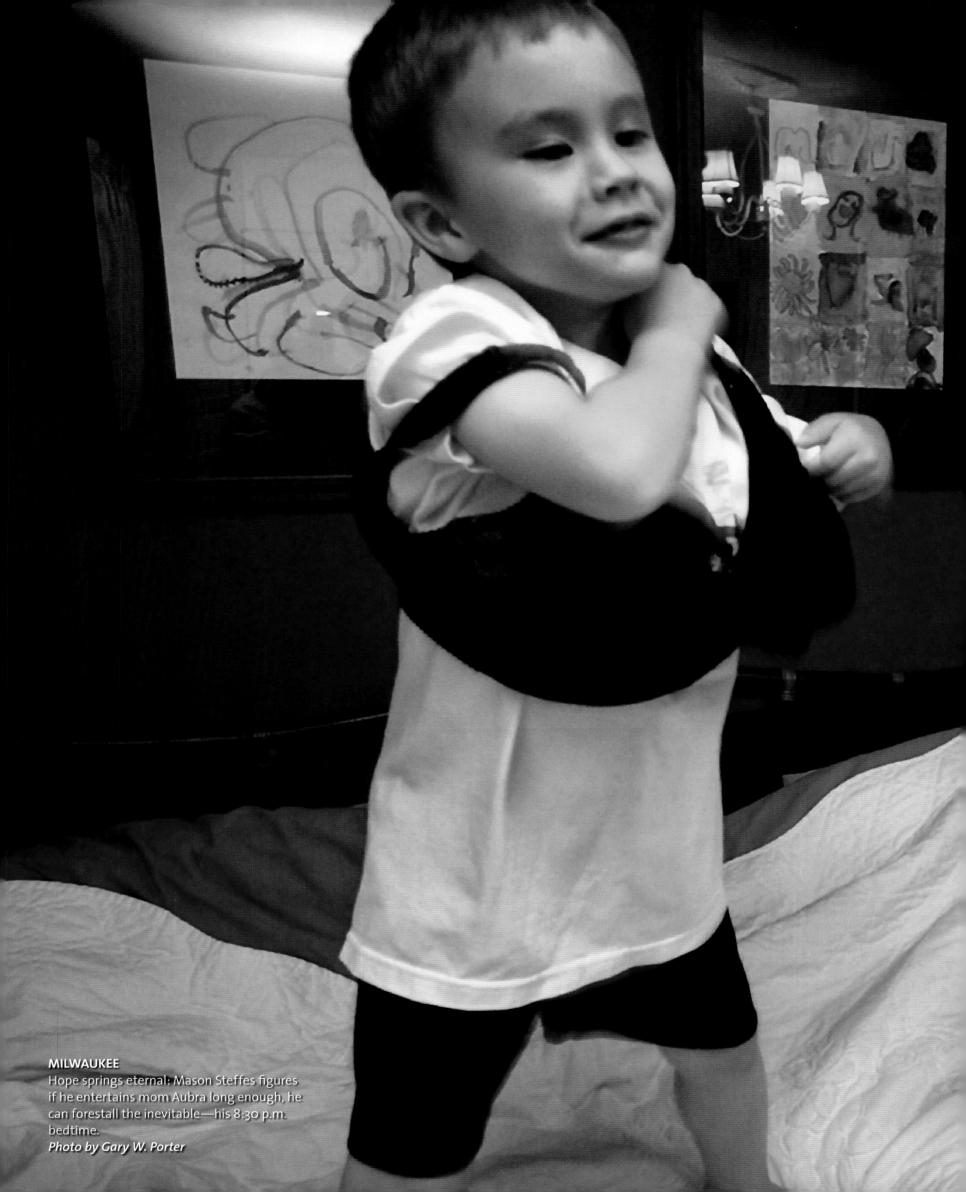

MILWAUKEE
Hope springs eternal: Mason Steffes figures
if he entertains mom Aubra long enough, he
can forestall the inevitable—his 8:30 p.m.
bedtime.
Photo by Gary W. Porter

PORT WASHINGTON
Tyke-sized tub: The sound of the kitchen sink being filled after dinner gets 9-month-old Riley Pierringer giddy with excitement for her daily bubble bath. She'd spend hours in the sink if her mom Lynn would let her.
Photo by David Dunai

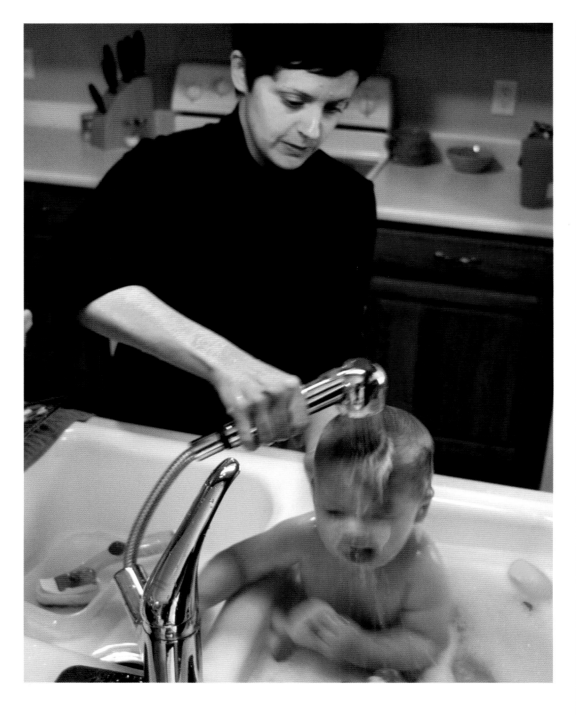

RACINE

Malaney Peterson endures the onset of a shampoo. She far prefers playing during her daily bath. Occasionally, her mother Melissa fills the old claw-foot tub to the rim and gives Malaney a swimming lesson. The lessons work—she has fearlessly gone right into Lake Michigan.
Photo by Gregory Shaver

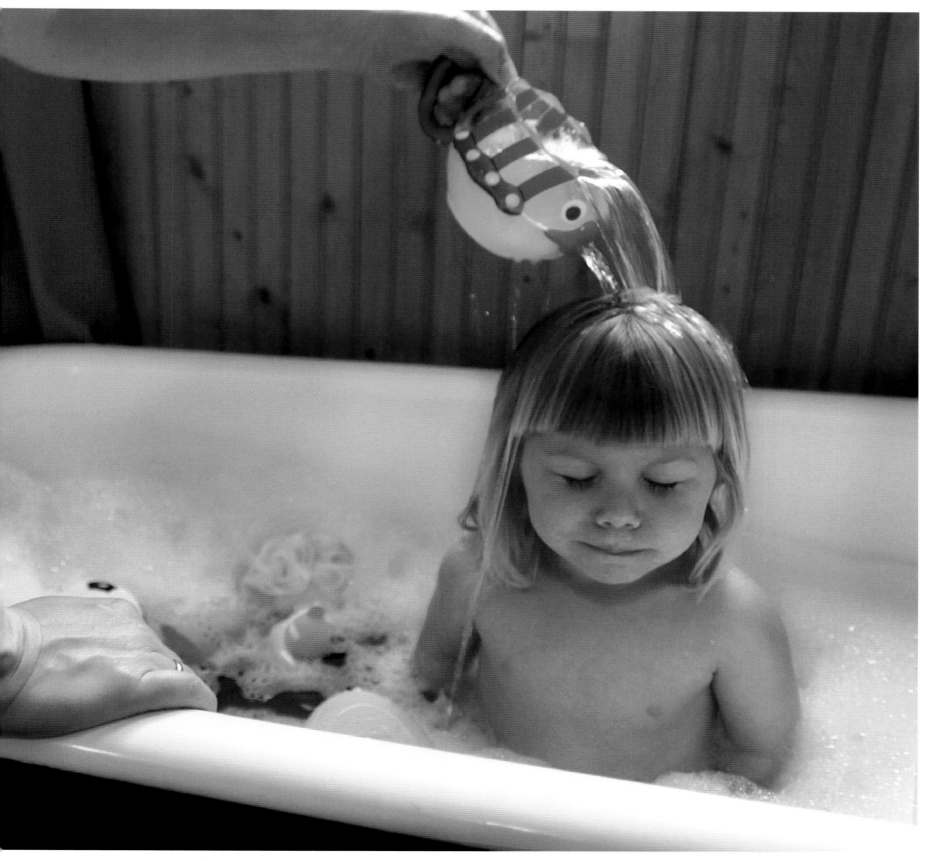

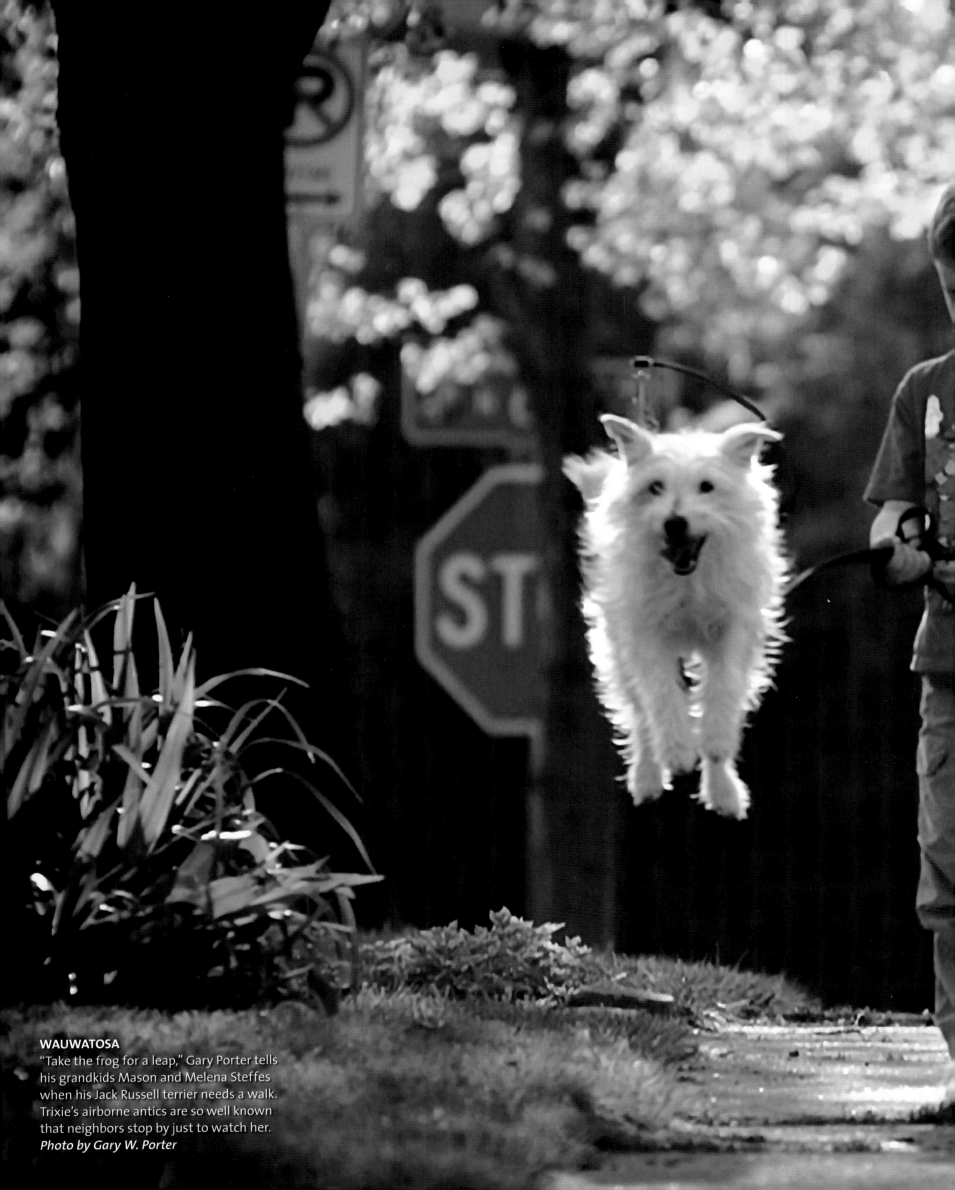

WAUWATOSA
"Take the frog for a leap," Gary Porter tells his grandkids Mason and Melena Steffes when his Jack Russell terrier needs a walk. Trixie's airborne antics are so well known that neighbors stop by just to watch her.
Photo by Gary W. Porter

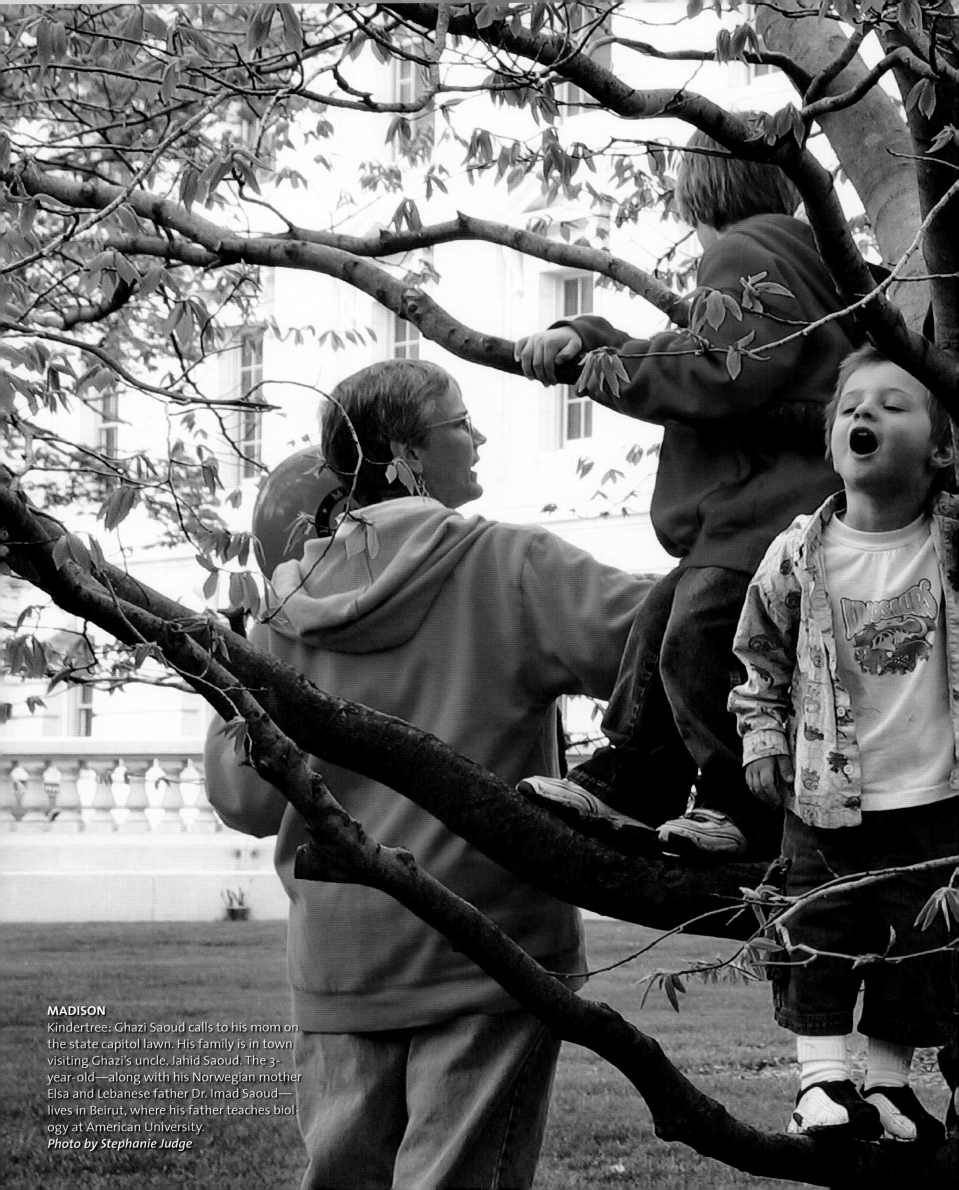

MADISON

Kindertree: Ghazi Saoud calls to his mom on the state capitol lawn. His family is in town visiting Ghazi's uncle, Jahid Saoud. The 3-year-old—along with his Norwegian mother Elsa and Lebanese father Dr. Imad Saoud—lives in Beirut, where his father teaches biology at American University.
Photo by Stephanie Judge

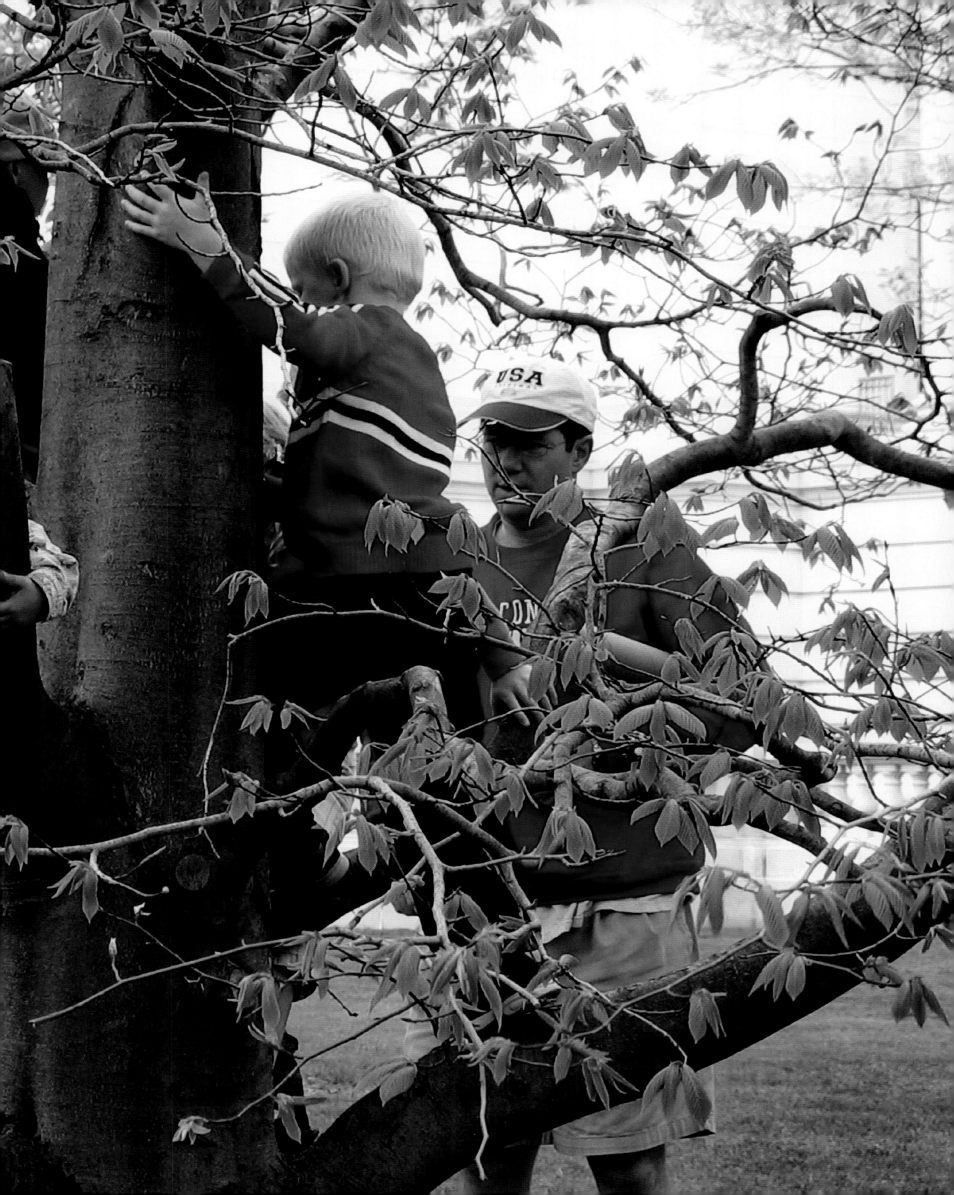

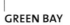

GREEN BAY

Lawn care is an art in suburban Green Bay. But the pleasure of creating a verdant, well-trimmed plot is tempered by the knowledge that it lasts only five months.
Photo by Tim Dardis

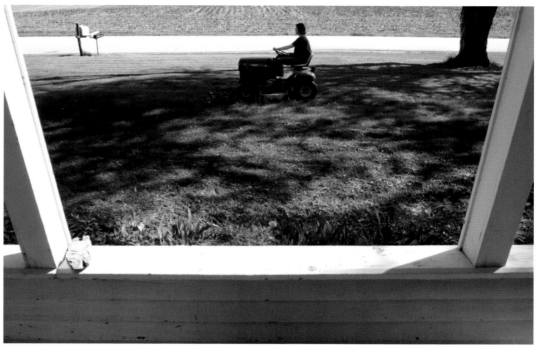

EAST TROY
Michele Stute, a former city girl from Madison, mows the front lawn on the farm where she raises sheep. The lawn is not fenced—otherwise she'd use the sheep.
Photo by Jeff Miller

EAST TROY

Rachel Stute gets a post-lunch washing from mom Michele. When Rachel has been served her favorite, macaroni and cheese, the aftermath is especially widespread and sticky.
Photos by Jeff Miller

EAST TROY

Rachel bonds with a Clun Forest sheep, one of 100 her mother raises for wool and meat. Rachel doesn't yet know the connection, says her mom, between her furry companions and food.

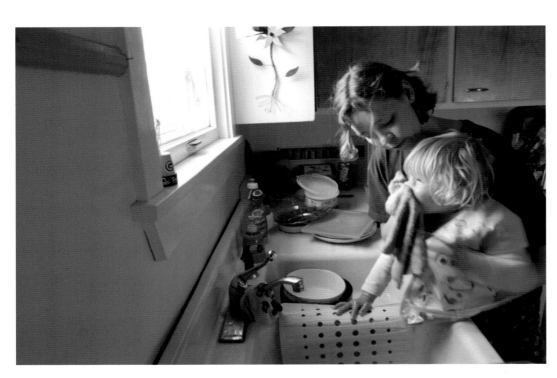

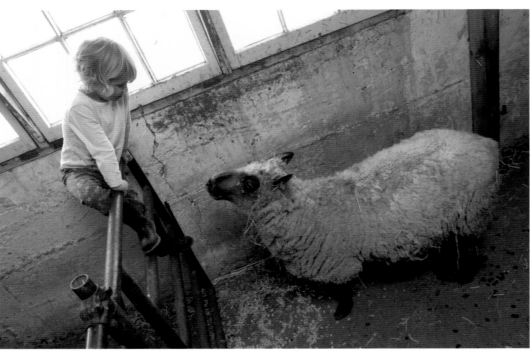

EAST TROY

Photographer Jeff Miller and his niece Rachel
Stute cast shadows on the family's sheep barn.
Miller went to take pictures of farm work but
ended up trying to keep pace with the 3-year-old.
"She runs more than she walks," he says.

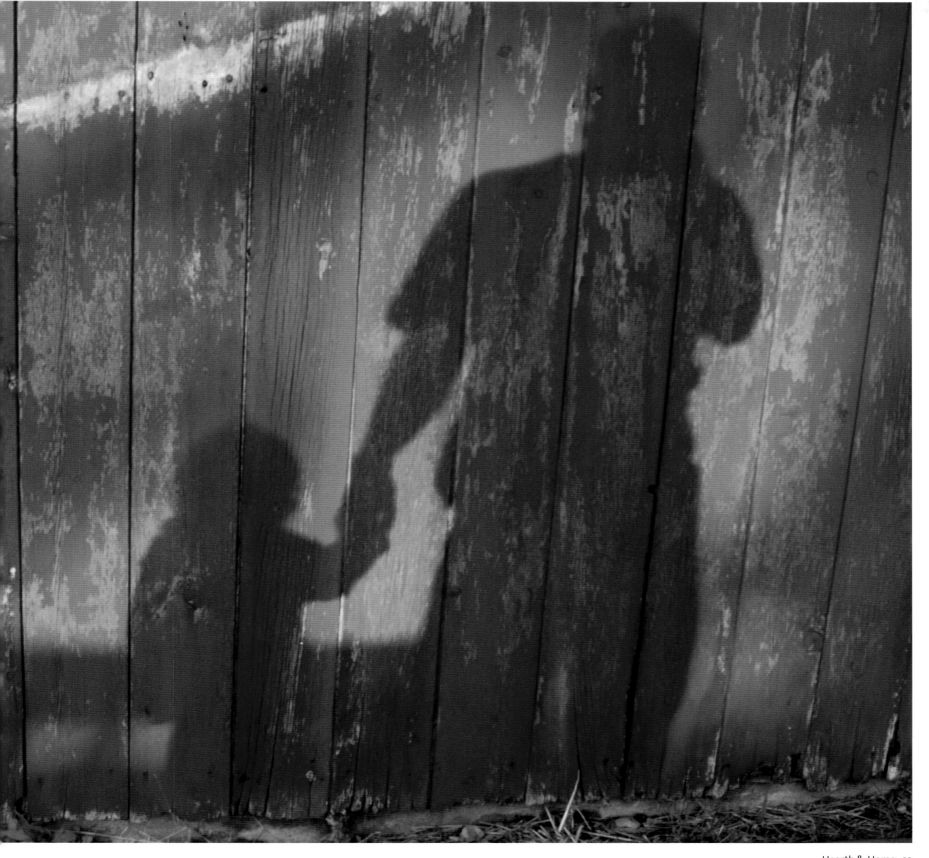

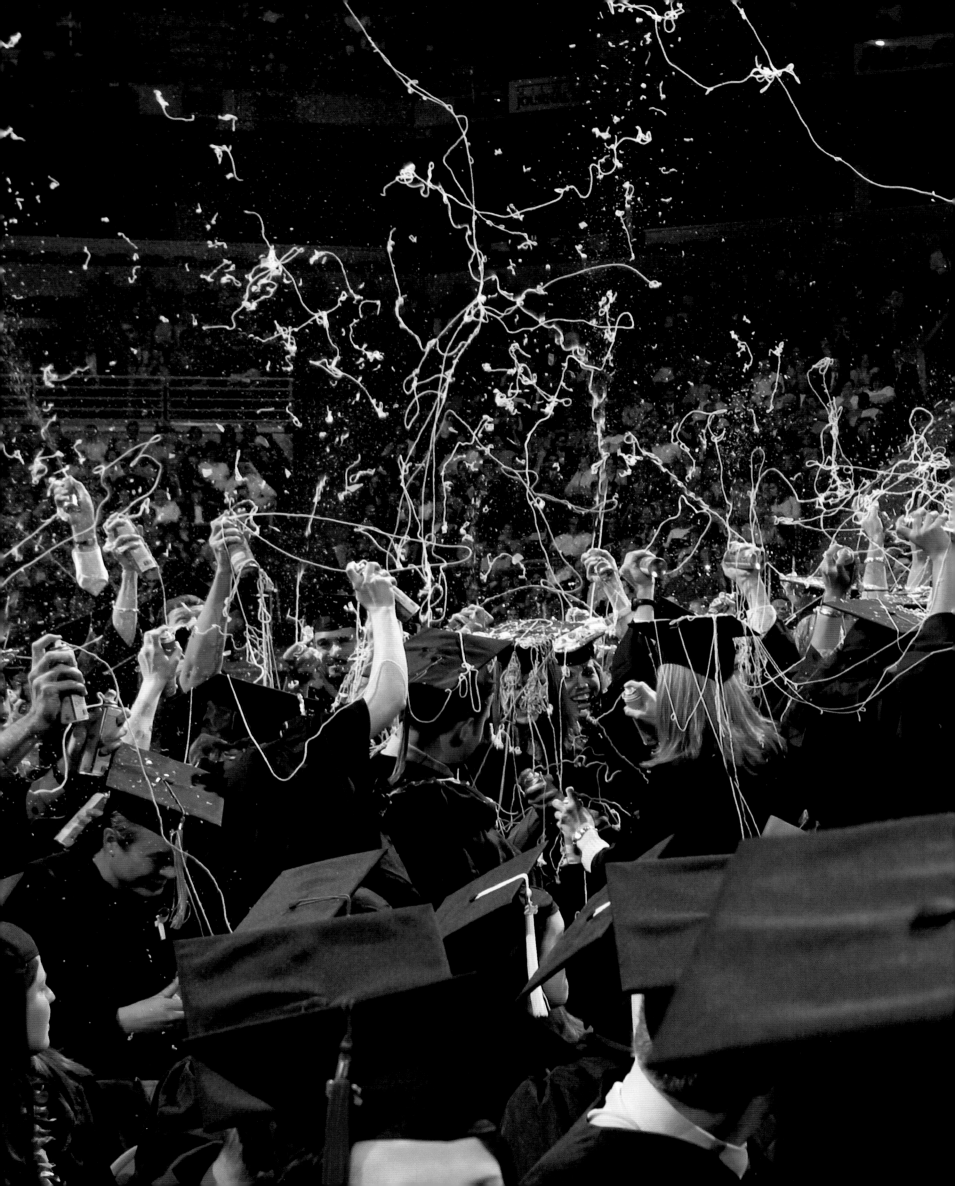

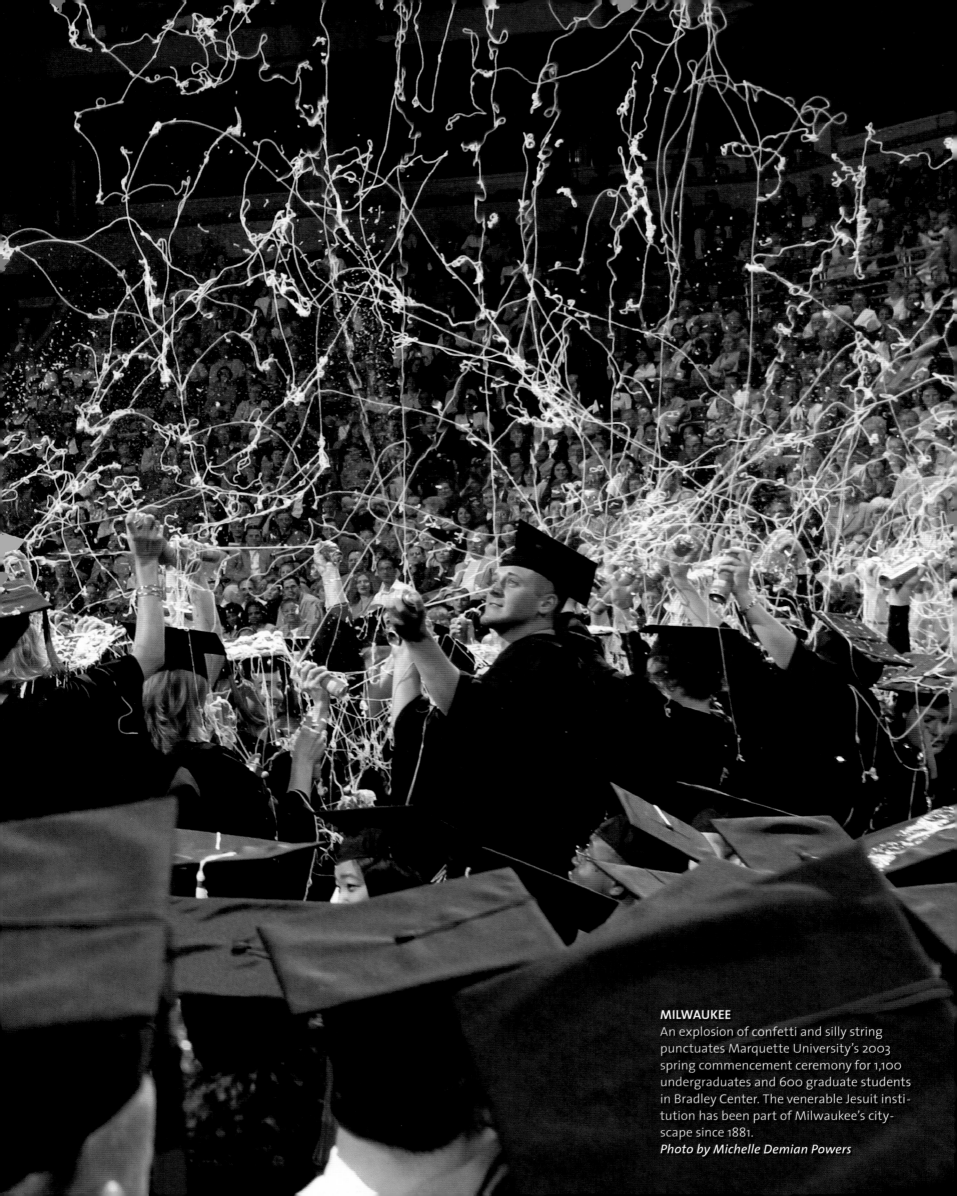

MILWAUKEE
An explosion of confetti and silly string punctuates Marquette University's 2003 spring commencement ceremony for 1,100 undergraduates and 600 graduate students in Bradley Center. The venerable Jesuit institution has been part of Milwaukee's cityscape since 1881.
Photo by Michelle Demian Powers

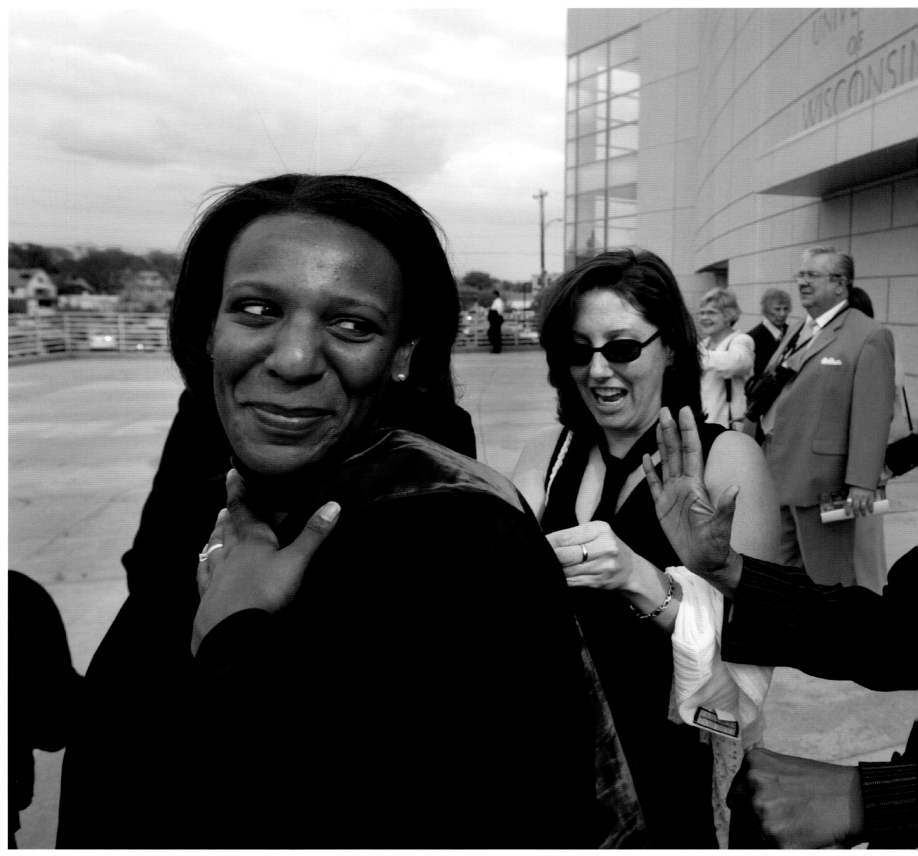

MADISON

Jacalyn Blackwell-White (right) adjusts daughter Candace White-Halverson's chevron just before she receives her law degree from the University of Wisconsin. It's an advanced-degree weekend for the family: Daughter Erica is graduating from veterinary school and Candace's husband Charles is also receiving his law degree.

Photo by Andy Manis, manisphoto.com

MADISON

A family affair: Brian Edwards poses with eldest son Nick, a medical school graduate, for youngest son Nate's camera. Daughter Jessica also got her B.A. in elementary education that weekend. The kids follow in their parents' footsteps. Edwards and his wife Mary are 1972 graduates of UW-Madison.

Photo by Michael Forster Rothbart, University of Wisconsin

MADISON

"In and out in four years," says an ecstatic Mitch Simon during commencement at the University of Wisconsin-Madison's Kohl Center. One of 4,441 undergraduates, Simon received a bachelor of science degree in economics.

Photo by Michael Forster Rothbart, University of Wisconsin

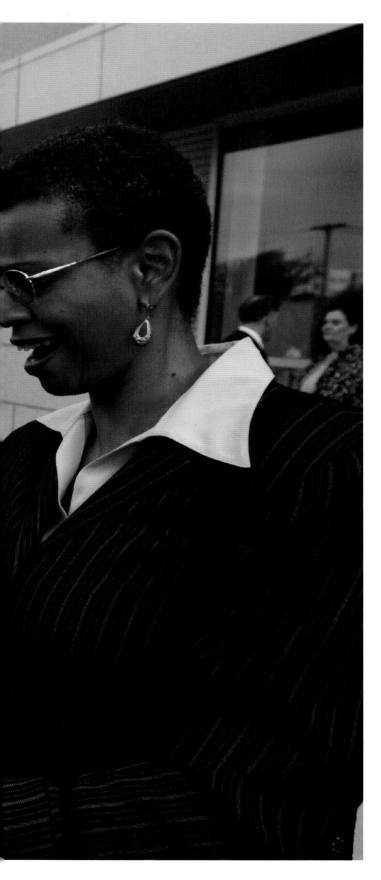

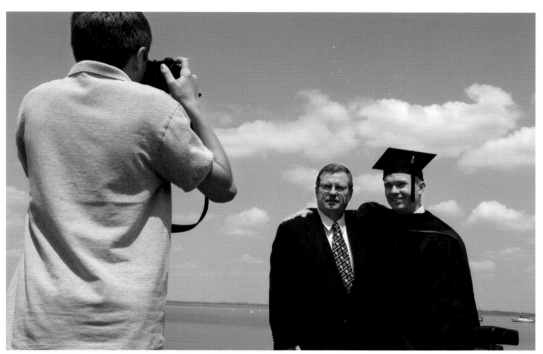

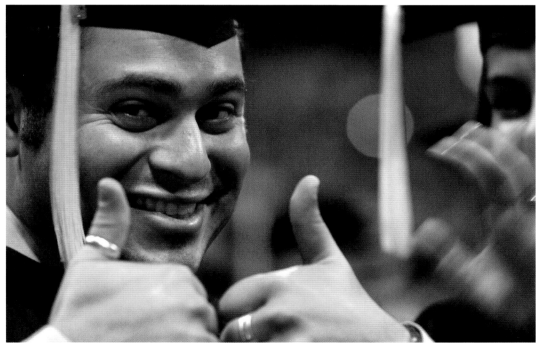

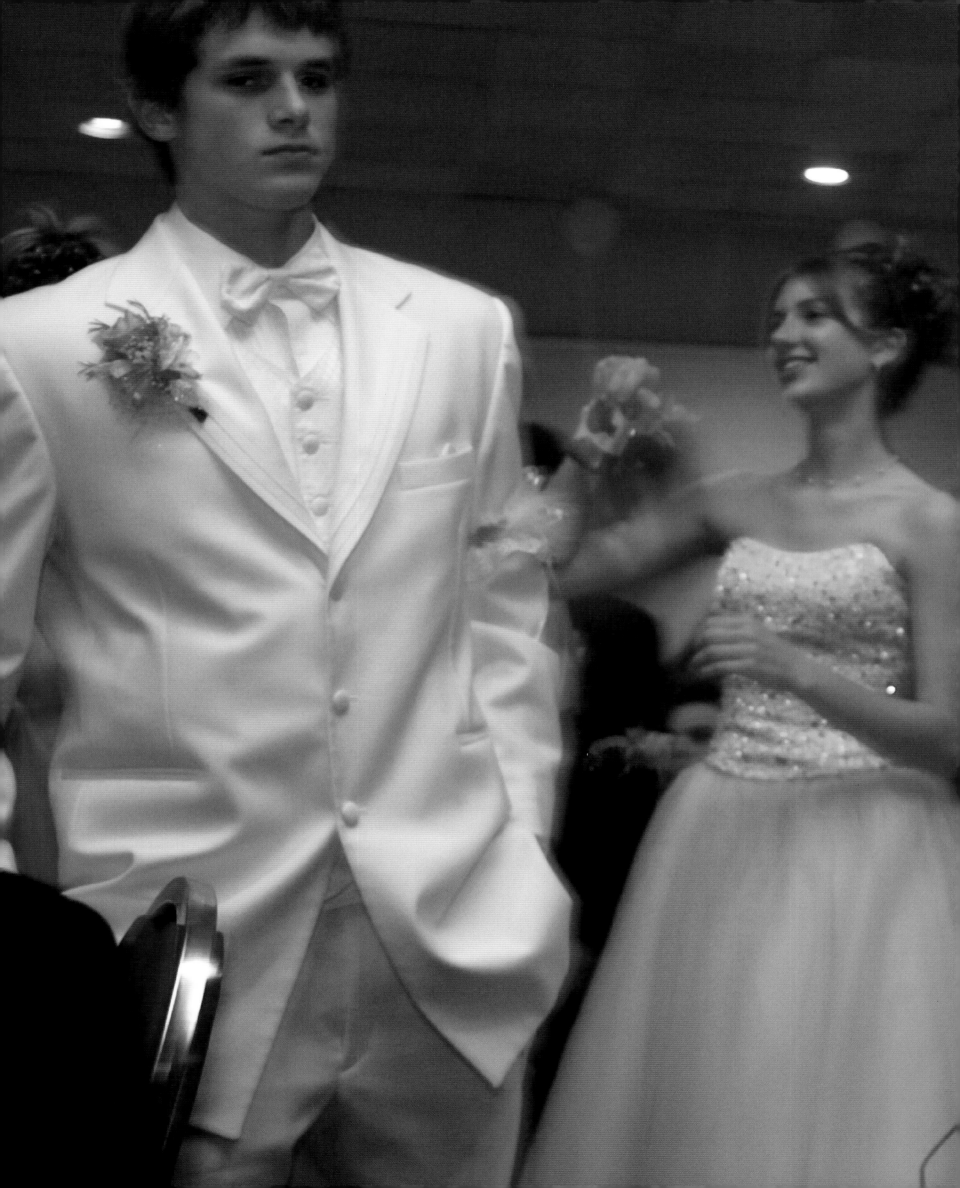

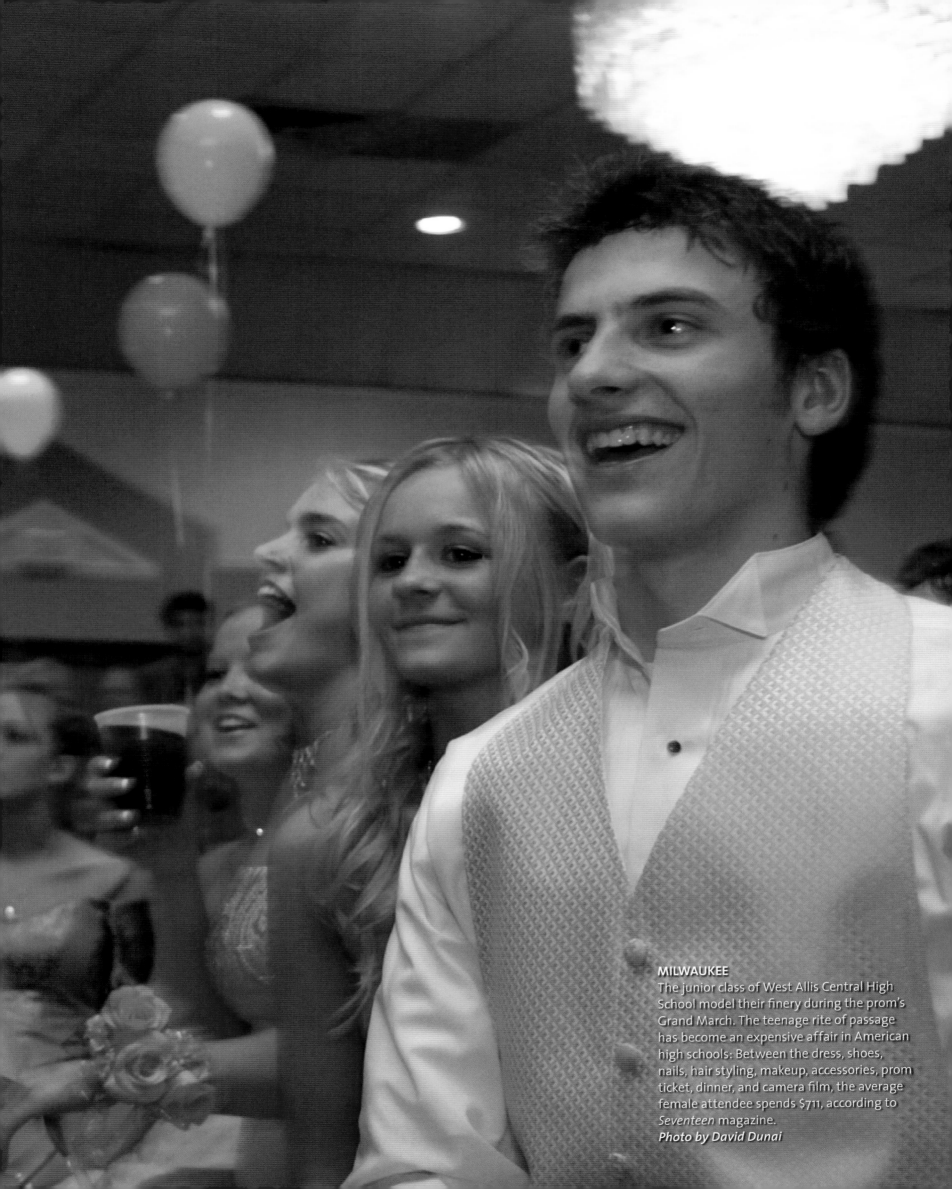

MILWAUKEE
The junior class of West Allis Central High School model their finery during the prom's Grand March. The teenage rite of passage has become an expensive affair in American high schools: Between the dress, shoes, nails, hair styling, makeup, accessories, prom ticket, dinner, and camera film, the average female attendee spends $711, according to *Seventeen* magazine.
Photo by David Dunai

RACINE

Graduating seniors try to one-up each other in their livery for the arrival at Racine Rotary's city-wide post-prom party. When Chase Leonard showed Rachel Clum his father's new tow truck, she said, *"That's* what we're going in?" Adding a garden swing strung with artificial flowers made all the difference.

Photos by Gregory Shaver

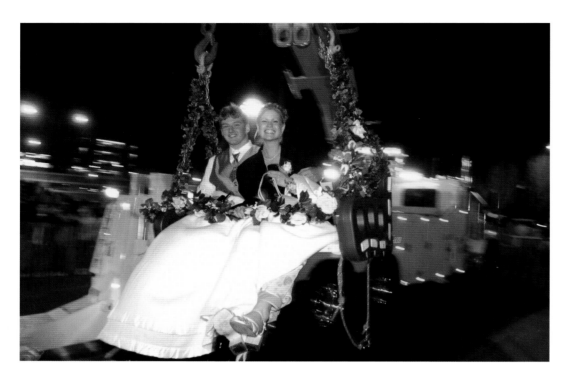

RACINE
St. Catherine's senior Christy Brucker and college student David Pautz get in the groove at the Rotary's post-prom festivities.

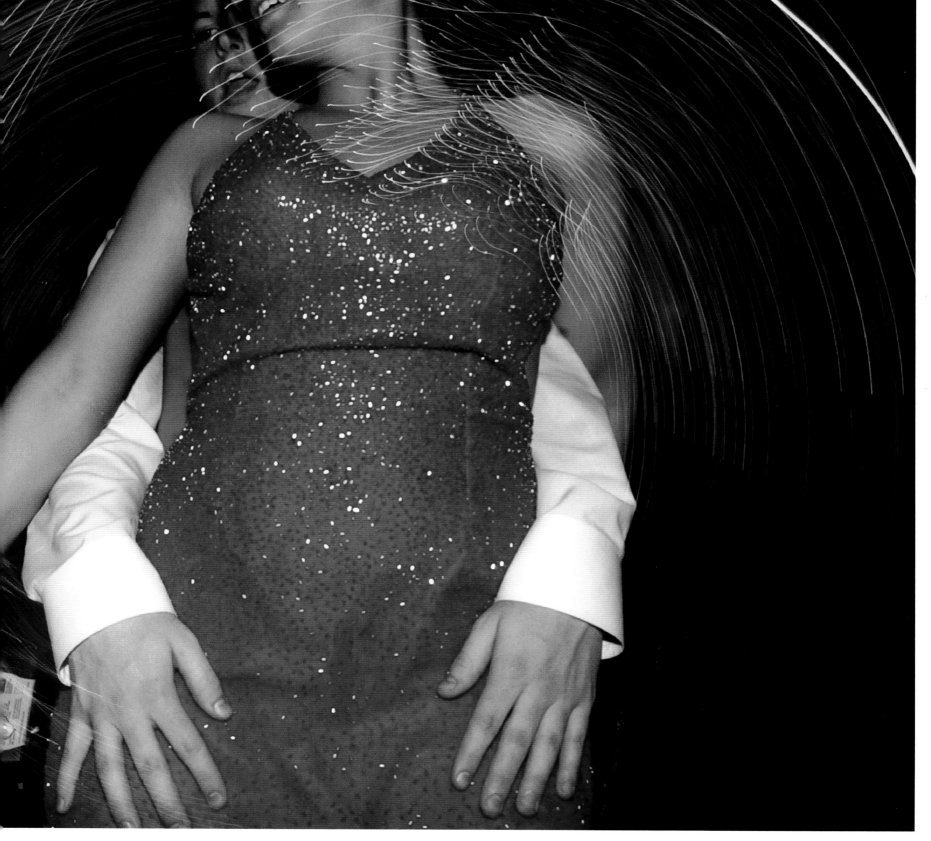

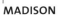

MADISON
Randy Wagner and Aaron Schultz met at a barbecue three years ago and have been together ever since. Wagner is a family counselor specializing in domestic violence problems. Schultz is a wine salesman.
Photos by Jeff Miller

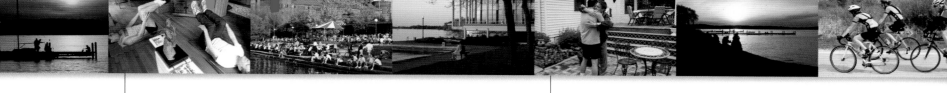

MADISON

Ab time. Every day, Wagner and Schultz put on what Schultz calls "the dreaded abs tape" and go through "eight minutes of hell." They are getting in shape for a ceremony that they don't know what to call: Celebration of their union as life partners? Commitment ceremony? Wedding?

MADISON

Schultz and Wagner, about to go their separate ways for the day, stand in the patio where they plan to hold their celebration.

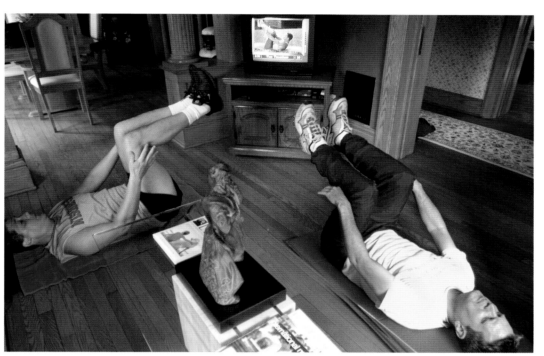

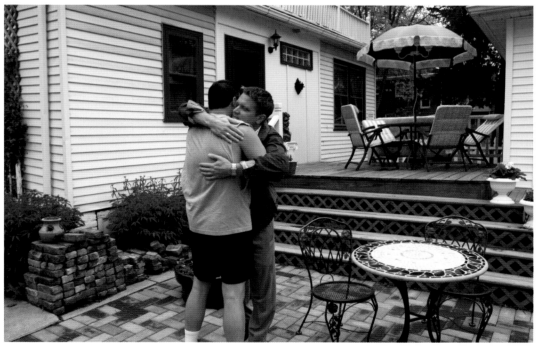

Going strong: Even at 83, Edna Holleran hasn't slowed down much. She only recently gave up bowling and golf. The Holleran matriarch still teaches Sunday school, cooks meals for the homeless, plays bridge, and throws parties for her family of 11 children and 33 grandchildren.
Photo by Gary W. Porter

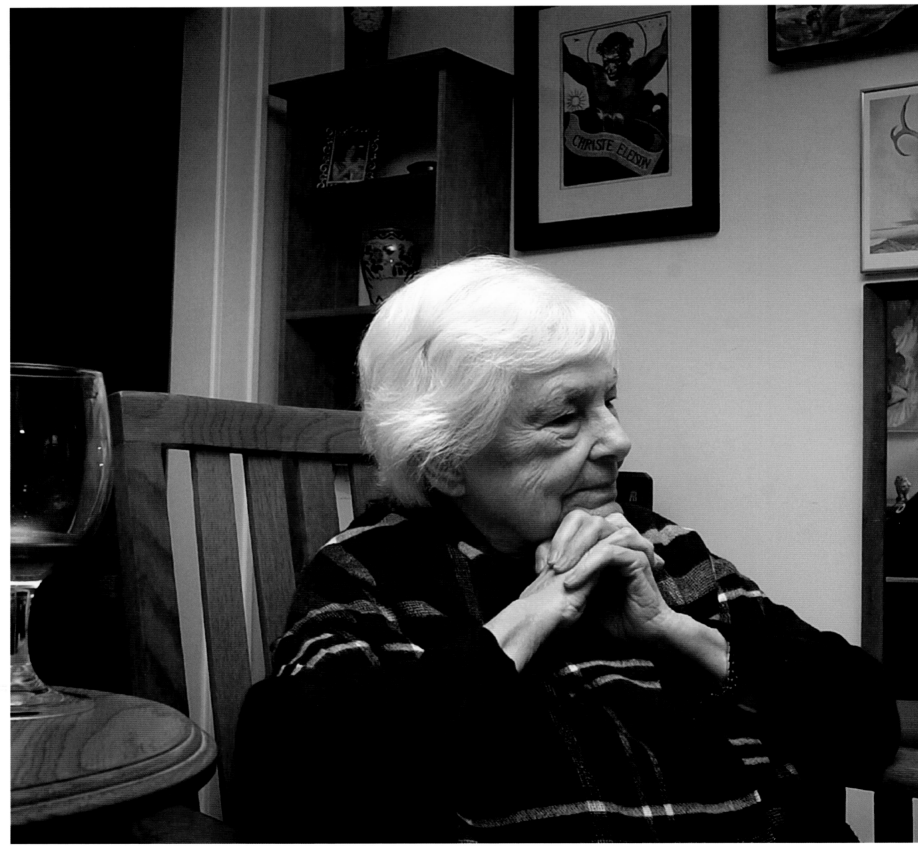

MEQUON

In the 1830s, the King of Prussia ruled that Pomeranian Lutherans had to join his United Church. Seeking religious asylum, Harold Schoessow's great-grandfather (in photograph) and 19 other families immigrated to the Milwaukee area. They were not allowed to leave Prussia individually, so entire congregations moved together. Harold and his son still farm the land his great-grandfather bought in 1839.
Photo by Kris Lorentzsen

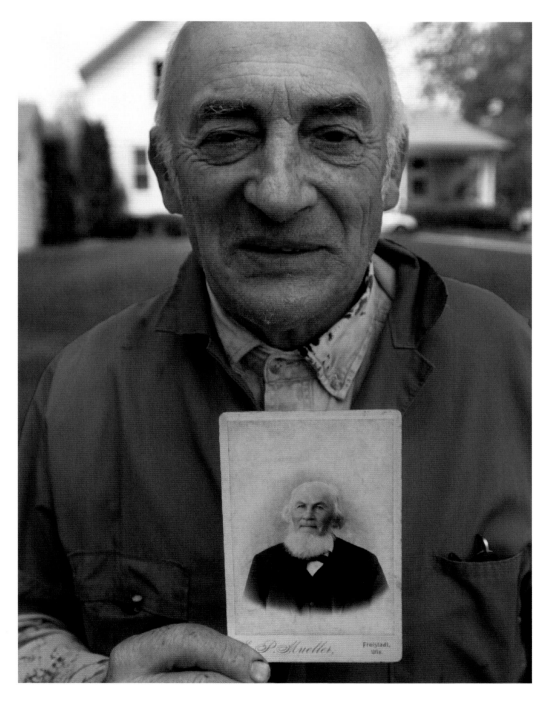

The year 2003 marked a turning point in the history of photography: It was the first year that digital cameras outsold film cameras. To celebrate this unprecedented sea change, the *America 24/7* project invited amateur photographers—along with students and professionals—to shoot and, via the Internet, submit digital images. Think of it as audience participation. Their visions of community are interspersed with the professional frames throughout this book. On the following four pages, however, we present a gallery produced exclusively by amateur photographers.

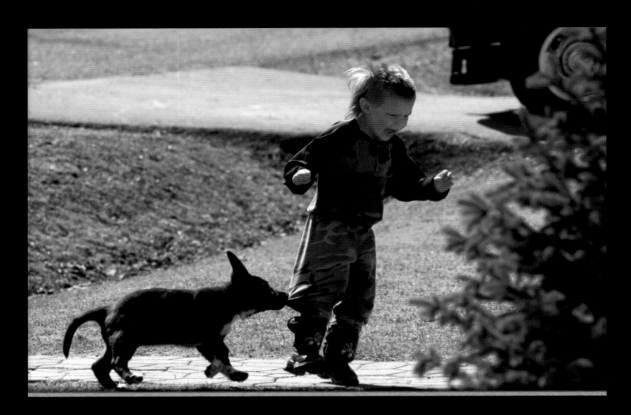

MARSHFIELD A boy and his dog: Gunnar David, 4, tries to shake off his puppy Ozzy, named for Ozzy Osbourne.
Photo by James Benson

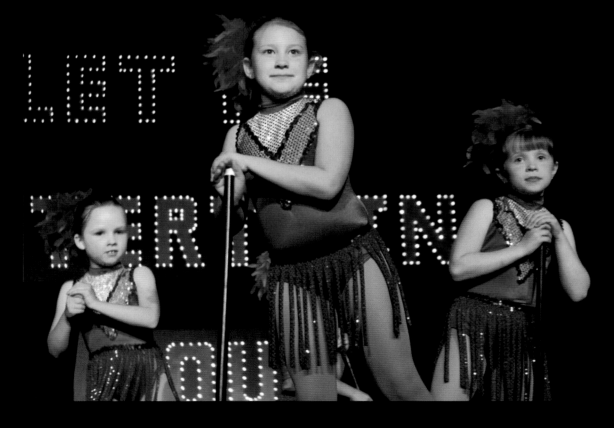

RIVER FALLS Razzle-dazzle 'em: Lauren Sandy, Kelsey Simmons, and Zoe Friesen shimmy their way through "Friend Like Me" from the movie *Aladdin* at the Hudson Academy's spring recital. *Photo by Jay Langhurst*

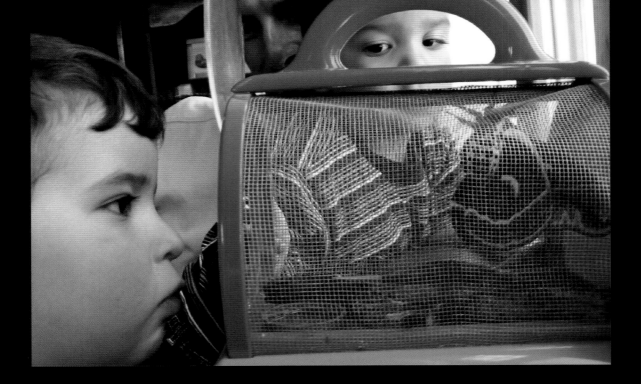

RAYMOND Catch and release: Wyatt Koelsch, his brother Gilbert, and their father James bid farewell to a great big cecropia moth before they set it free. *Photo by Janet Buckner*

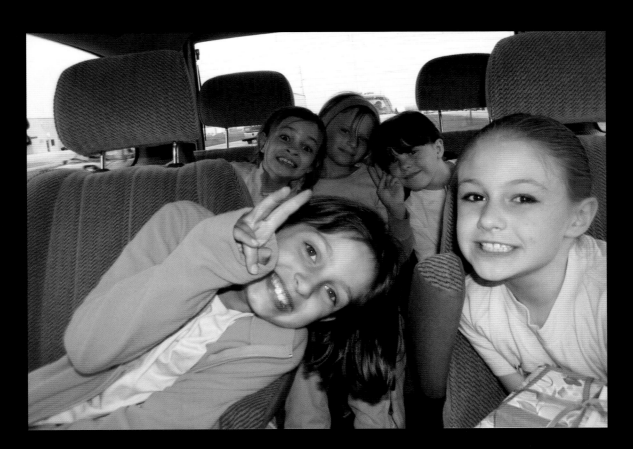

MADISON The light turned red, so Eric Bertun grabbed a quick shot of daughter Sydney (middle back) and friends en route to a birthday party. *Photo by Eric Bertun*

FOND DU LAC Cat nap: The sunny corner of his owner's bed is Tigger's favorite place to spread out for his afternoon nap. *Photo by Carol Glaman*

GREENFIELD Blooming dogwood and crab apple trees in Whitnall Park signal the end of winter for Greenfield residents. *Photo by Michael Lutzenberger*

CENTURIA Ah, spring! Buster sunbathes in the Pollock family's yard. *Photo by Mary Pollock*

MADISON Paper globe lamps festoon the Urban Outfitters store on State Street. Adjoining the University of Wisconsin-Madison campus, the downtown street's shops are geared to students. *Photo by Bruce Caucutt*

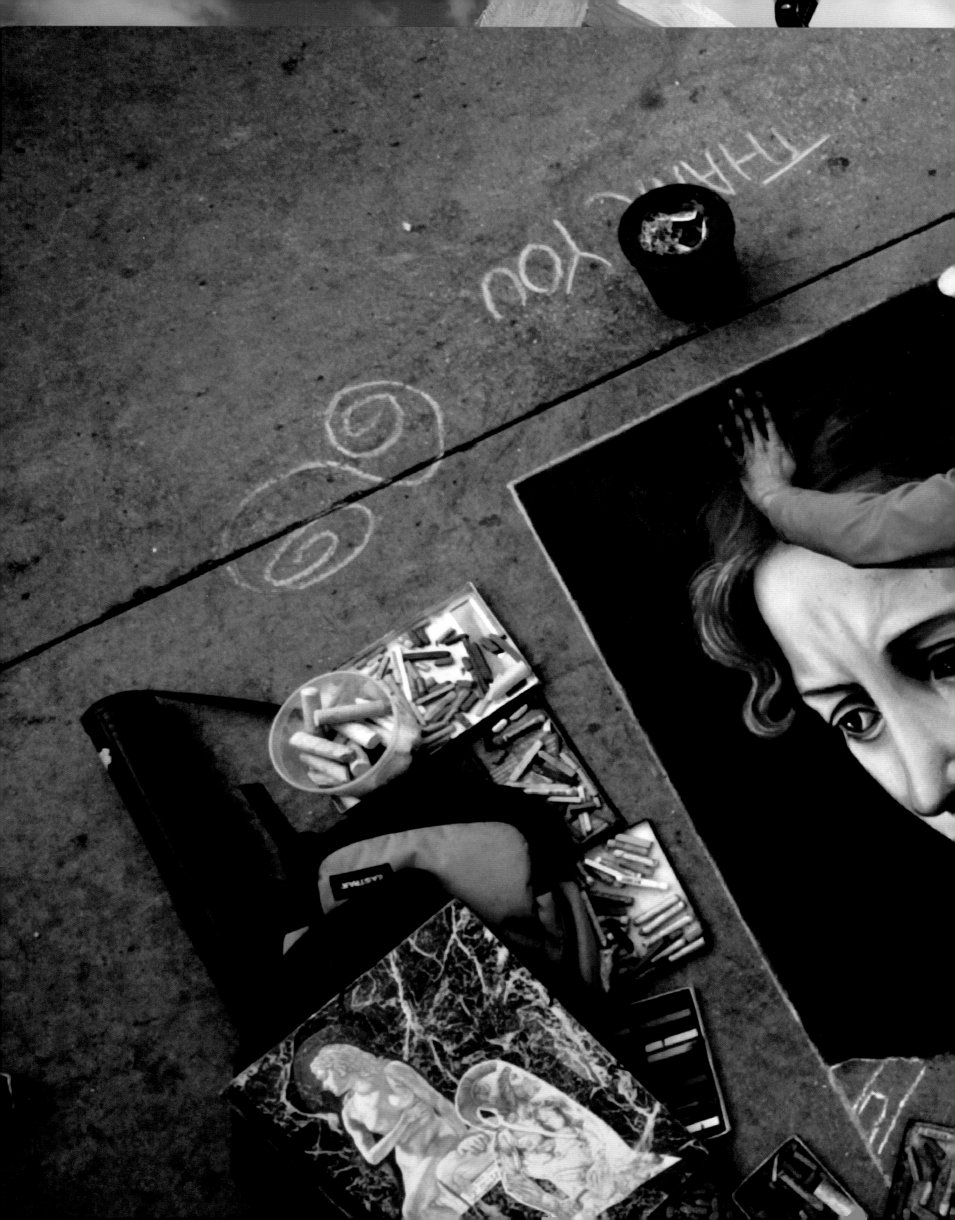

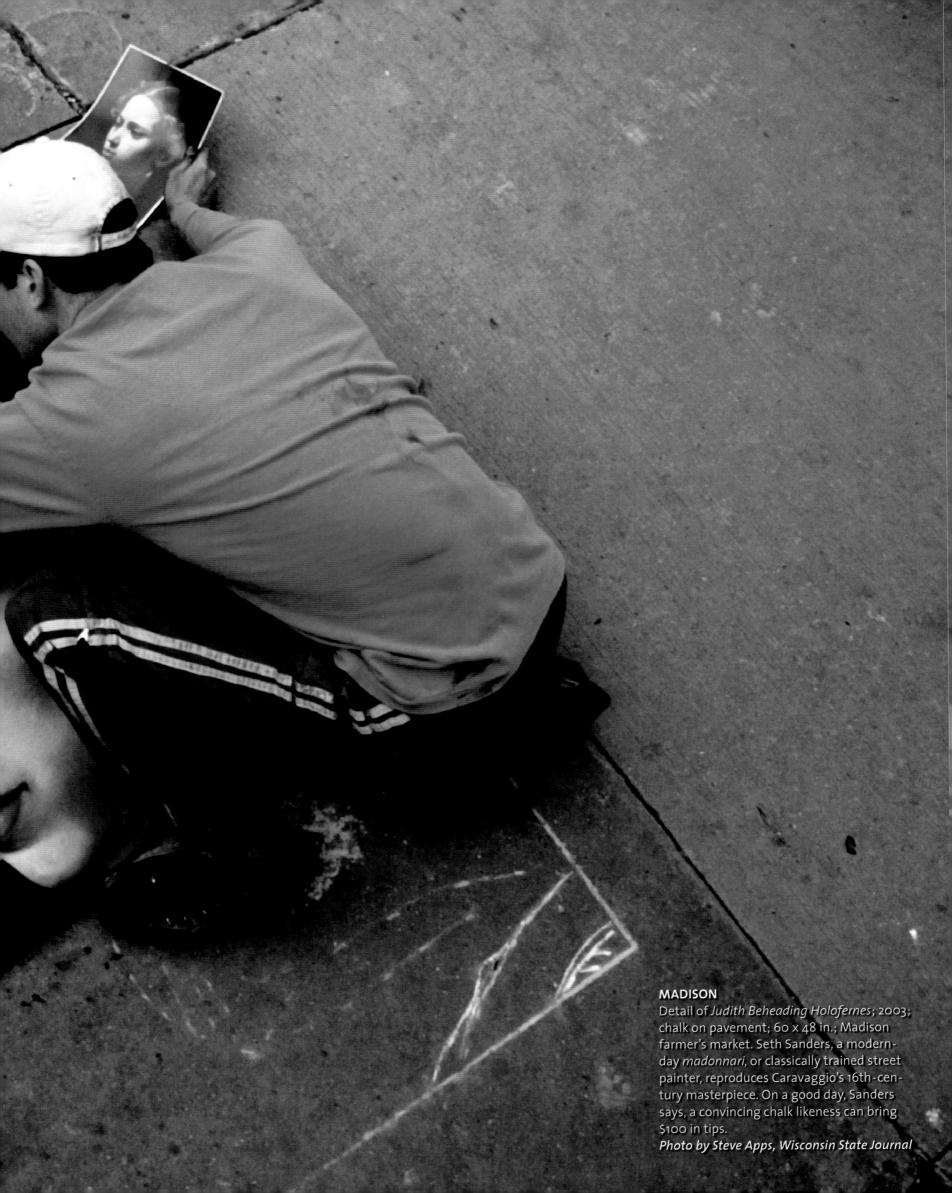

MADISON
Detail of *Judith Beheading Holofernes*; 2003; chalk on pavement; 60 x 48 in.; Madison farmer's market. Seth Sanders, a modern-day *madonnari*, or classically trained street painter, reproduces Caravaggio's 16th-century masterpiece. On a good day, Sanders says, a convincing chalk likeness can bring $100 in tips.
Photo by Steve Apps, Wisconsin State Journal

MILWAUKEE

Areka Ikeler's speed on a sewing machine earned her the nickname "Fashion Ninja" during college. She kept the moniker for her new South Side store, where she sells one-of-a-kind designs, including this asymmetrical denim ensemble.
Photo by Darren Hauck

FOX POINT

"I get to crawl around on the floor, make faces, and act like a kid all day," says Steve LaMaster. The elementary school photographer uses toys, impersonations, and rattles to elicit smiles. When all else fails, his Donald Duck imitation usually does the trick.
Photo by David Dunai

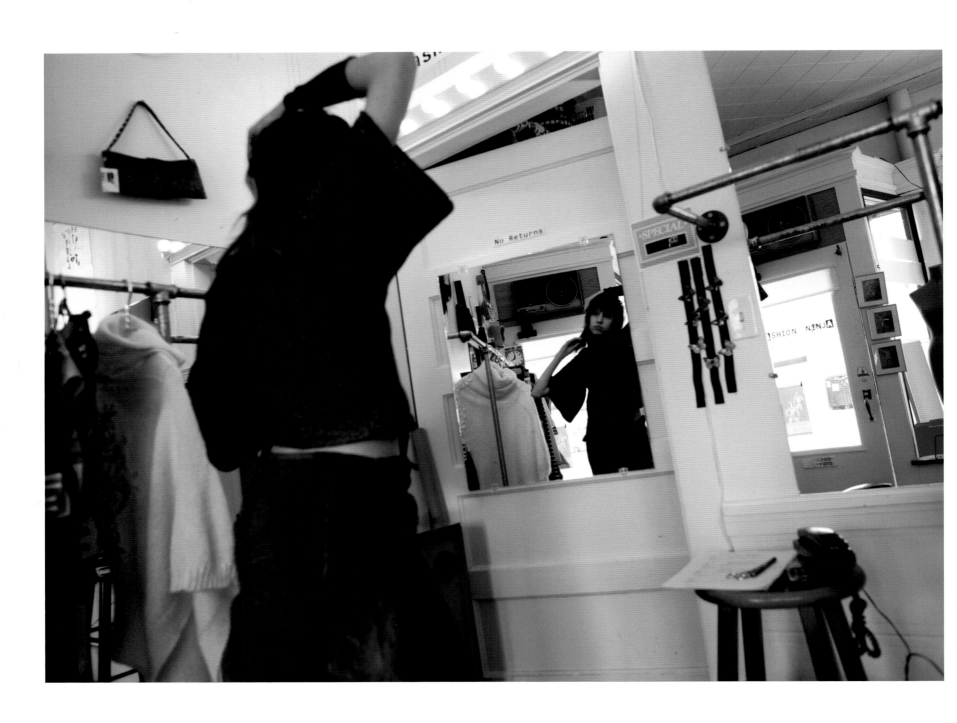

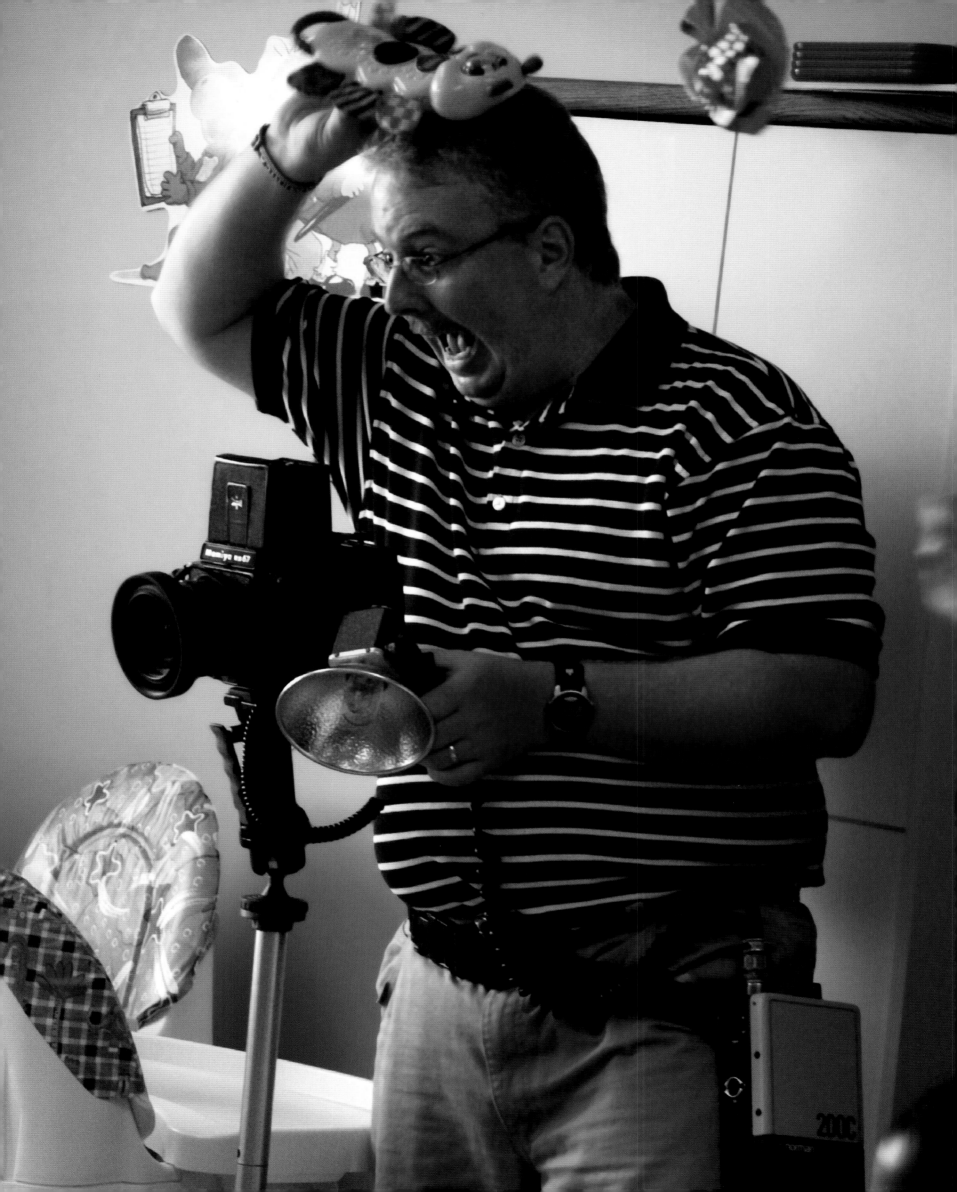

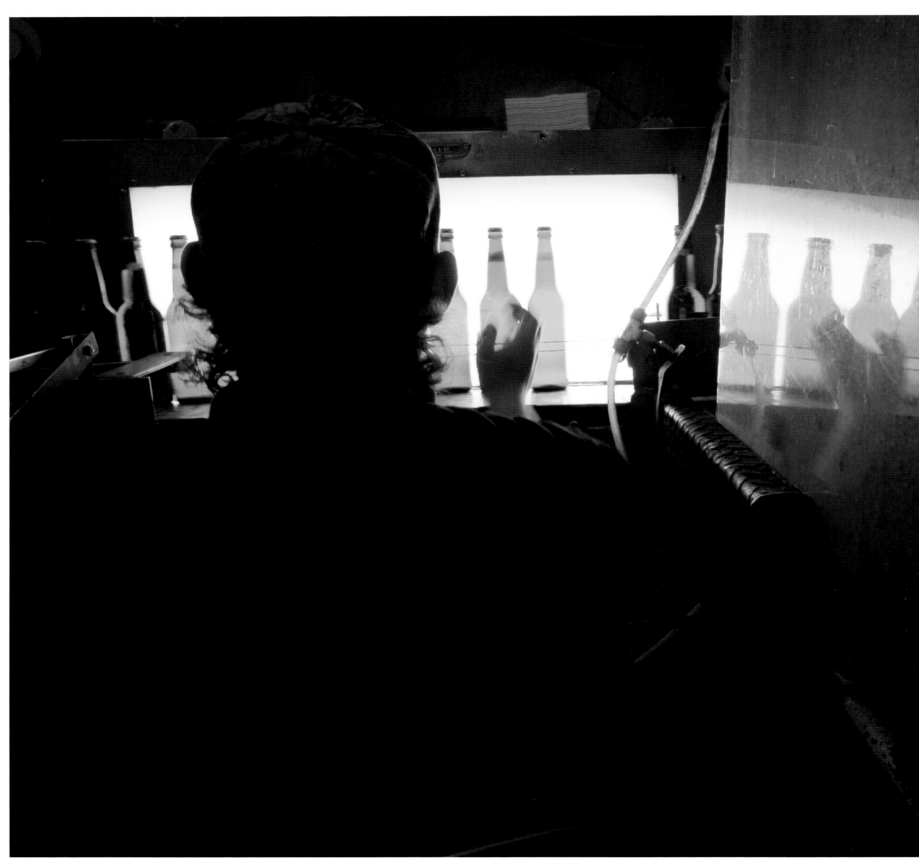

CHIPPEWA FALLS

Kettleman Bob Bromeisl cleans visitor finger-prints off a copper brew kettle lid in Leinenkugel's Brewery. A 39-year veteran of the small, family-run company founded in 1863, Bromeisl says, "I'm the brewing technician responsible for running the equipment. And I'm particular about how my kettle looks."

Photo by Dan Reiland

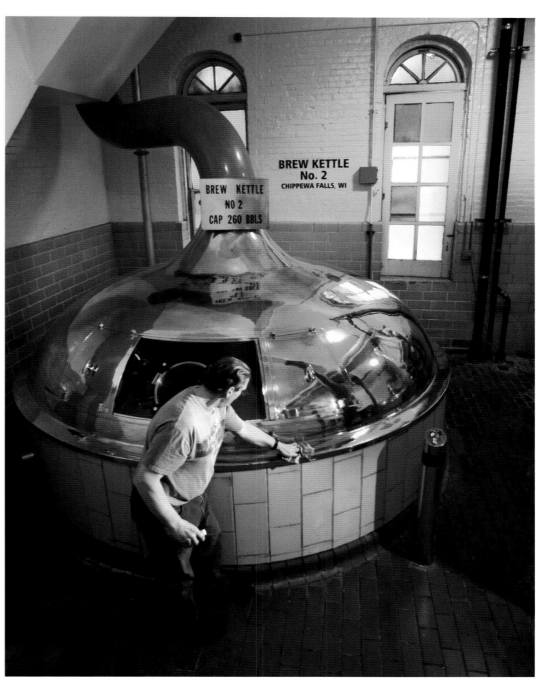

MILWAUKEE

Holler House, a South Side tavern, has the oldest American Bowling Congress–sanctioned alley in the country. The two wooden lanes in the basement were built by the Skowronski family in 1908. "My grandson Kris Stuckert is one of the pin setters," says owner Marcy Skowronski. "A good pin setter is faster than the automatic machines in those big alleys."

Photo by Andy Manis, manisphoto.com

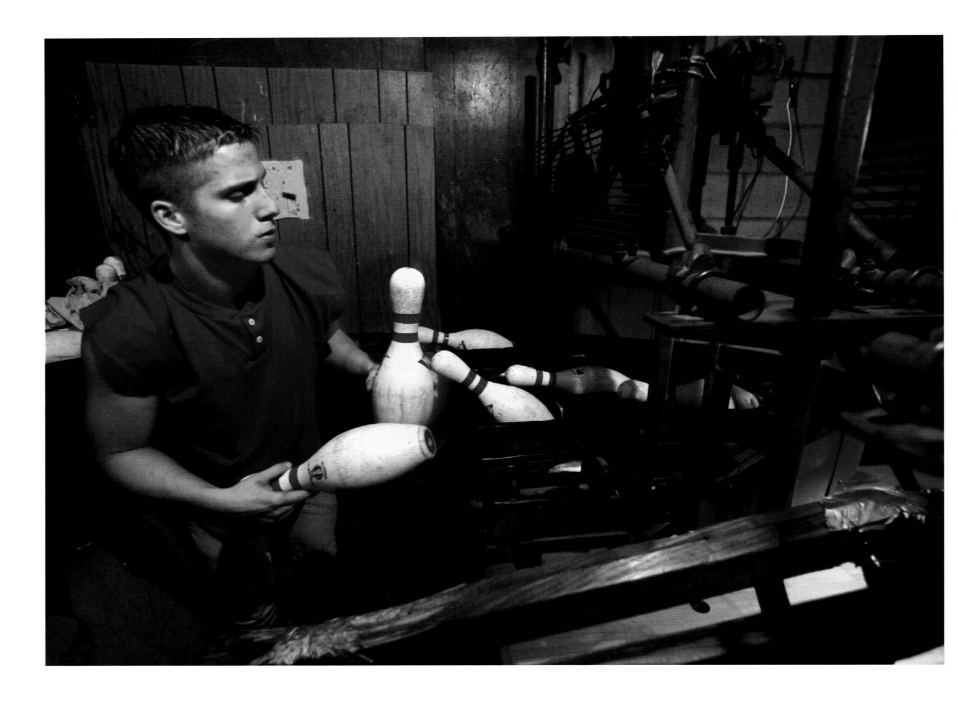

GREEN BAY

Packers defensive end Kabeer Gbaja-Biamila tones his glutes and lower back with strength and conditioning coach Barry Rubin. The 6-foot 4-inch, 255-pound starter is one of the top sackers in the NFL.

Photo by Mike Roemer, Roemer Photography

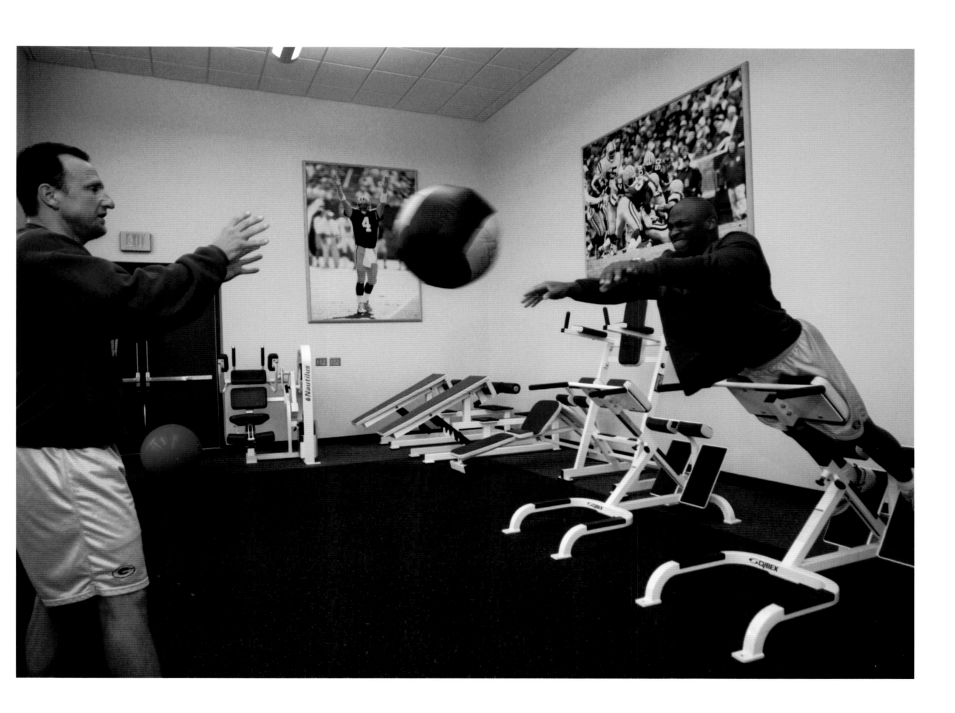

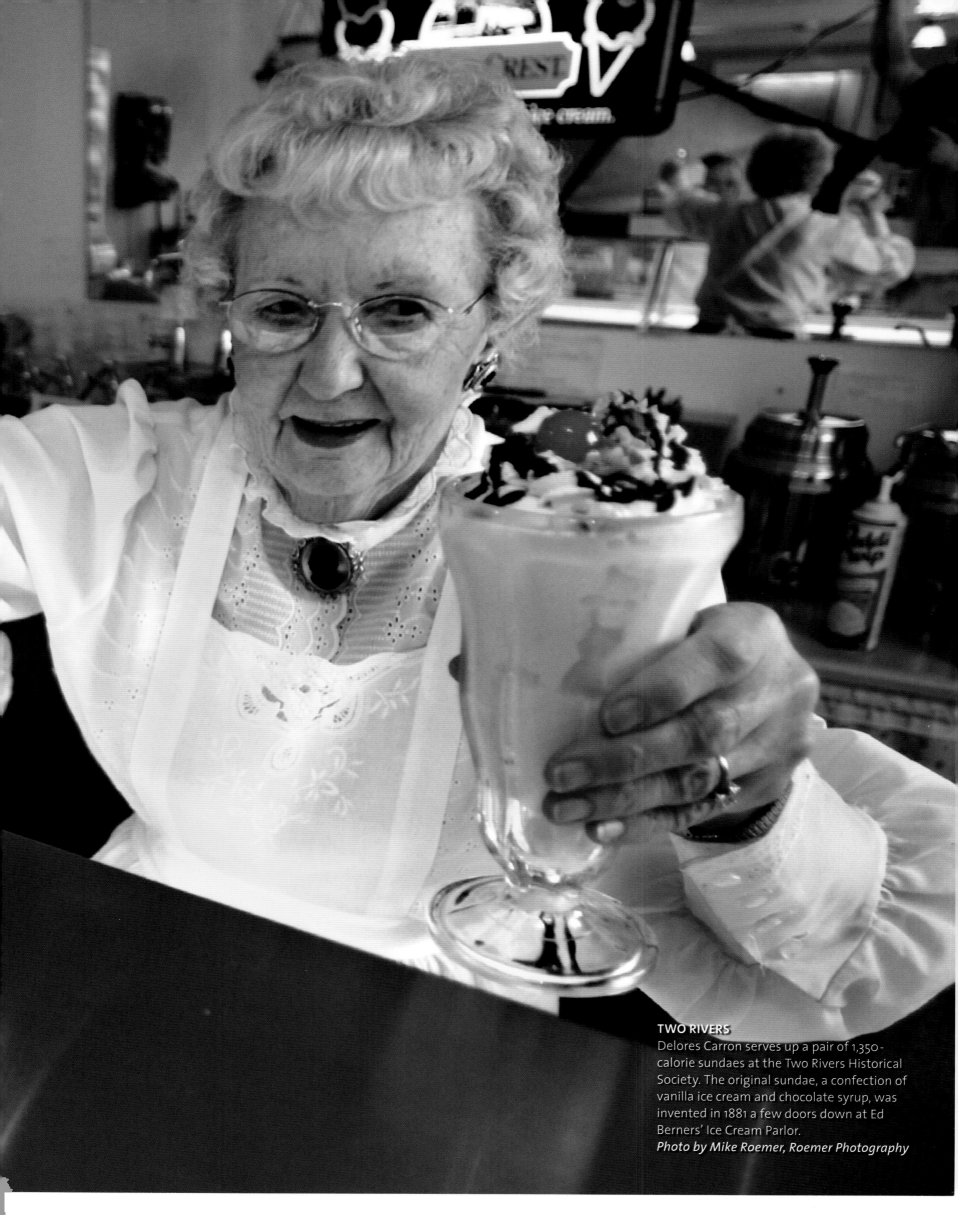

TWO RIVERS
Delores Carron serves up a pair of 1,350-calorie sundaes at the Two Rivers Historical Society. The original sundae, a confection of vanilla ice cream and chocolate syrup, was invented in 1881 a few doors down at Ed Berners' Ice Cream Parlor.
Photo by Mike Roemer, Roemer Photography

MADISON

Vicki Schwantes and Ted Cummings, researchers with the Center for Limnology at the University of Wisconsin, use a special net to gather zooplankton samples as part of a biweekly monitoring of Lake Mendota. The university is a world leader in limnology, the study of inland waters.

Photo by Michael Forster Rothbart, University of Wisconsin

LAC VIEUX DESERT

Department of Natural Resources scientist Allan Swenson collects eggs from a white sucker as part of the state's muskie restocking program. After being fertilized, the eggs go to a hatchery. The newly hatched suckers are fed to young muskie in rearing ponds. When the muskie mature, they're released into lakes.

Photo by Mark Derse Photography

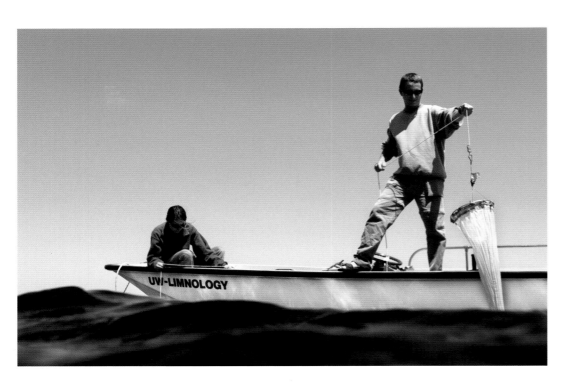

NEW LONDON

At Wind River Wildlife Rehabilitation and Release, Randie Segal examines a malnourished juvenile great horned owl. Segal says 70 percent of birds of prey do not survive. Something might have happened to this one's parents, or they abandoned it. The owl will be released after several months of care.

Photo by Brad Allen

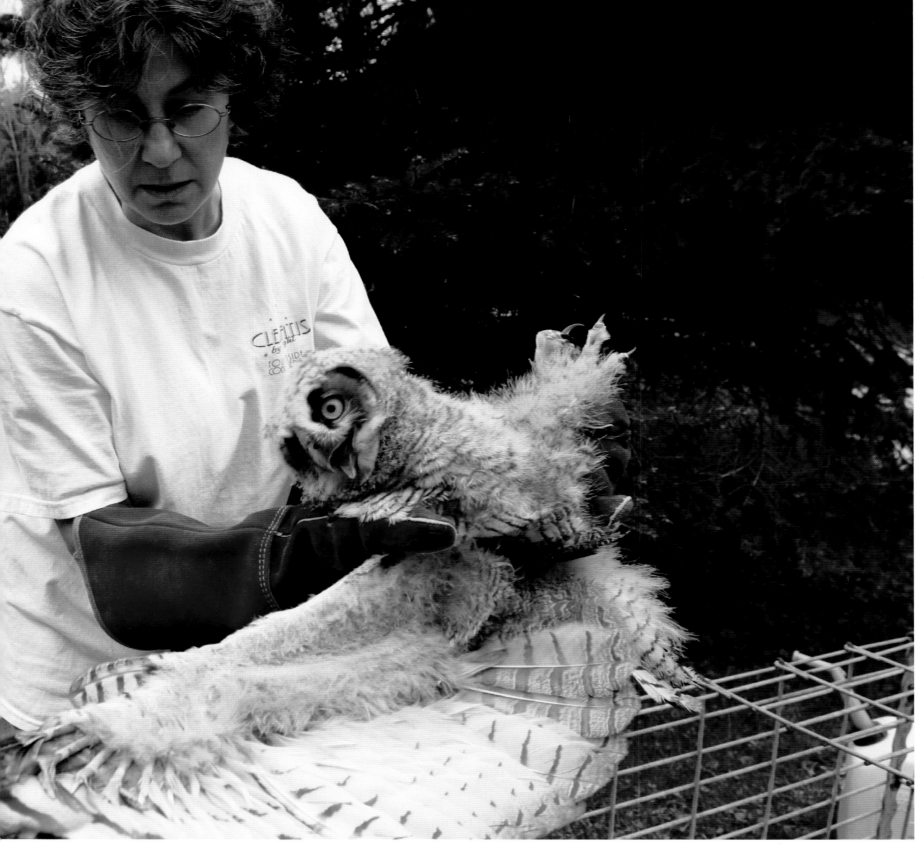

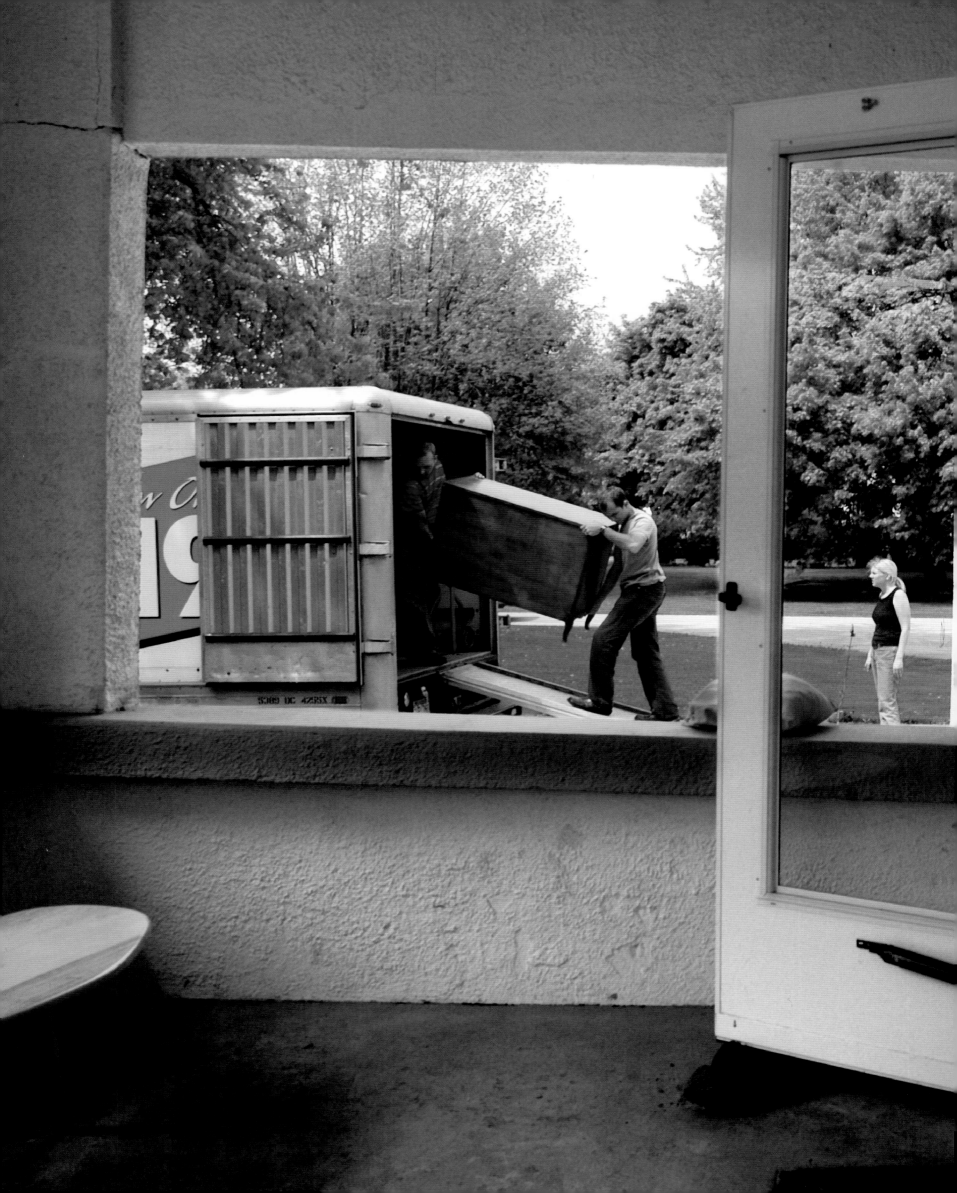

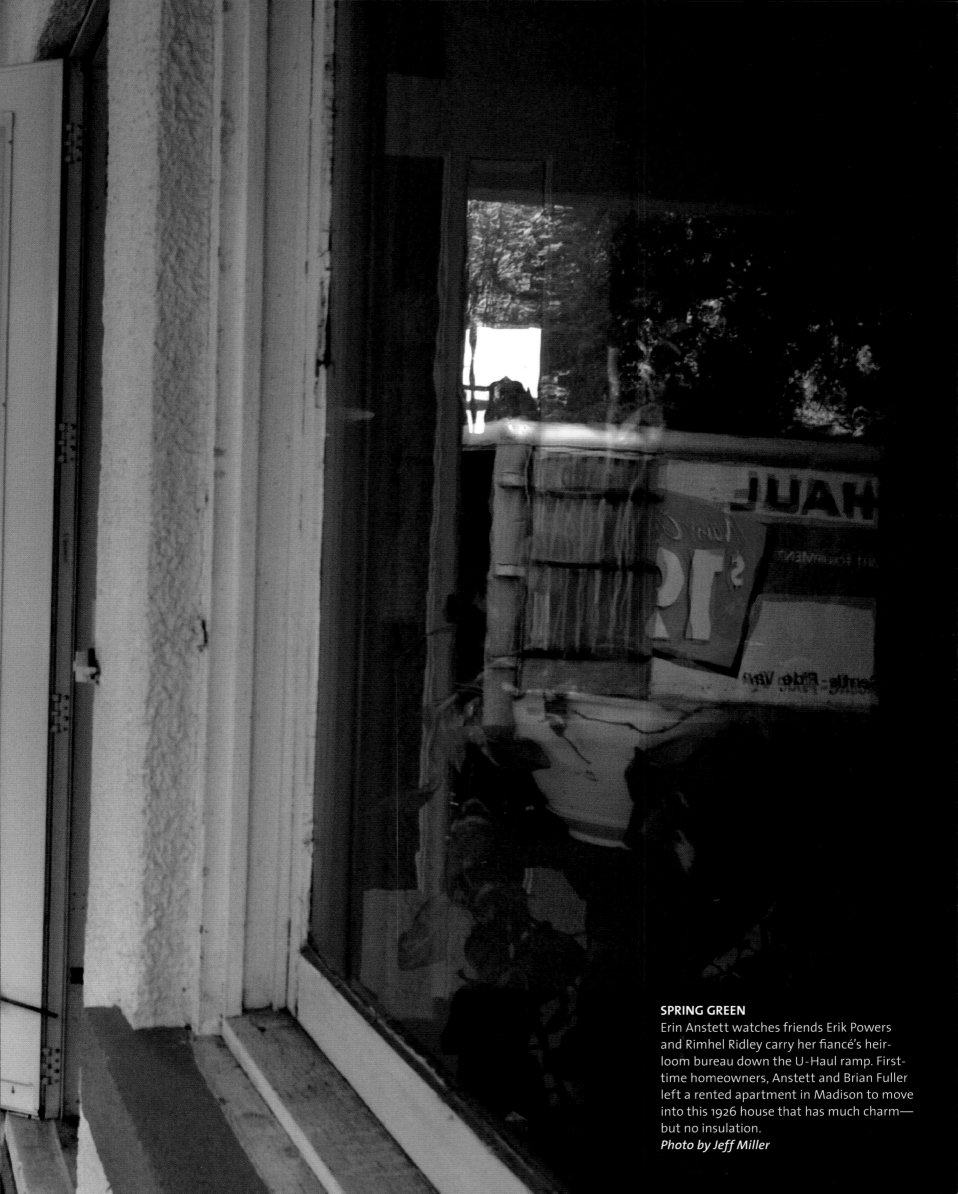

SPRING GREEN
Erin Anstett watches friends Erik Powers and Rimhel Ridley carry her fiancé's heirloom bureau down the U-Haul ramp. First-time homeowners, Anstett and Brian Fuller left a rented apartment in Madison to move into this 1926 house that has much charm—but no insulation.
Photo by Jeff Miller

MILWAUKEE
A job for the pros: A fireman douses a dumptruck that burst into flames after backfiring. At first, the truck's driver tried to put out the fire himself, but then called in the big hoses.
Photo by Dale Guldan

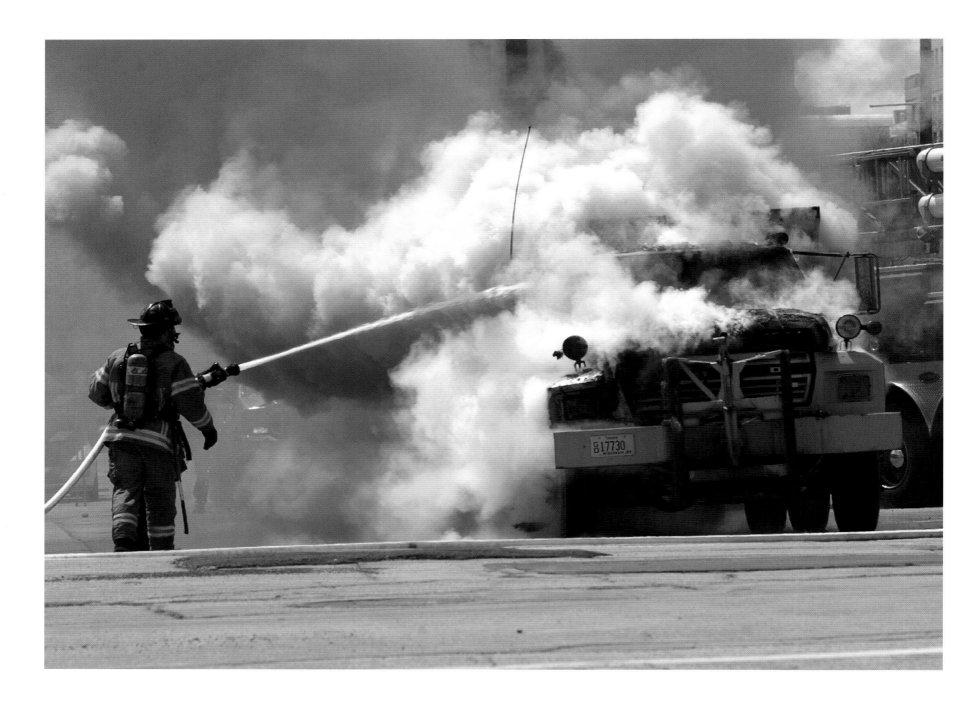

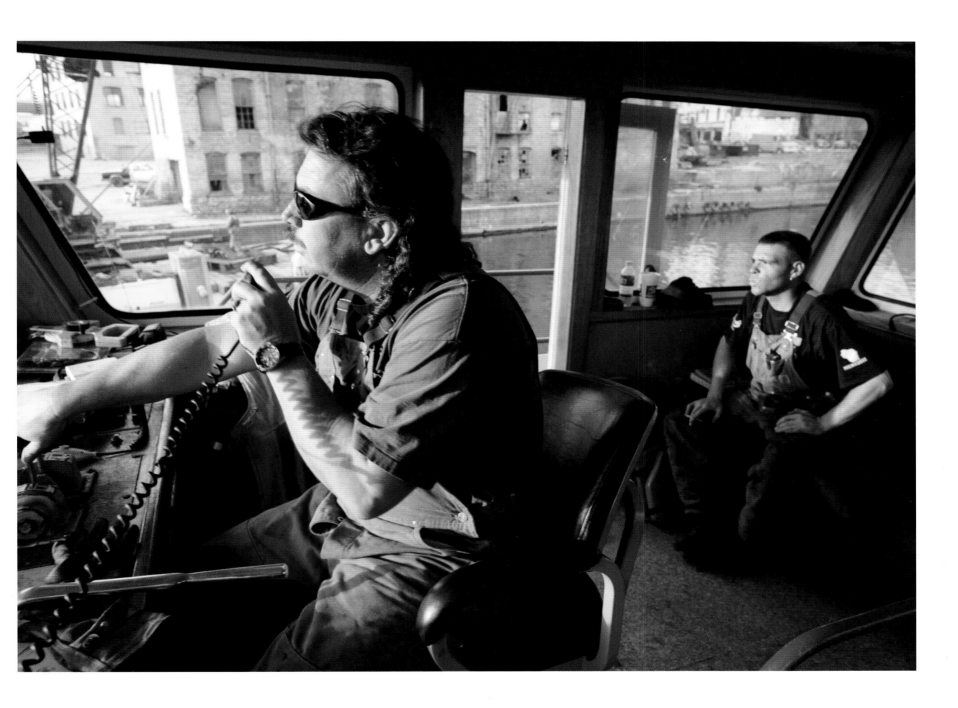

MILWAUKEE
Kadinger Marine Captain Rick Hopper eases his tugboat and barge past a row of warehouses and shipyards along the Menomonee River. Kadinger Marine delivers 700,000 tons of coal a year to the We Energies Valley Power Plant, which generates steam heat for Milwaukee businesses and homes.
Photo by Darren Hauck

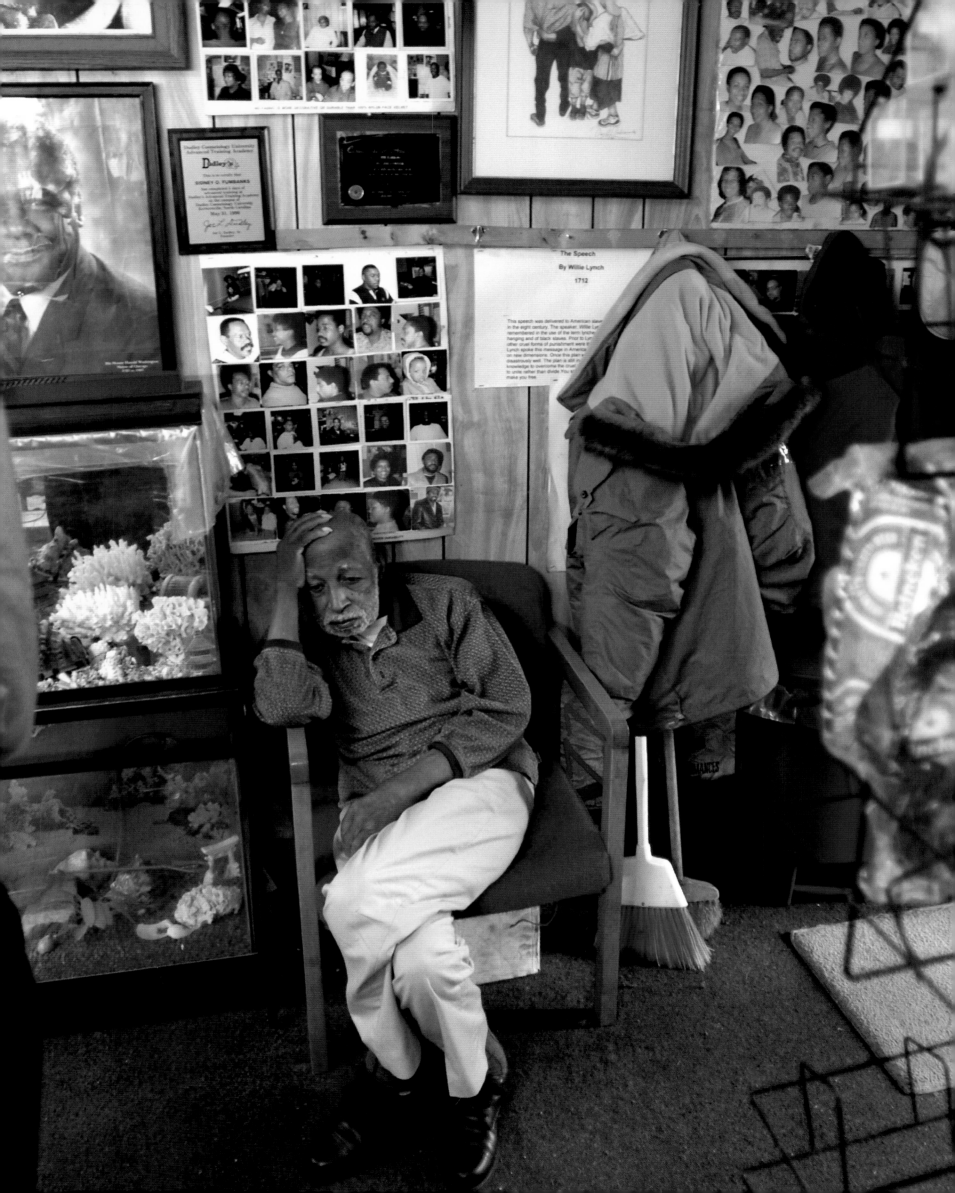

MILWAUKEE

Robert Ed Burns, 92, waits for a trim at Sid's Shear Magic barbershop downtown, on West Hopkins Street. Lively discussions about politics, black history, and sports are par for the course at the neighborhood barbershop. "My customers like the camaraderie," says owner Sid Fumbanks.
Photo by Buck Miller

MILWAUKEE

A.W. Ballantine has been operating BB Washing Machine Repair on the Near North Side of Milwaukee for 30 years. He got his start when his machine at home died and he had to fix it.
Photo by Gary W. Porter

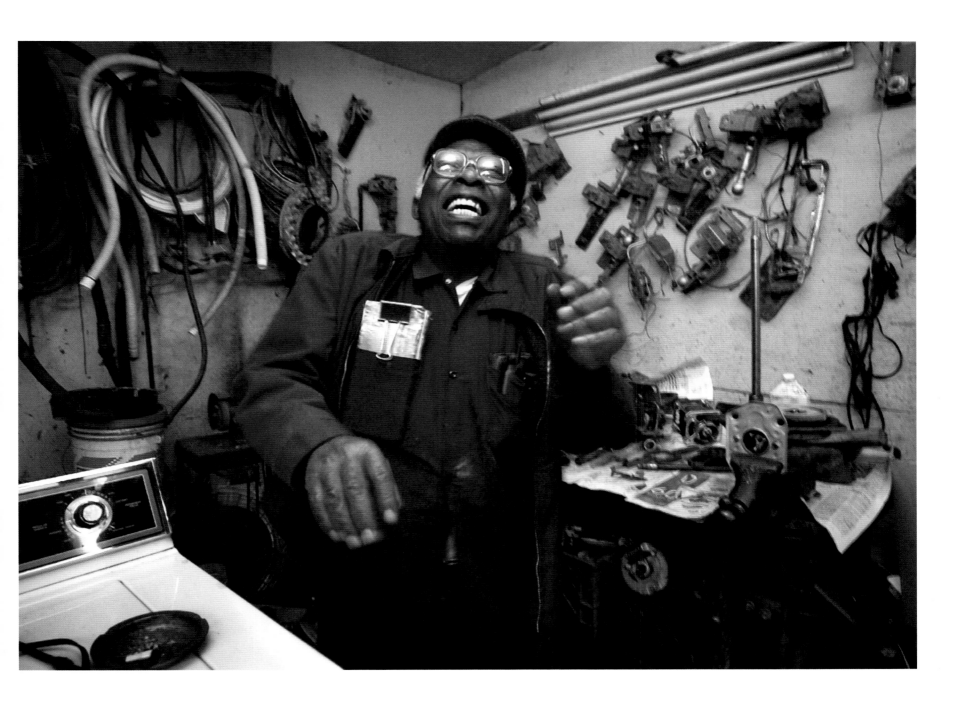

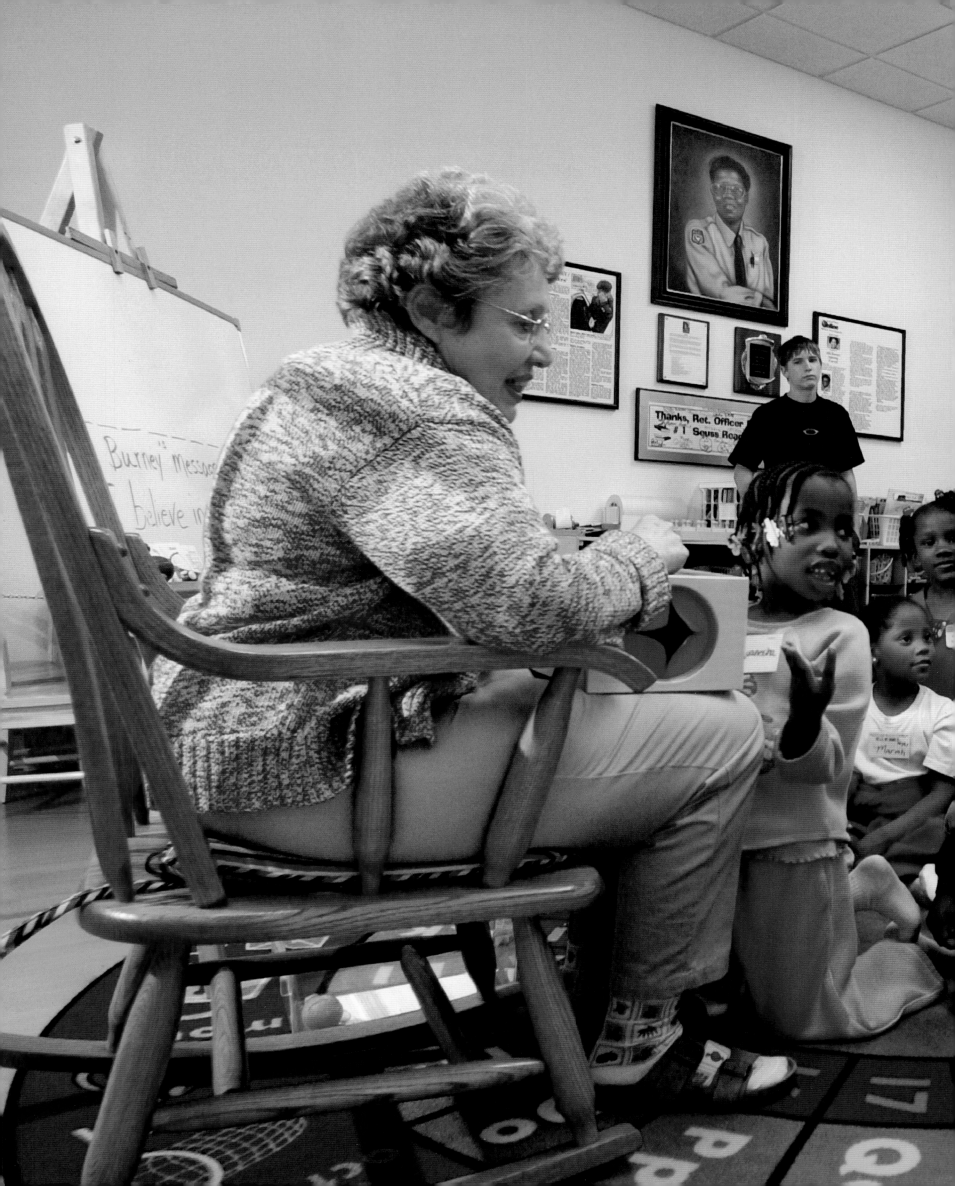

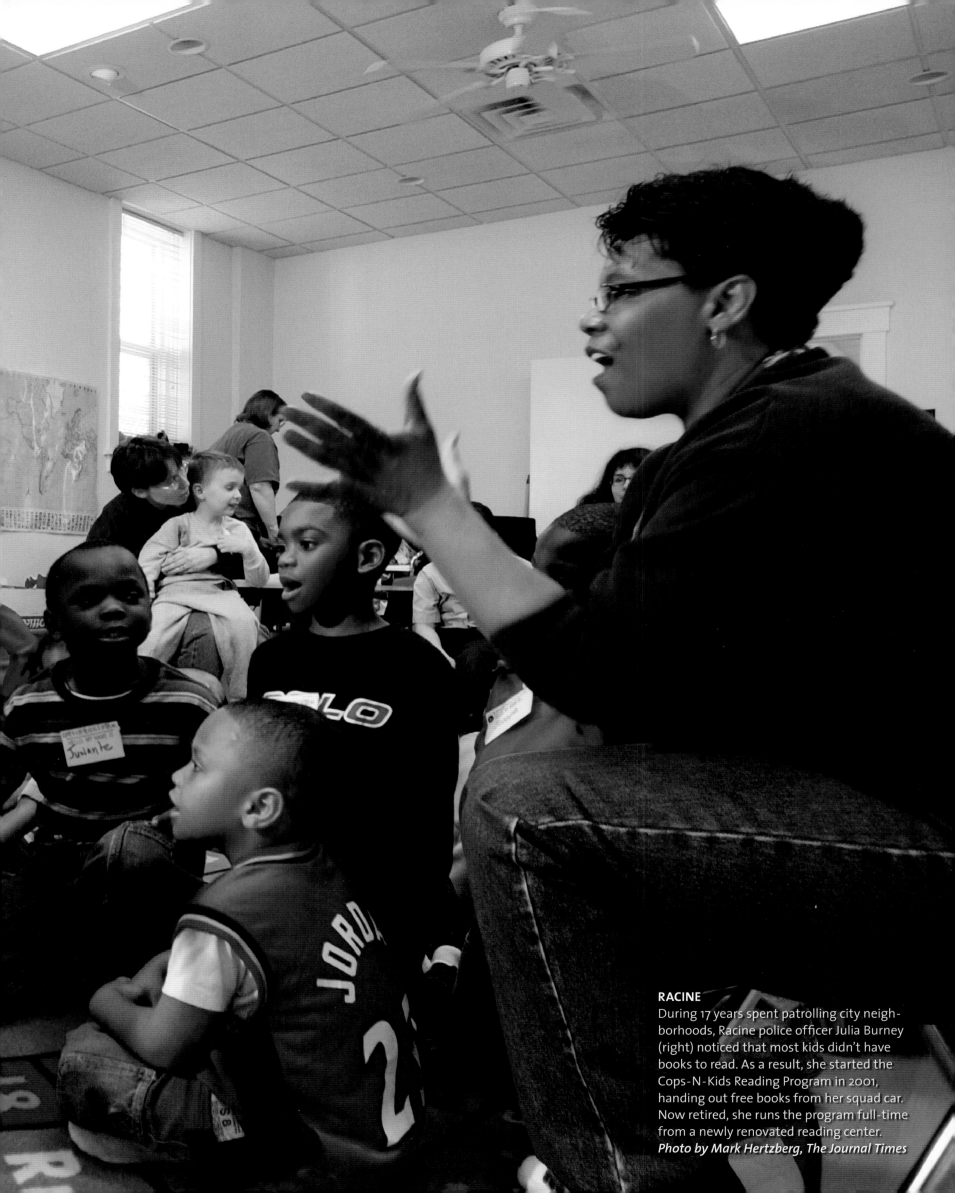

RACINE
During 17 years spent patrolling city neighborhoods, Racine police officer Julia Burney (right) noticed that most kids didn't have books to read. As a result, she started the Cops-N-Kids Reading Program in 2001, handing out free books from her squad car. Now retired, she runs the program full-time from a newly renovated reading center.
Photo by Mark Hertzberg, The Journal Times

SOUTH WAYNE

Heating his curds and whey: Mike Godfrey pours cheese curds into molds at the Valley View Cheese Co-op. Later, he'll heat the batch for 2.5 hours so the curds form solid bricks of creamy butterkase cheese.

Photo by Buck Miller

ALGOMA

Cheese whiz: Tom Kinjerski coats a batch of Renard's cheddar cheese wheels in paraffin before packing and stacking them for shipment. Working in the cheese business is a point of pride for Kinjerski, who has been turning curds into cheese for more than 15 years. "In Wisconsin we love our cheese, brats, and beer," he says.

Photo by Mike Roemer, Roemer Photography

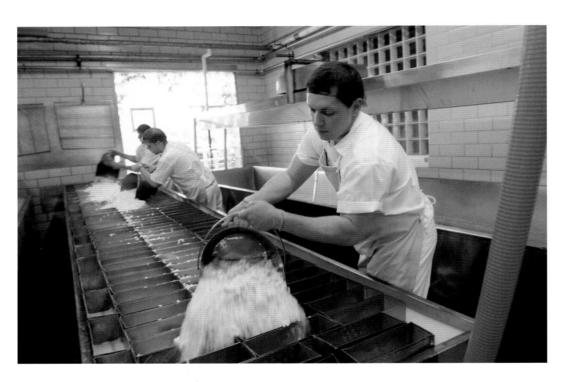

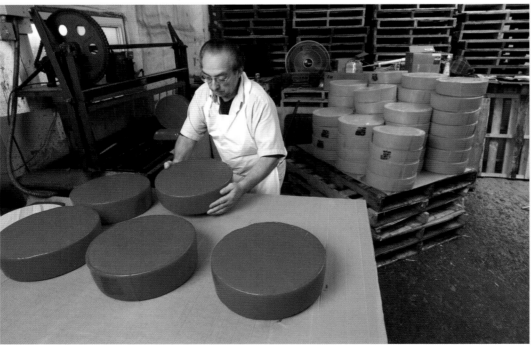

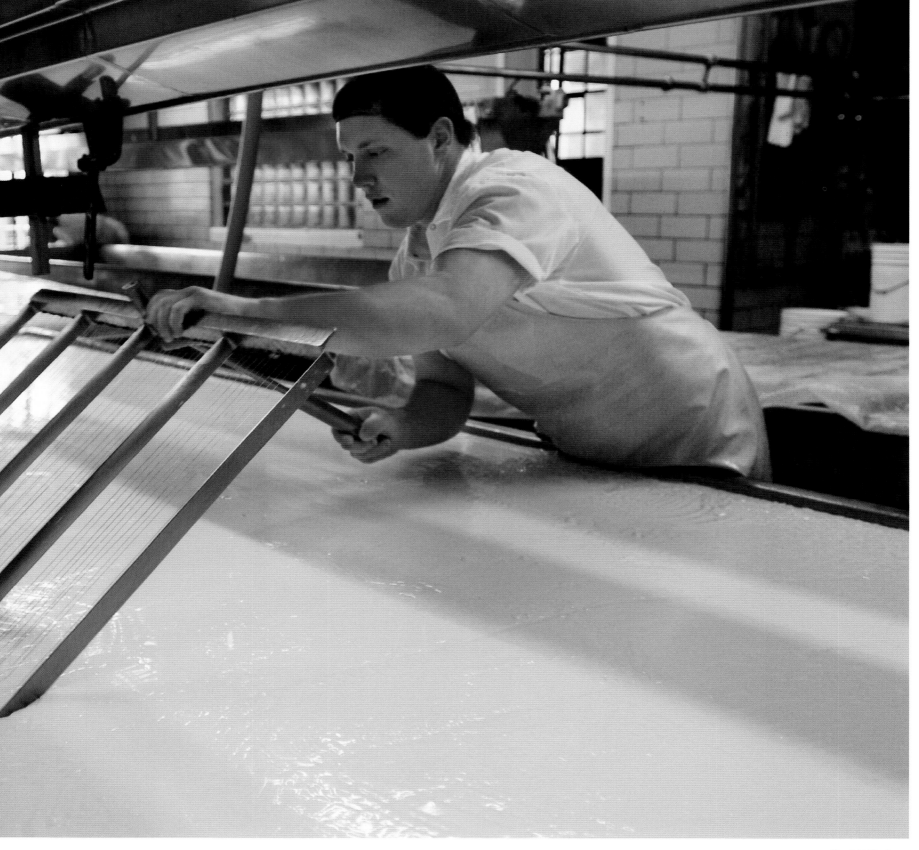

SOUTH WAYNE

Pasteurized milk treated with bacterial culture and rennet heats in a vat tended by Roger Godfrey. As the mixture curdles, his probing cheese rake keeps the batch from lumping up around the edges. Before the curds are poured into molds and heated into solid bricks, they must first pass muster with Godfrey's discriminating palate. "I taste every single vat," he says.
Photo by Buck Miller

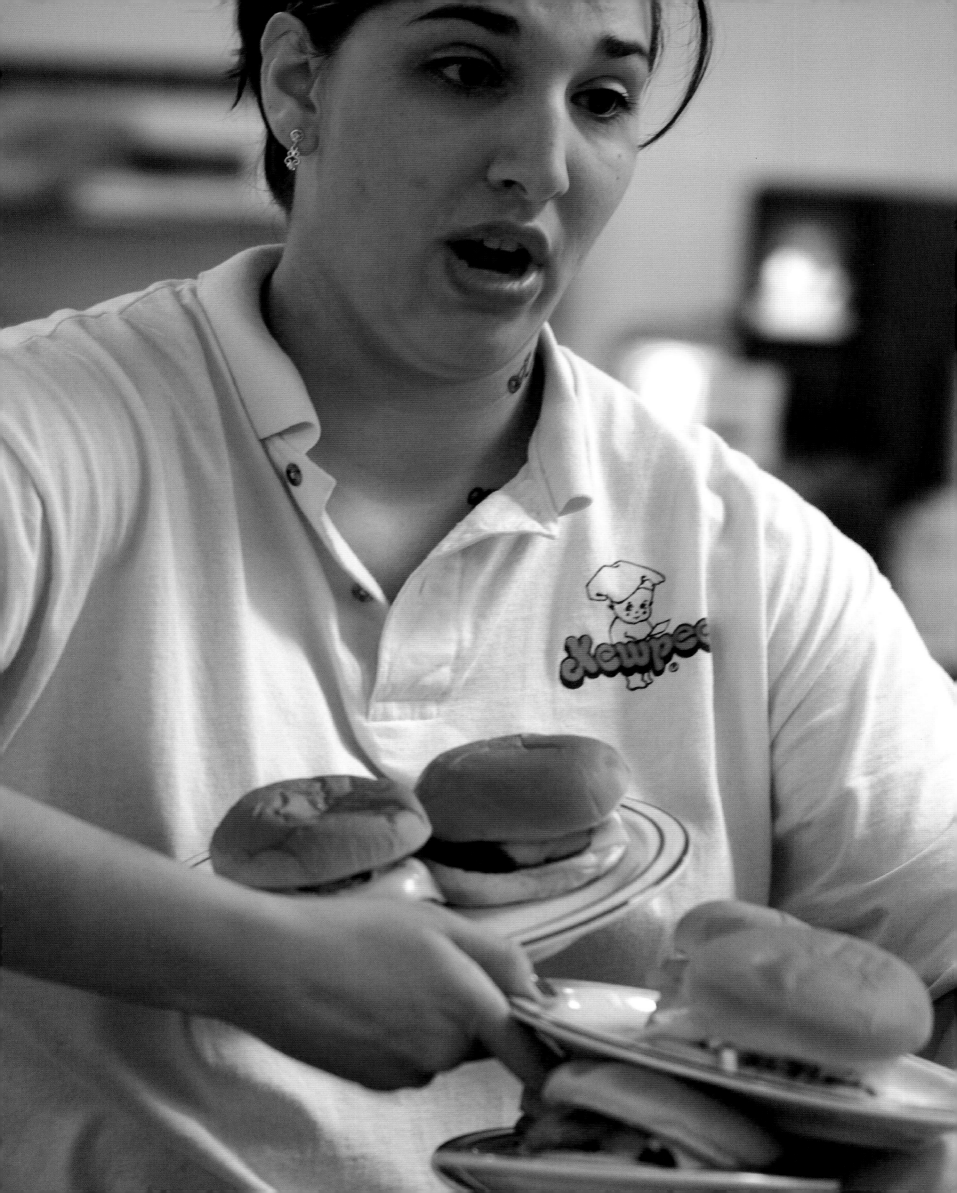

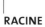

RACINE

Waitress Carmen Matsen juggles a load of cheeseburgers for Kewpee's lunch crowd. She memorizes her orders and then writes them on a piece of paper and hands it to the chef. Kewpee's, with its two counters and seven tables, has served freshly ground, handmade burgers from its downtown location for more than 80 years.
Photo by Mark Hertzberg, The Journal Times

EAGLE RIVER

Sullivan's Flowerland has been in Cindy Powell's family for 38 years. "Working with flowers is a family talent. My father passed the skill down to me," says Powell, who grows flowers pesticide-free in the company's five greenhouses. She also designs gardens for businesses and homes.
Photo by Mark Derse Photography

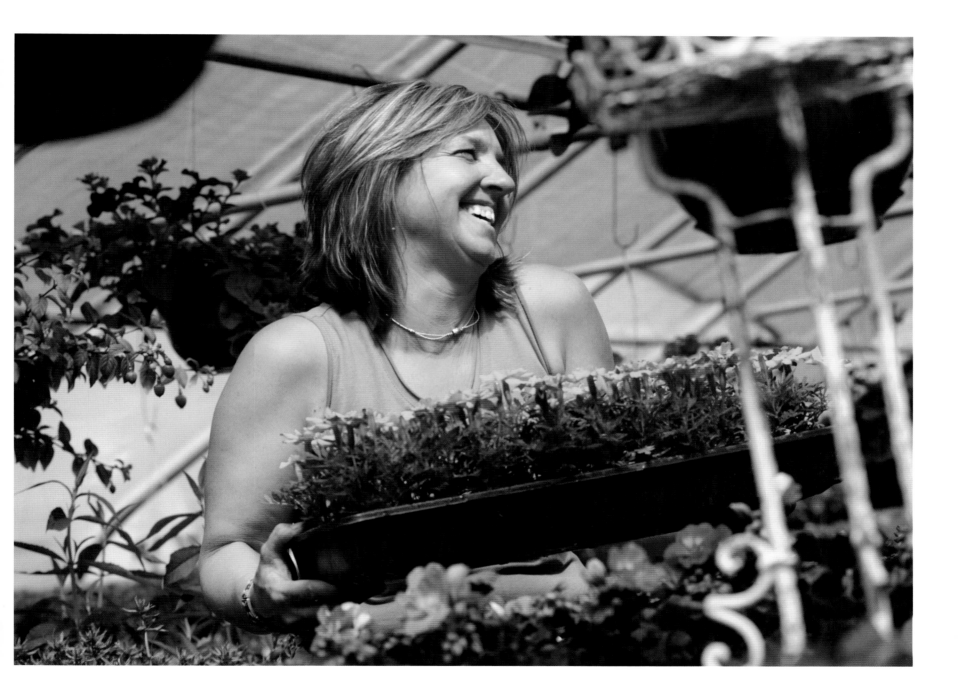

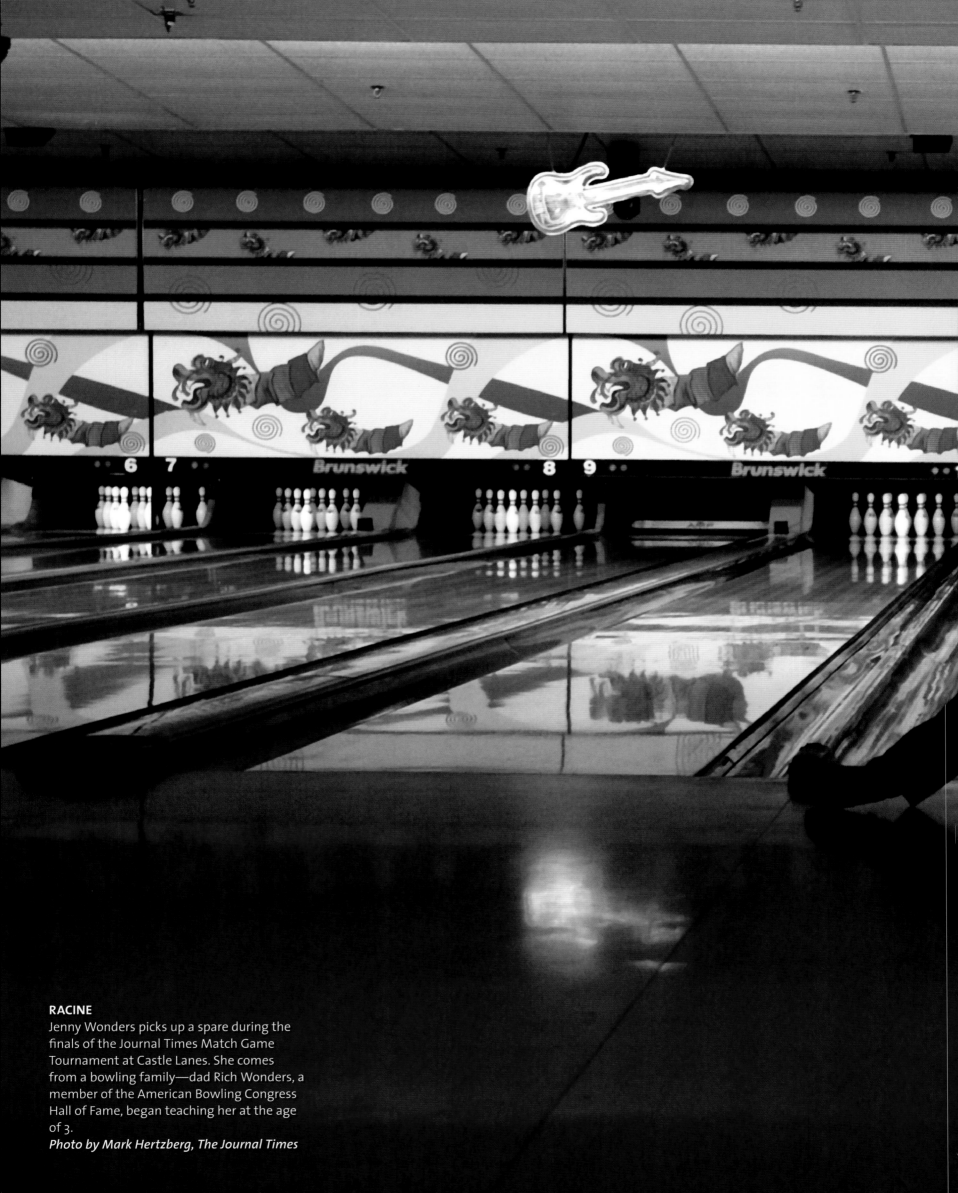

RACINE

Jenny Wonders picks up a spare during the finals of the Journal Times Match Game Tournament at Castle Lanes. She comes from a bowling family—dad Rich Wonders, a member of the American Bowling Congress Hall of Fame, began teaching her at the age of 3.

Photo by Mark Hertzberg, The Journal Times

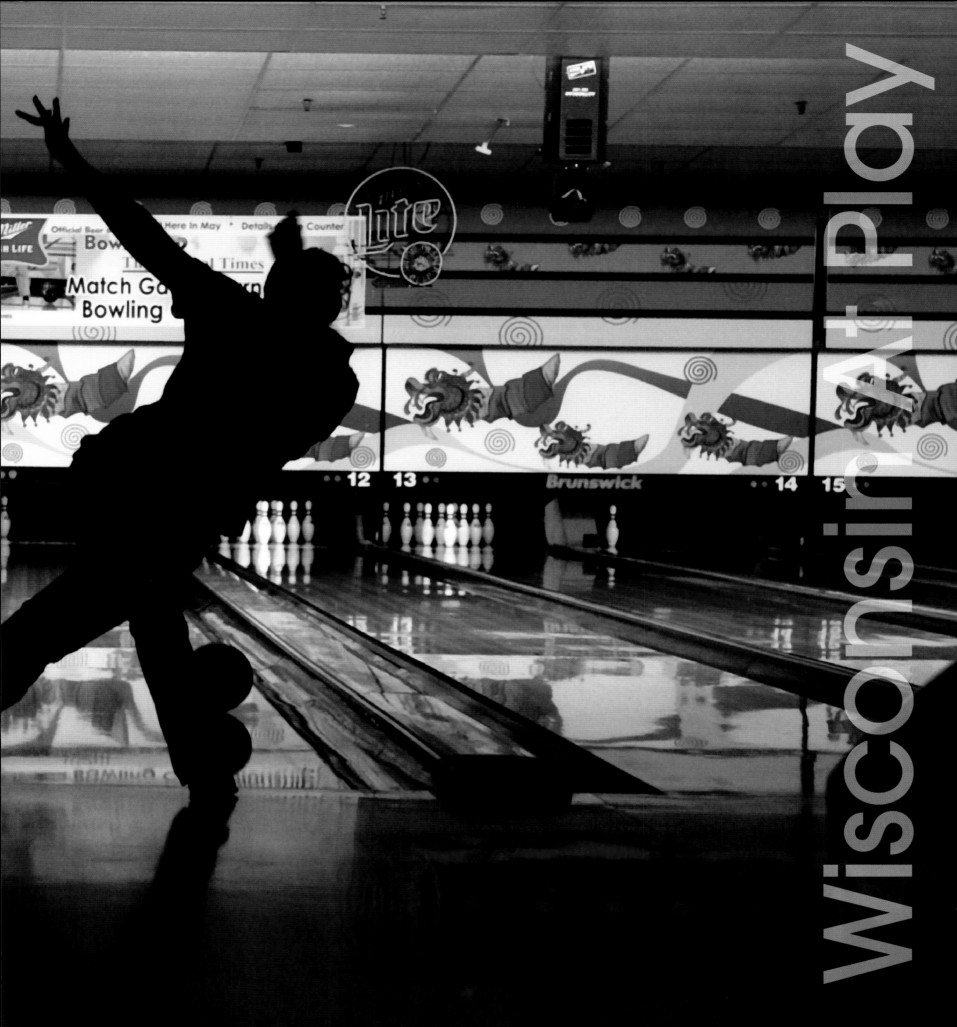

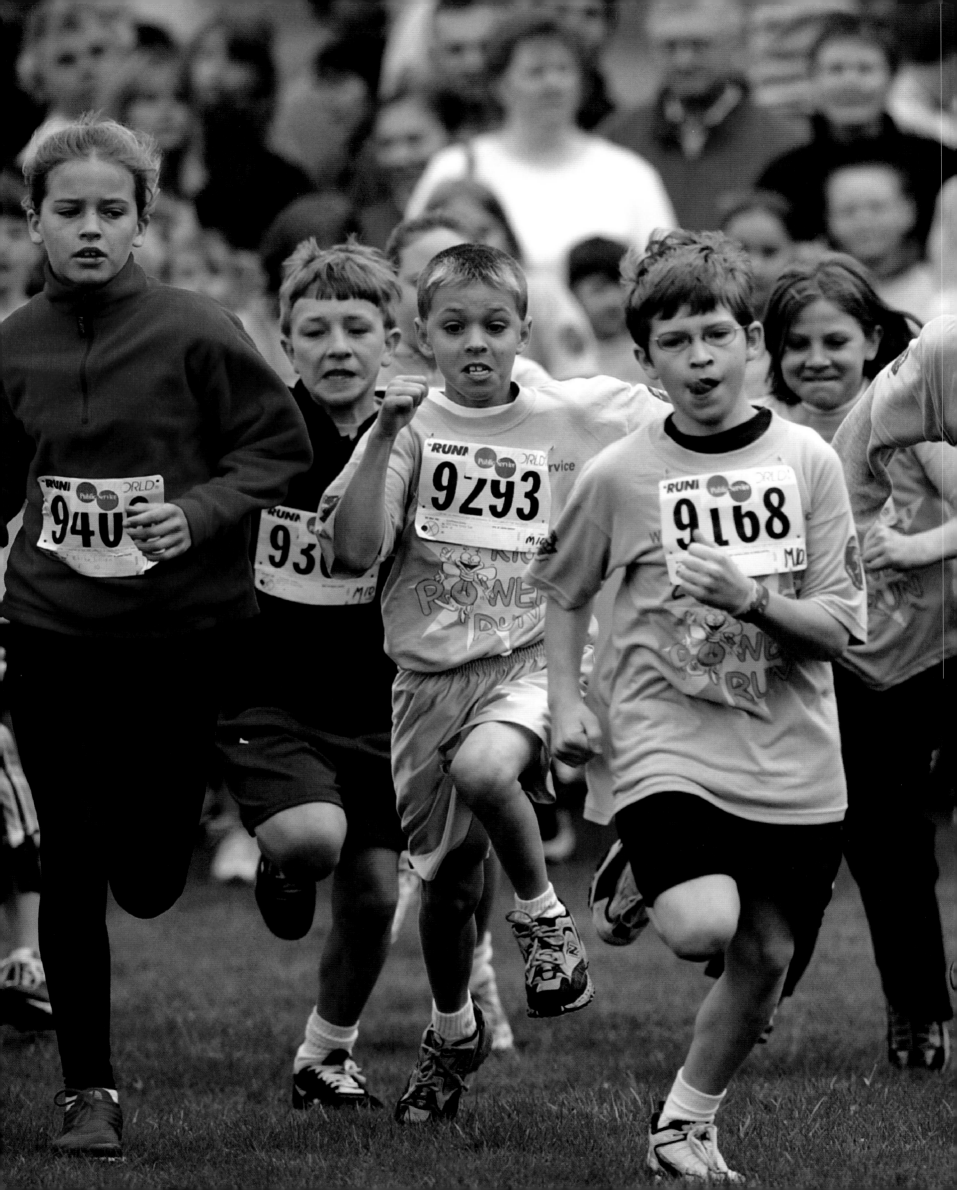

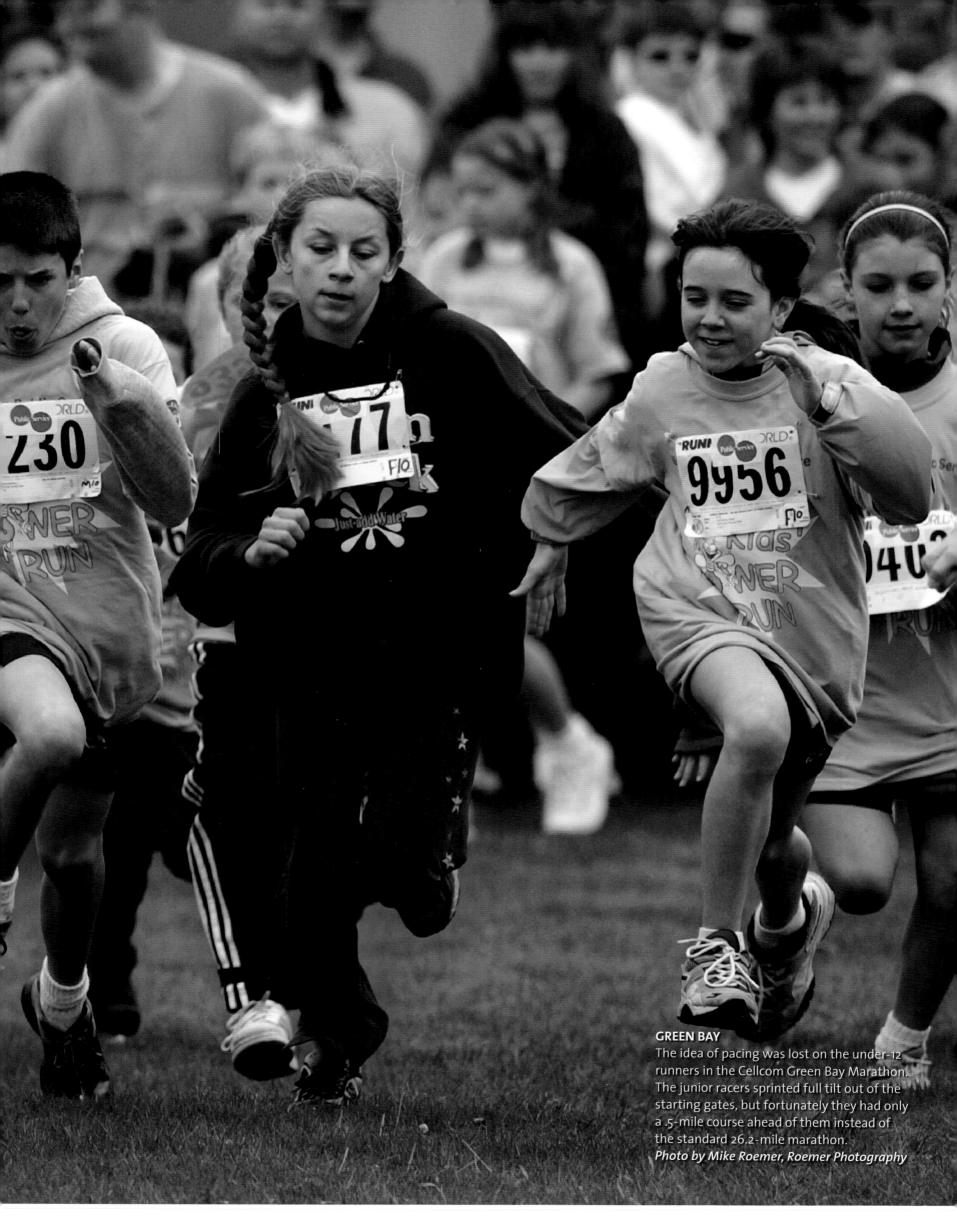

GREEN BAY
The idea of pacing was lost on the under-12 runners in the Cellcom Green Bay Marathon. The junior racers sprinted full tilt out of the starting gates, but fortunately they had only a .5-mile course ahead of them instead of the standard 26.2-mile marathon.
Photo by Mike Roemer, Roemer Photography

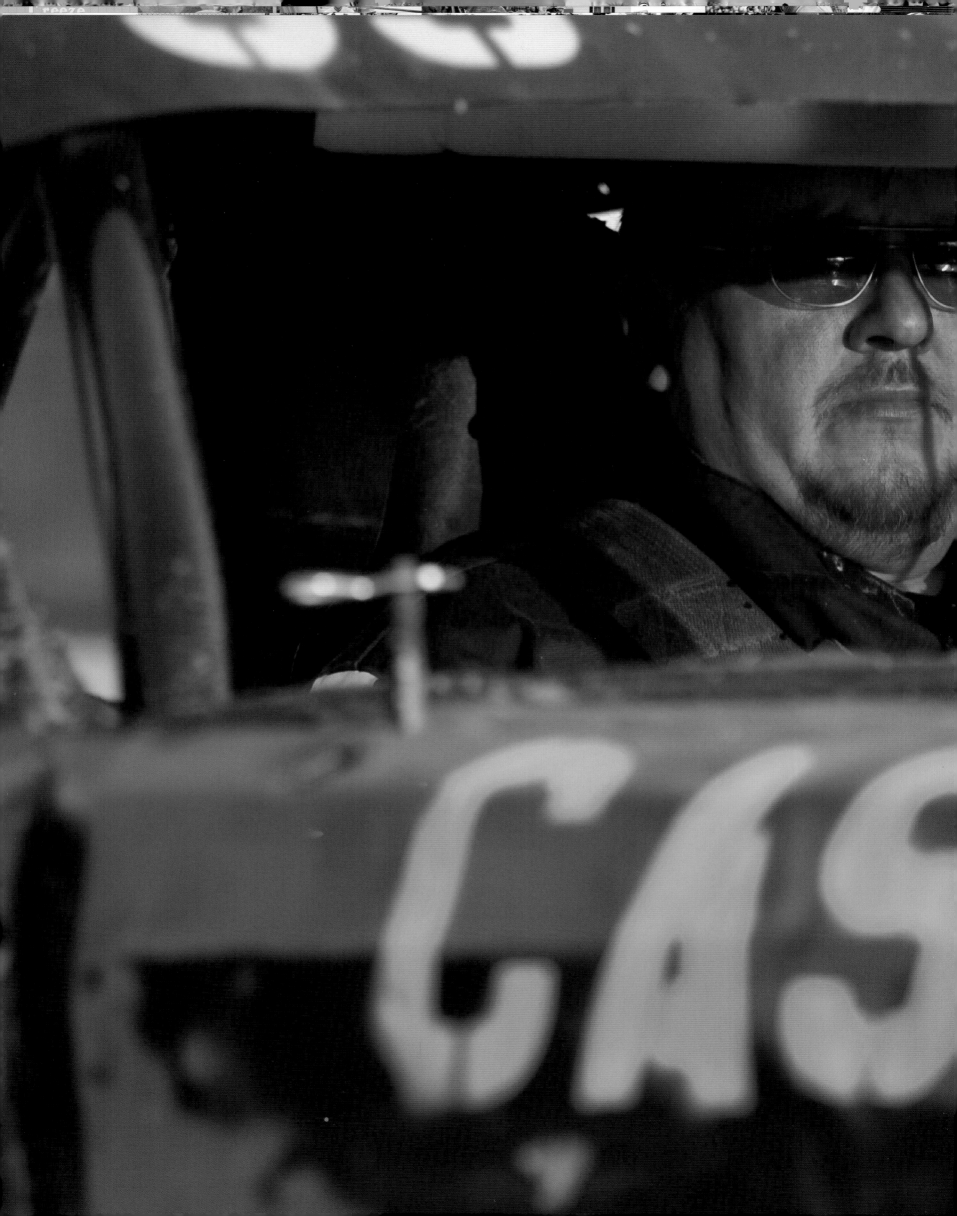

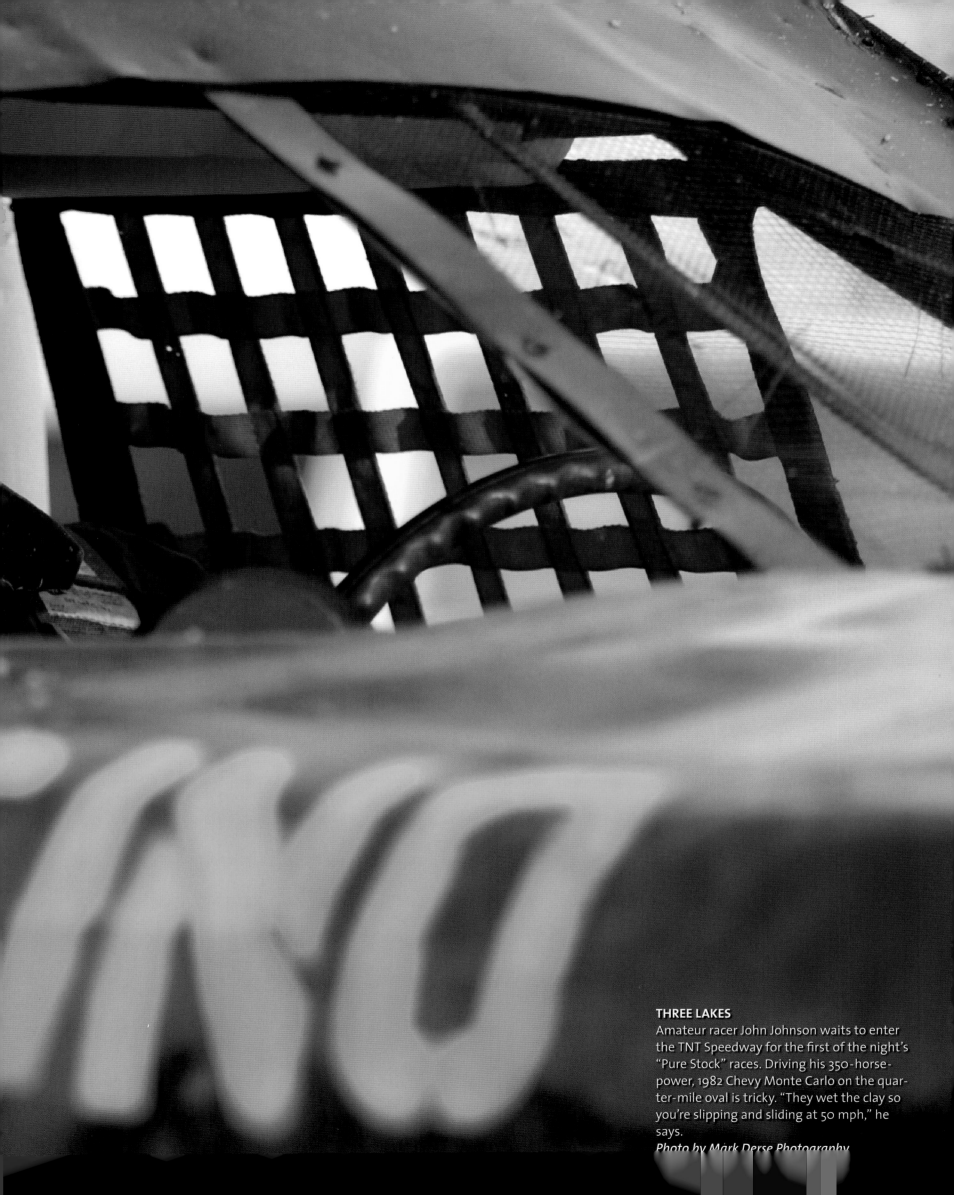

THREE LAKES
Amateur racer John Johnson waits to enter the TNT Speedway for the first of the night's "Pure Stock" races. Driving his 350-horse-power, 1982 Chevy Monte Carlo on the quarter-mile oval is tricky. "They wet the clay so you're slipping and sliding at 50 mph," he says.
Photo by Mark Derse Photography

RACINE
To get in shape, Sam Duchac hung a punching
bag on the fire escape outside his apartment. All
he has to do is suit up, climb out, and punch in.
Photos by Gregory Shaver

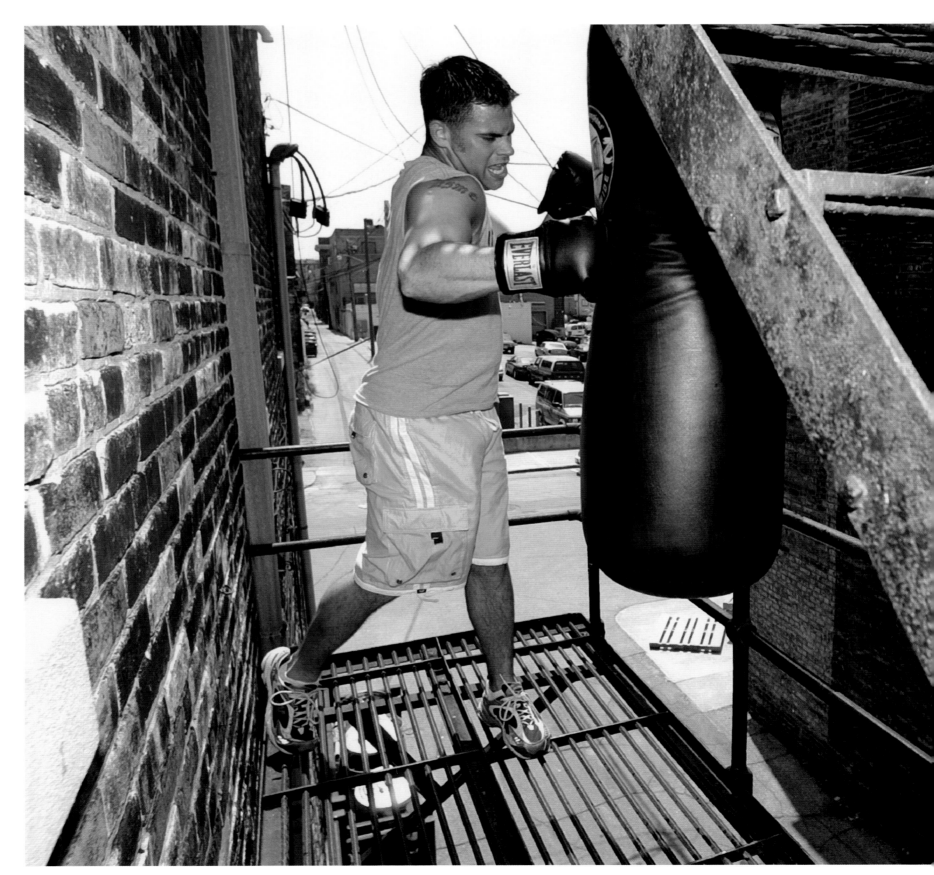

RACINE

Watch your steps. Novice boxer Jason Johnson, 24, trains by running up and down four flights of stairs at the Racine City Hall Annex 12 times each evening. Johnson, who trains at the Racine Boxing Club, says, "I don't want to brag, but I don't think anyone trains as hard as I do."

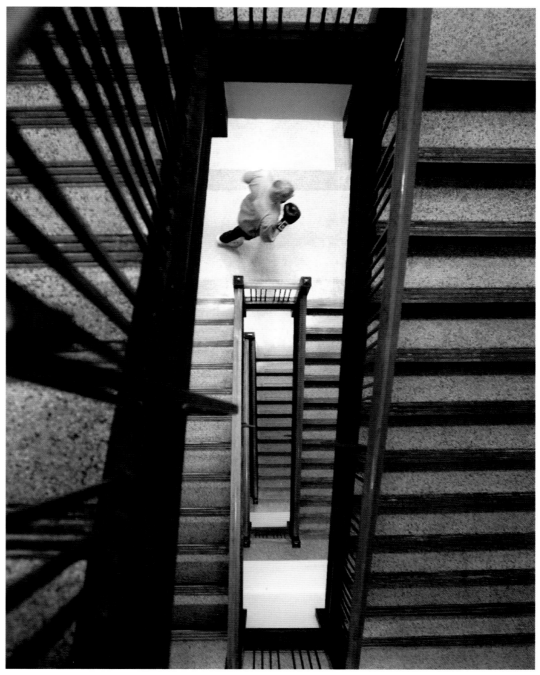

MENOMONEE FALLS

Ready, aim, smile. The Junior Civilian Marksman-
ship Program, affiliated with the Boy Scouts' Ven-
ture program and the NRA, accepts shooters of
both sexes from 12 to 21. Participants learn to
shoot .22 target rifles from prone, kneeling, sit-
ting, and standing positions. If they pass a series
of courses, they're allowed to shoot M-1 carbines
or AR-15 target rifles on Fun Shoot Night.
Photo by Dale Guldan

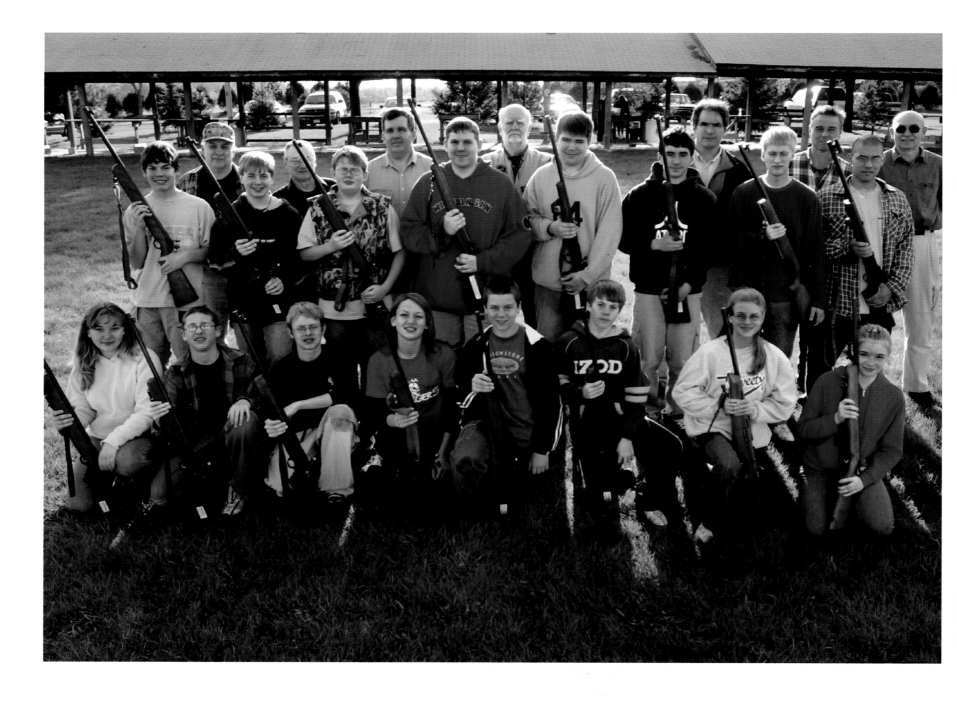

ABRAMS

There goes the groom. When Mark Decoster's bachelor party is combined with paintball, he becomes the perfect target. Stalker Jeremy Ness, preparing to fire, says that Decoster is a former military man who initially thought the idea was lame but quickly got into it.

Photo by Brad Allen

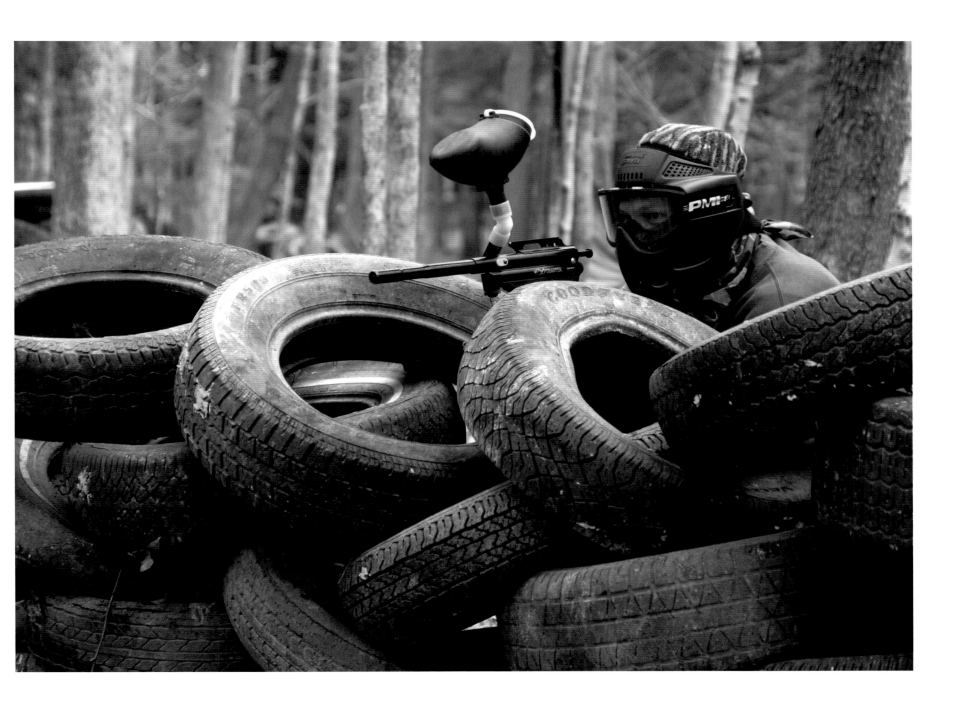

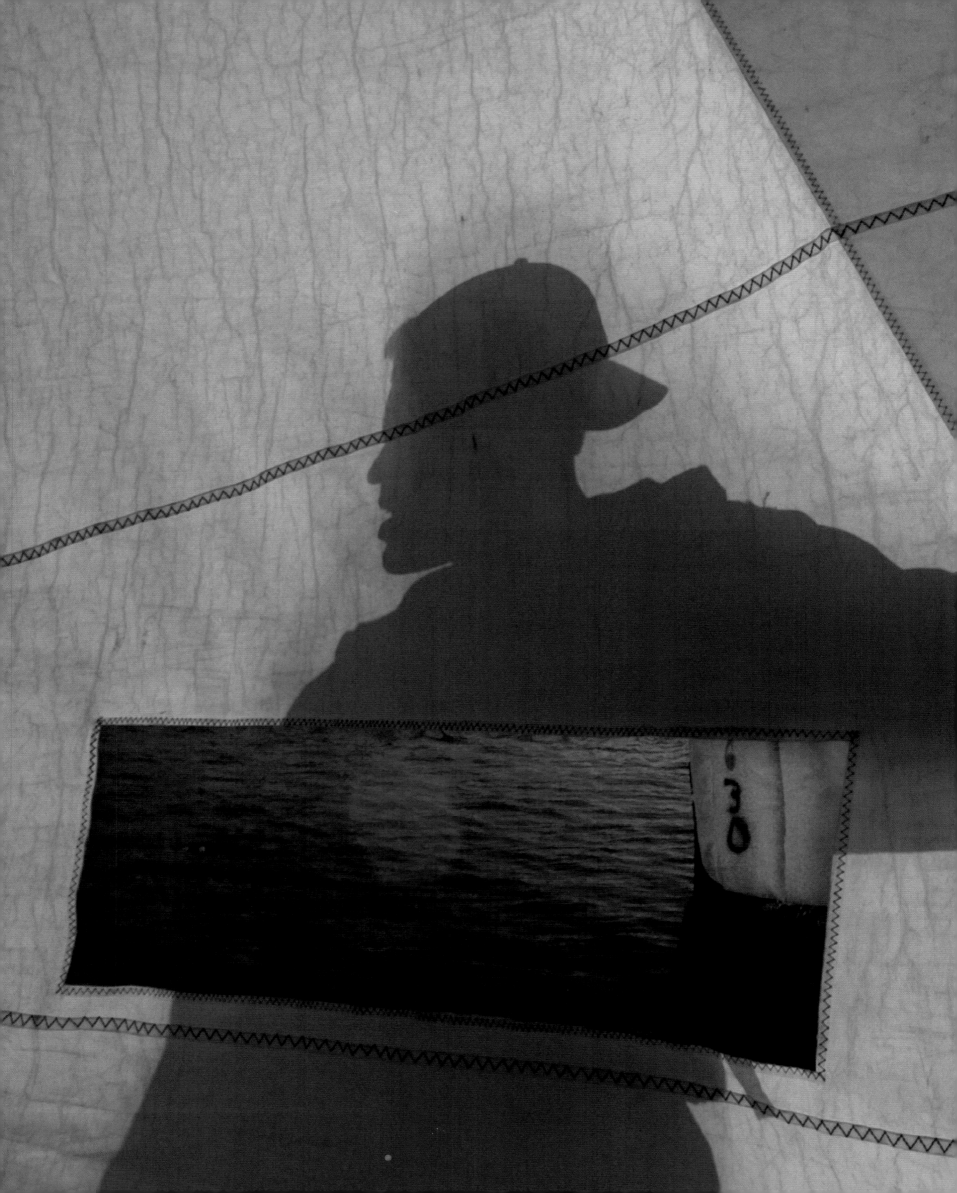

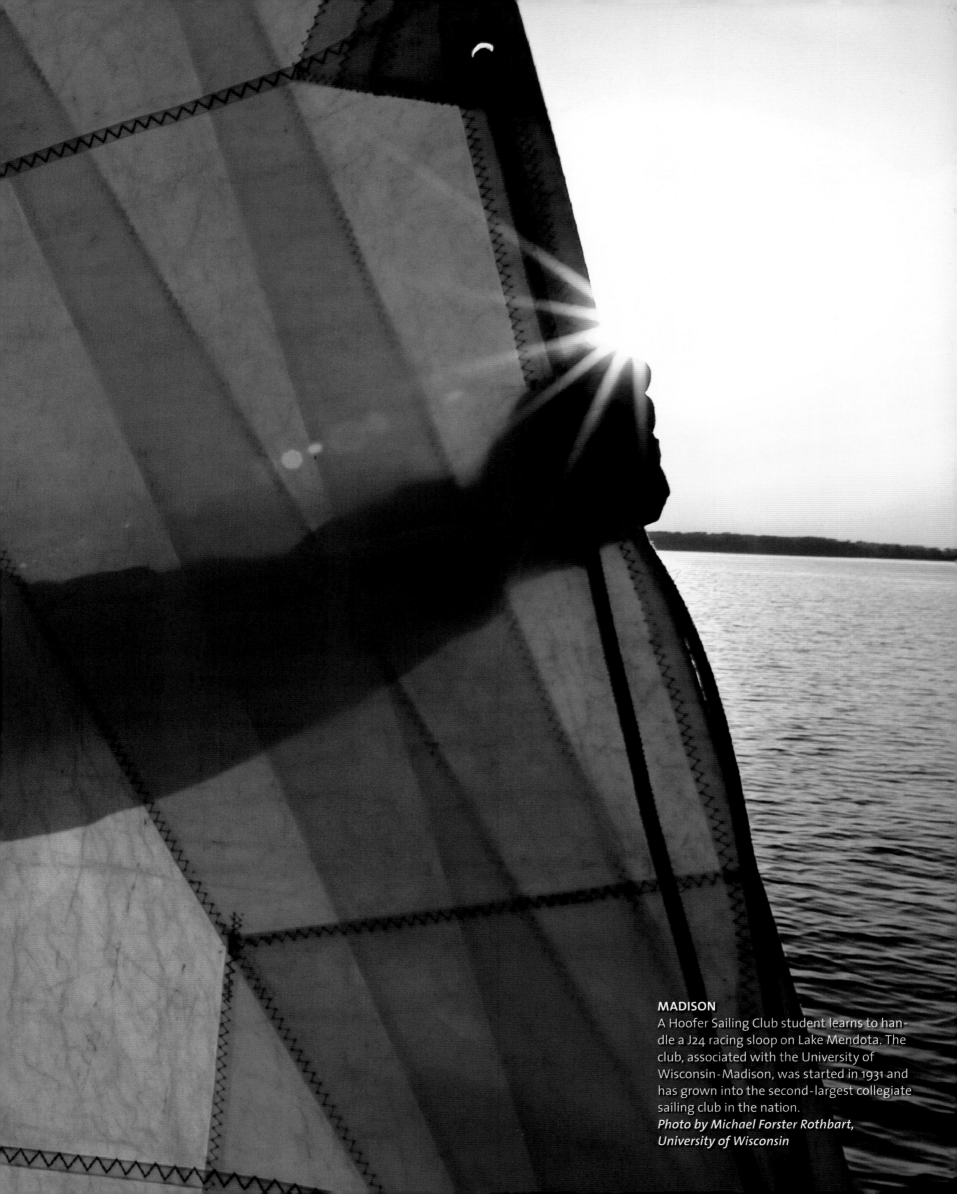

MADISON
A Hoofer Sailing Club student learns to handle a J24 racing sloop on Lake Mendota. The club, associated with the University of Wisconsin-Madison, was started in 1931 and has grown into the second-largest collegiate sailing club in the nation.
Photo by Michael Forster Rothbart,
University of Wisconsin

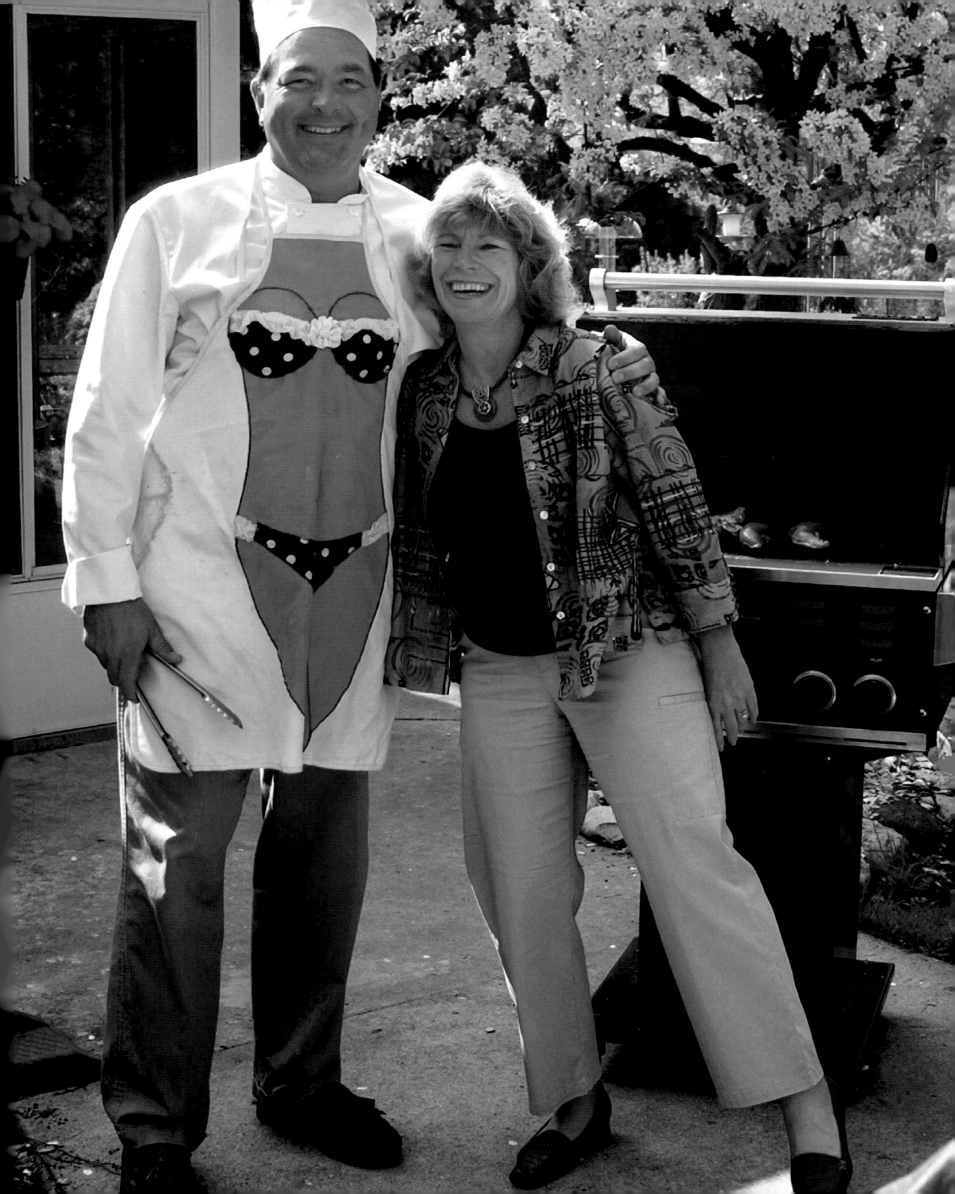

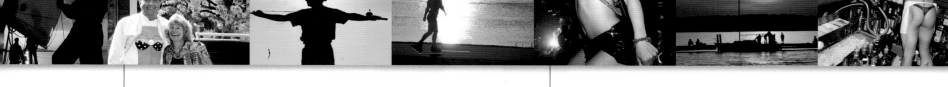

PEWAUKEE

Curvaceous John Krellwitz is one hot cook. He and wife Lynda are getting ready to host a pre-prom party.

Photo by Dale Guldan

MADISON

Every other Tuesday is Fetish Night at Madison's Cardinal Bar. Regulars Jessica O'Leary, a social work graduate student, and Joe Reznikoff, a firefighter, move to the groove.

Photo by Jeff Miller

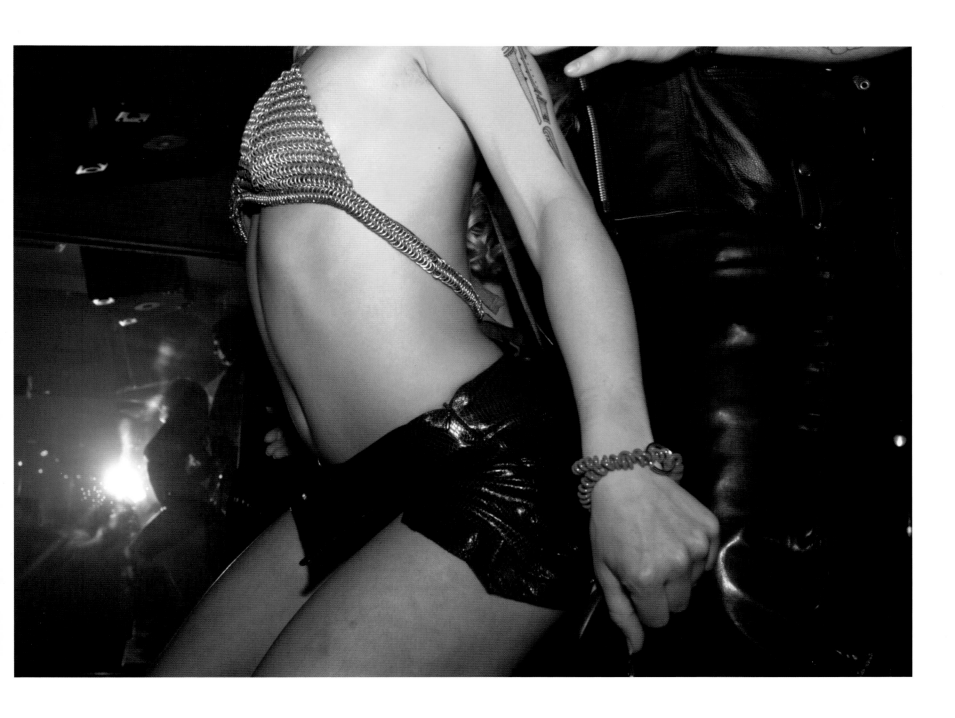

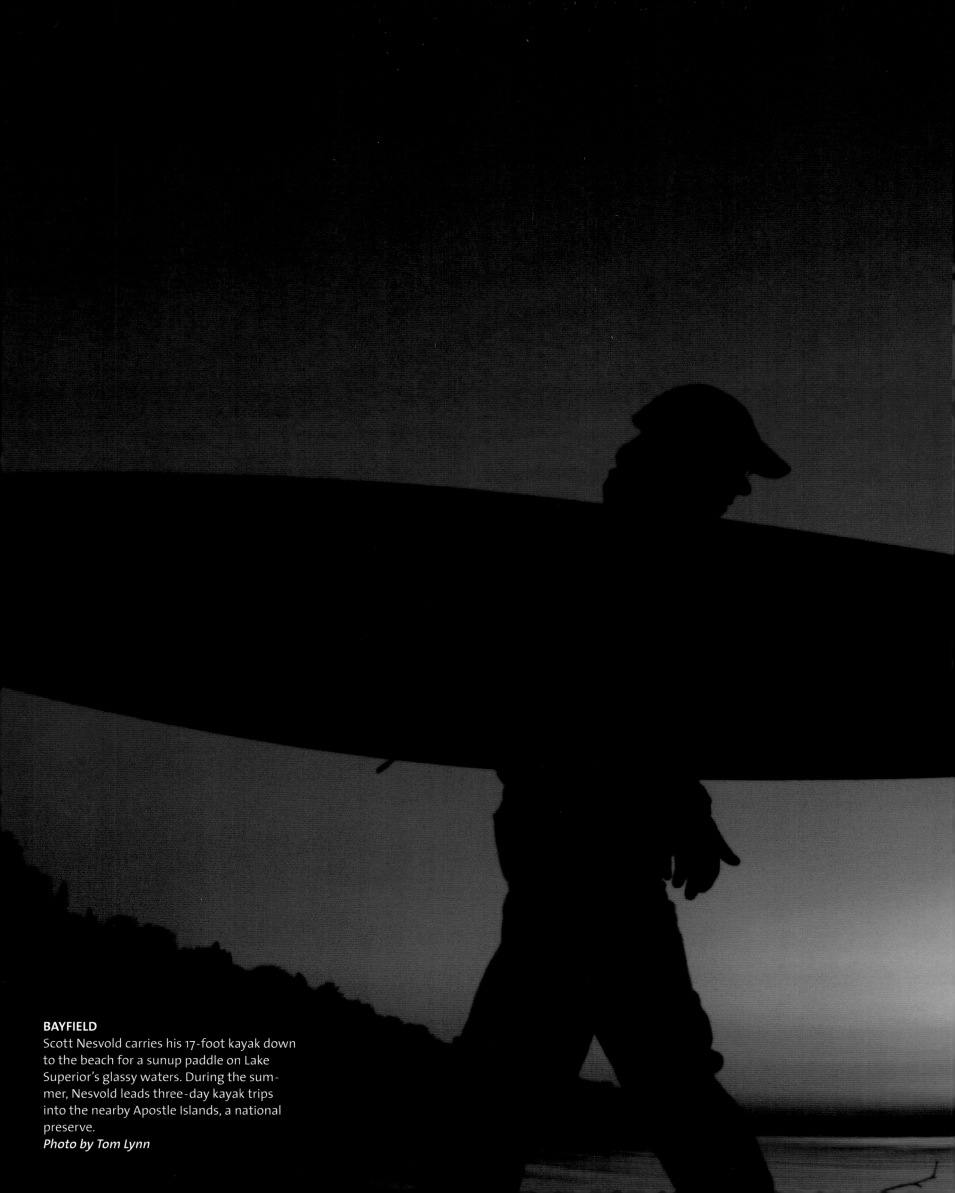

BAYFIELD
Scott Nesvold carries his 17-foot kayak down to the beach for a sunup paddle on Lake Superior's glassy waters. During the summer, Nesvold leads three-day kayak trips into the nearby Apostle Islands, a national preserve.
Photo by Tom Lynn

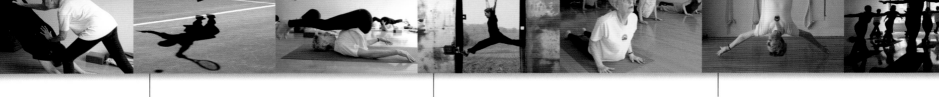

RACINE

Only the shadow serves. High school junior Jay Schoenwaelder makes his usual jumpshot serve during a doubles match. Jay and his partner won the match at Meadowbrook Country Club, 6–2, 6–2.
Photo by Gregory Shaver

HOLLANDALE

Fifteen-foot oil drums provide a dramatic setting for the Wild Space Dance Company's outdoor performance entitled "Field Work." The interpretive piece, a meditation on rural work and culture, was shown in conjunction with a traveling Smithsonian photography exhibit on American barns.
Photo by Scott C. Anderson

MADISON

Hanging hatha-style, as demonstrated by Mound Street Yoga Center instructor Nicole Plaut, 73, increases circulation and stimulates the brain. The Sanskrit word *yoga* means "union with the supreme spirit."
Photo by Jeff Miller

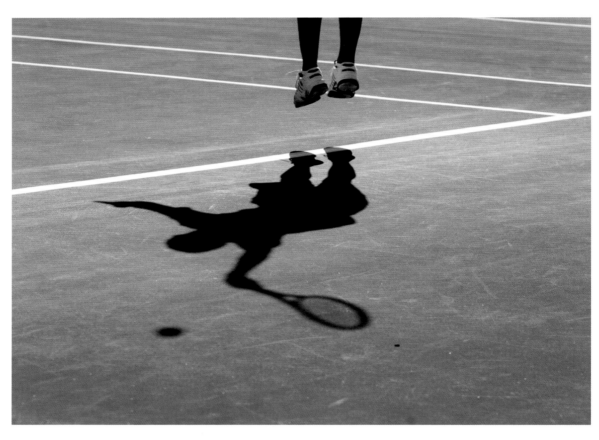

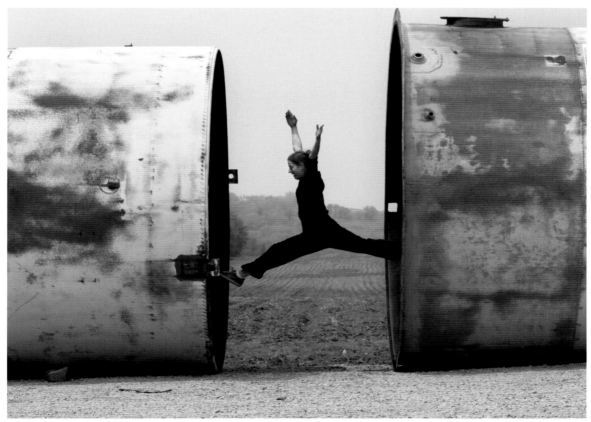

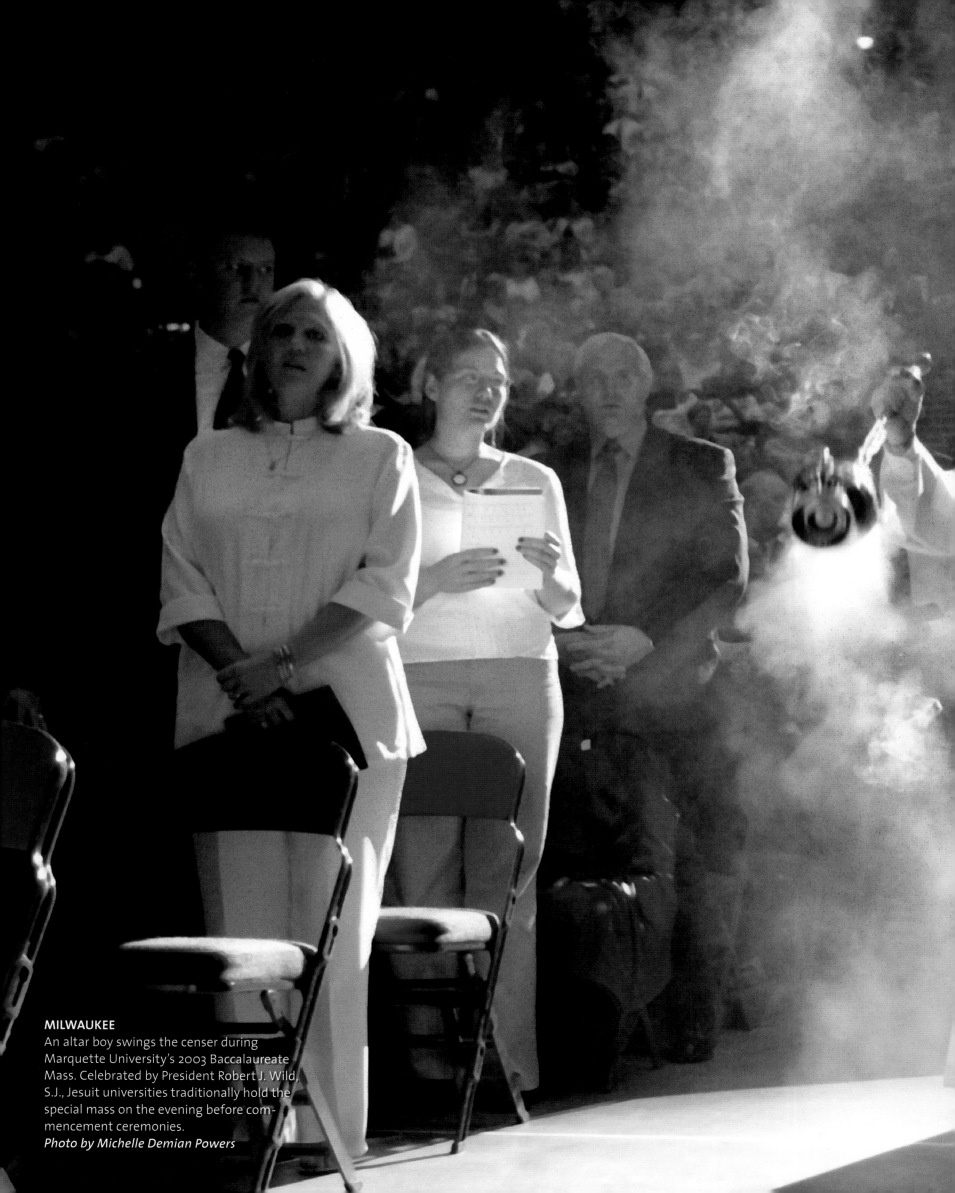

MILWAUKEE
An altar boy swings the censer during
Marquette University's 2003 Baccalaureate
Mass. Celebrated by President Robert J. Wild,
S.J., Jesuit universities traditionally hold the
special mass on the evening before com-
mencement ceremonies.
Photo by Michelle Demian Powers

Reason To Believe

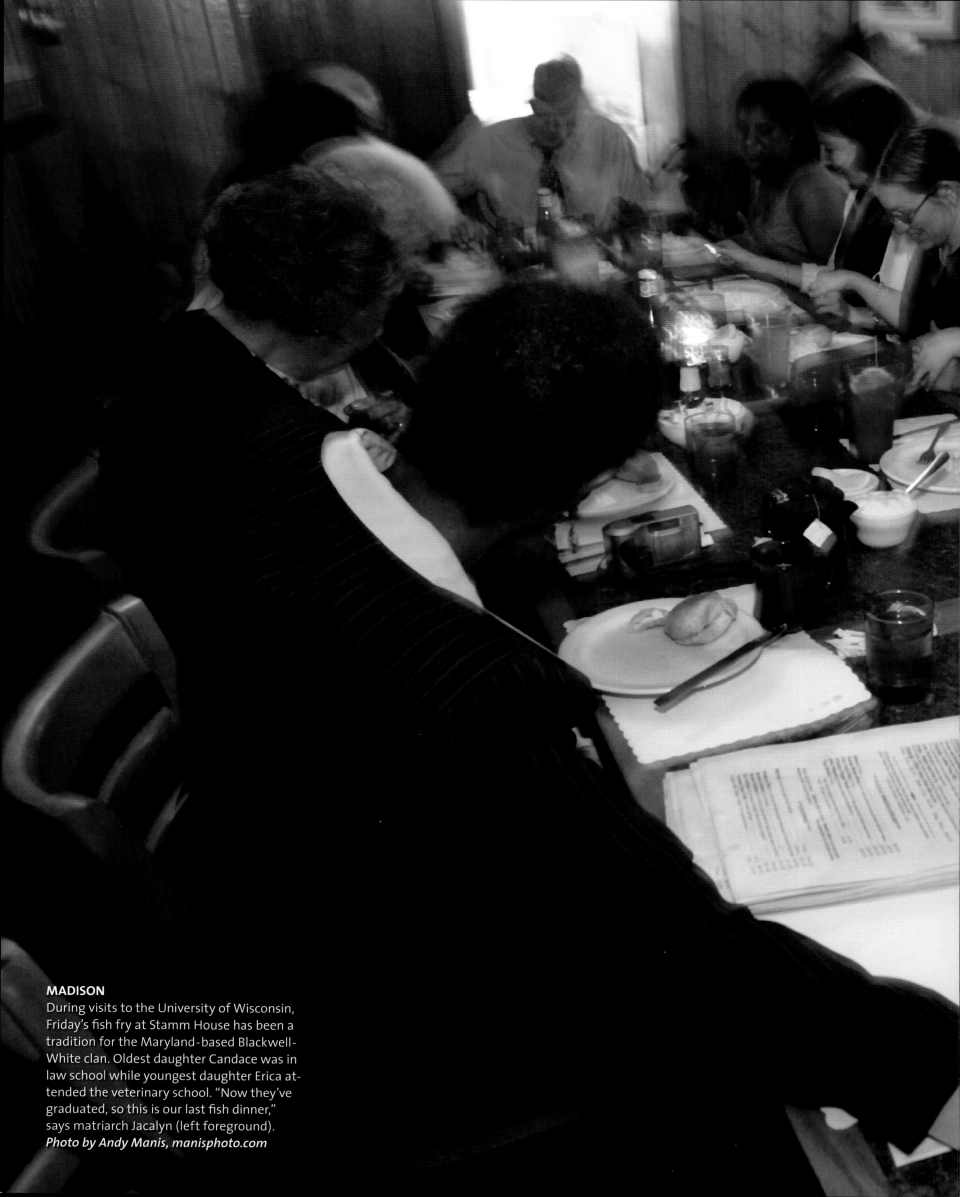

MADISON

During visits to the University of Wisconsin, Friday's fish fry at Stamm House has been a tradition for the Maryland-based Blackwell-White clan. Oldest daughter Candace was in law school while youngest daughter Erica attended the veterinary school. "Now they've graduated, so this is our last fish dinner," says matriarch Jacalyn (left foreground).
Photo by Andy Manis, manisphoto.com

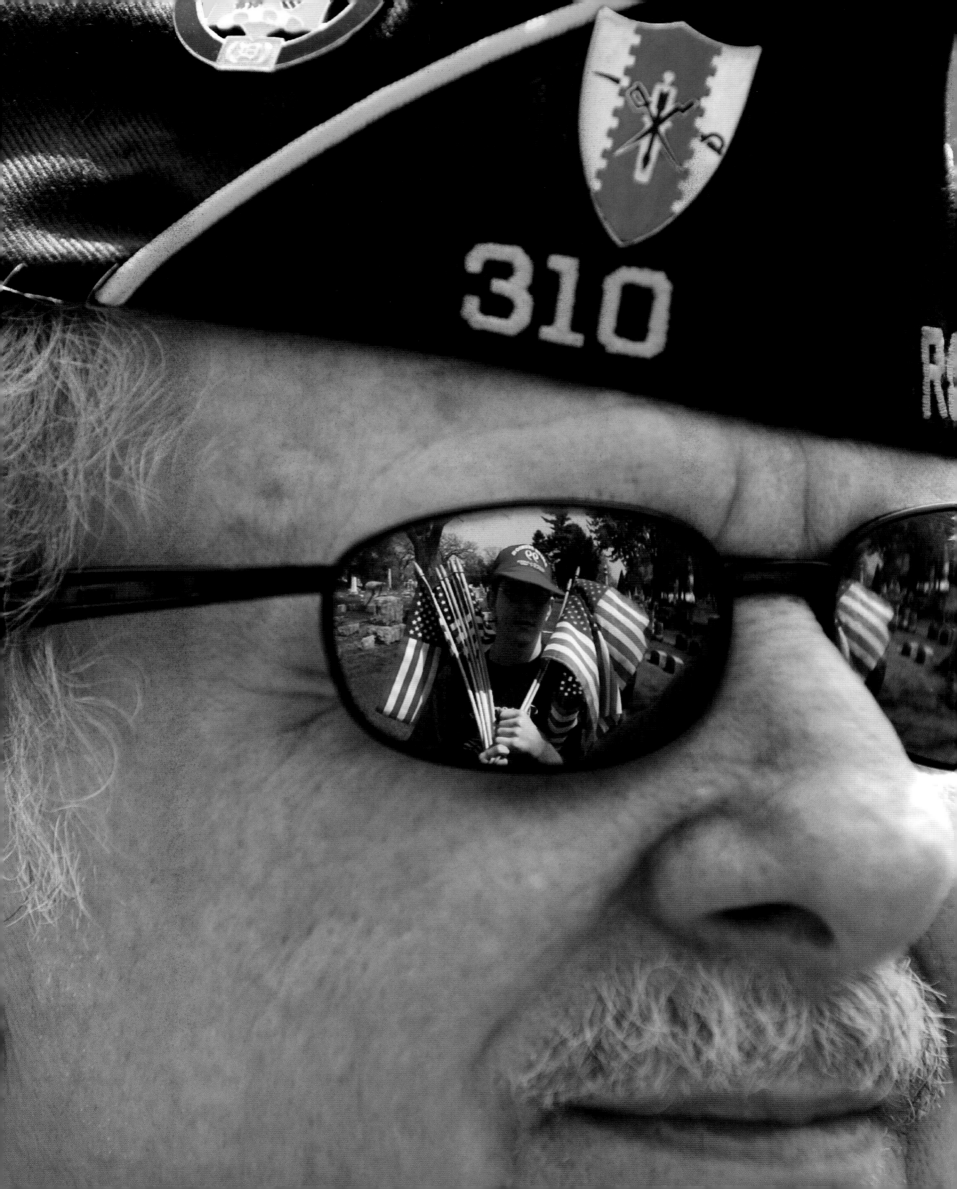

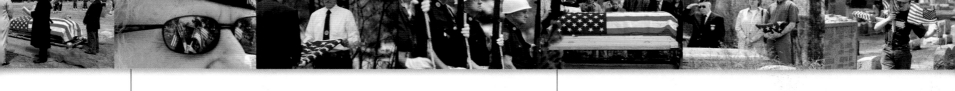

RACINE

Electrical supply salesman Steve Welch and son Jared plant flags on veterans' graves for Memorial Day at Mound Cemetery. Between the two of them, they decorated 150 grave sites, some dating back to the Civil War. "It makes me feel close to other vets, both living and dead," says Welch, a member of American Legion Post 310.

Photo by Mark Hertzberg, The Journal Times

THREE LAKES

Friends and family gather at the grave of Donald W. Burnside, a World War II Navy veteran whose Chicago family has owned a vacation home in the area since 1899. Burnside retired young and moved to Three Lakes, where he labored to create the town's main recreation center.

Photo by Mark Derse Photography

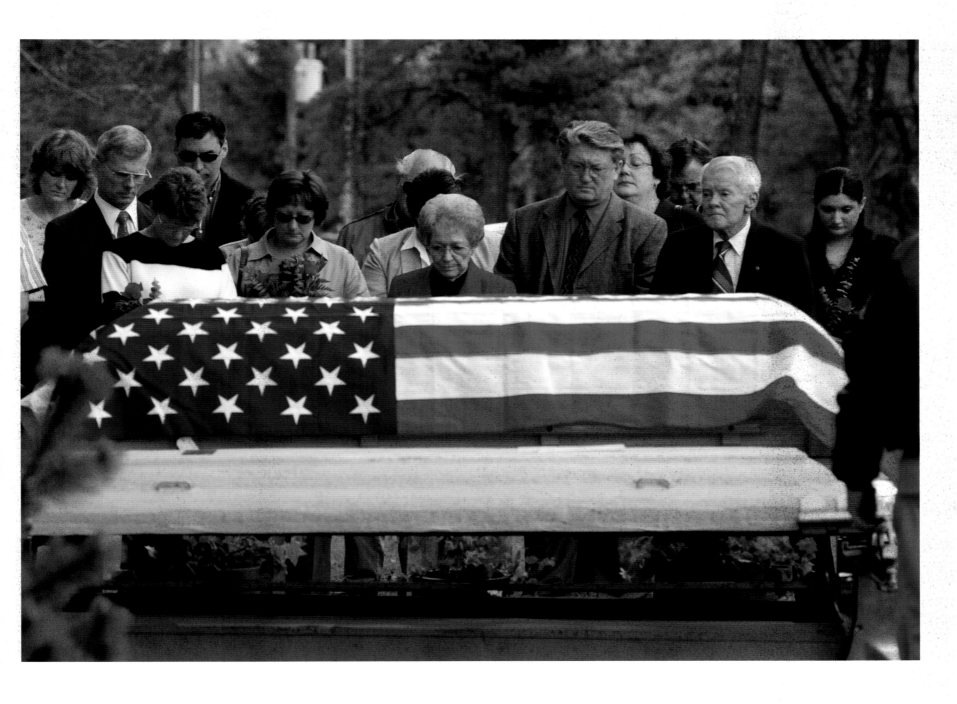

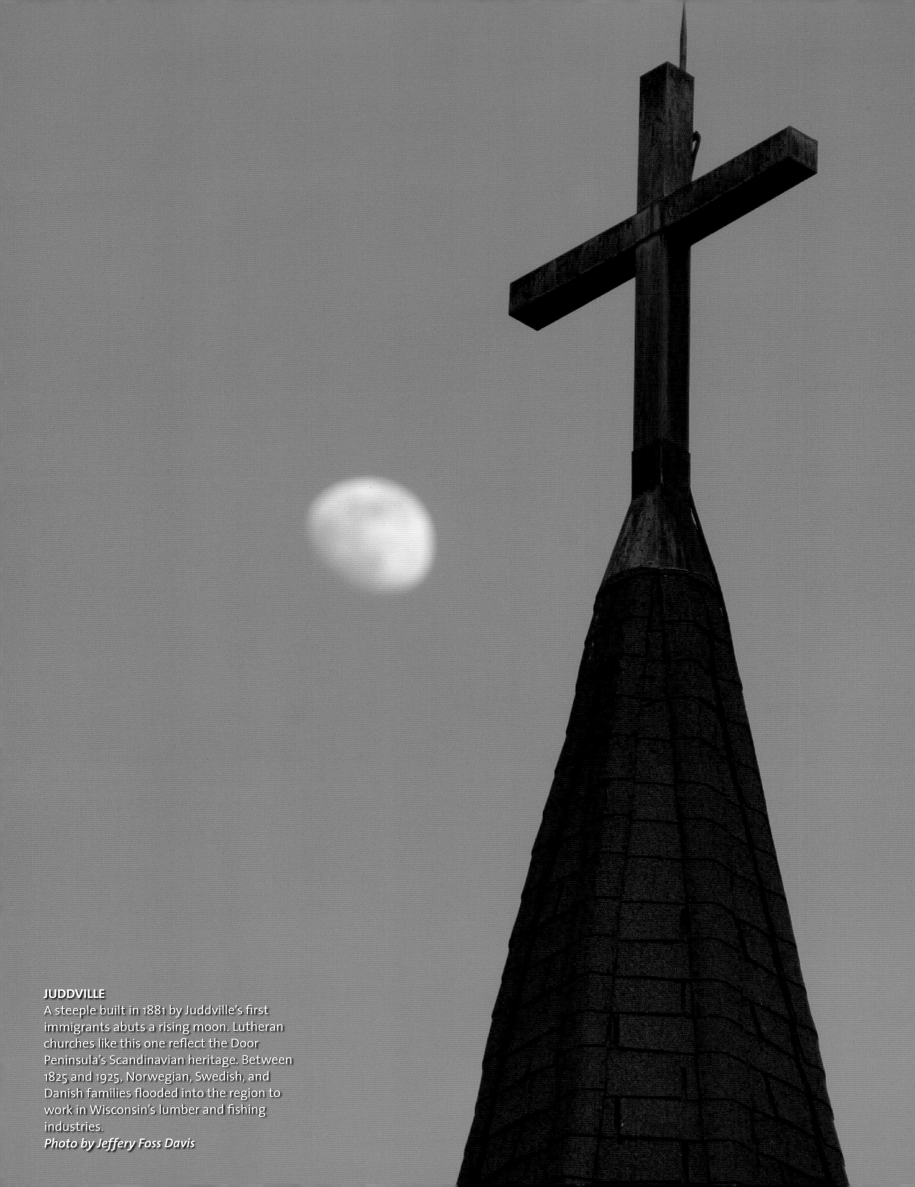

JUDDVILLE
A steeple built in 1881 by Juddville's first immigrants abuts a rising moon. Lutheran churches like this one reflect the Door Peninsula's Scandinavian heritage. Between 1825 and 1925, Norwegian, Swedish, and Danish families flooded into the region to work in Wisconsin's lumber and fishing industries.
Photo by Jeffery Foss Davis

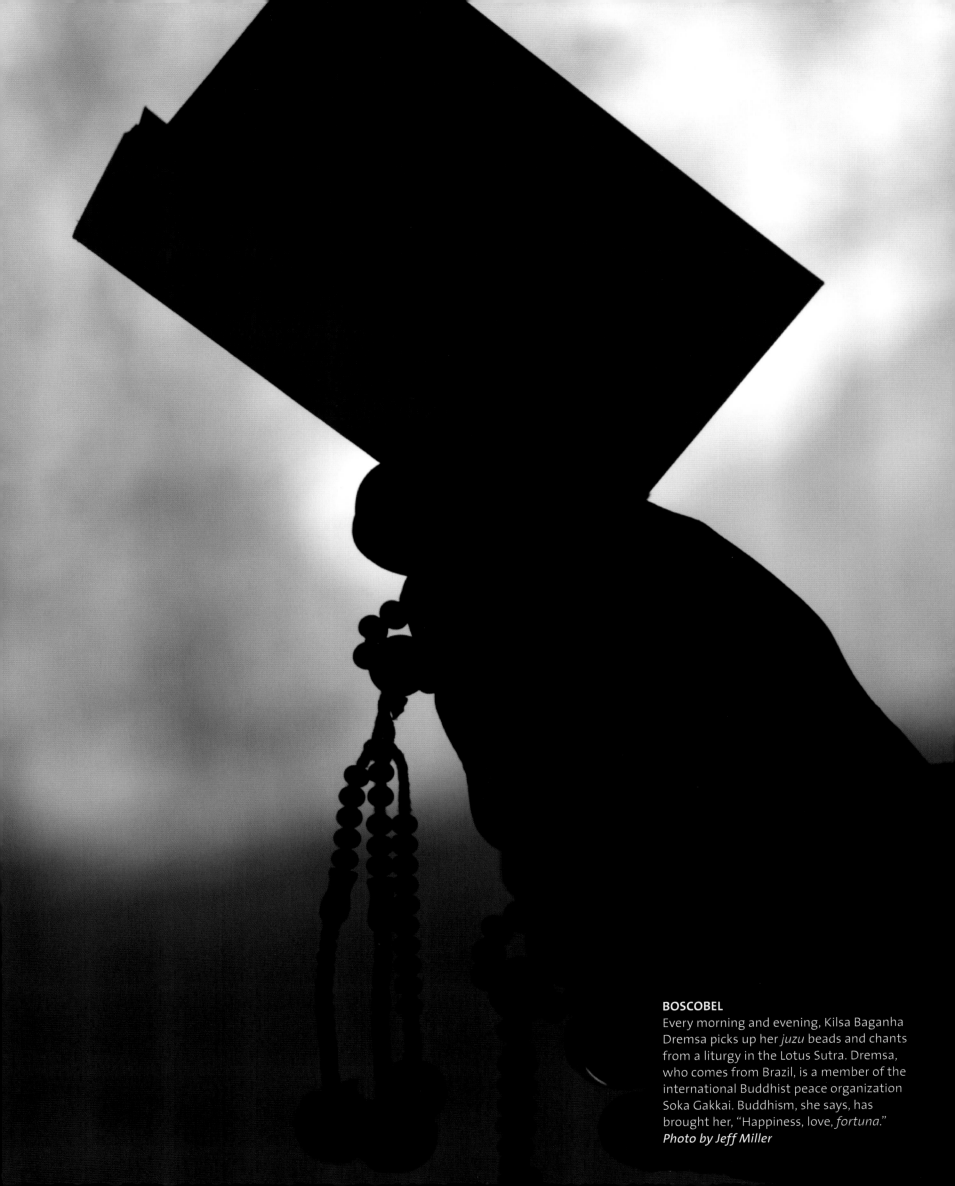

BOSCOBEL
Every morning and evening, Kilsa Baganha Dremsa picks up her *juzu* beads and chants from a liturgy in the Lotus Sutra. Dremsa, who comes from Brazil, is a member of the international Buddhist peace organization Soka Gakkai. Buddhism, she says, has brought her, "Happiness, love, *fortuna*."
Photo by Jeff Miller

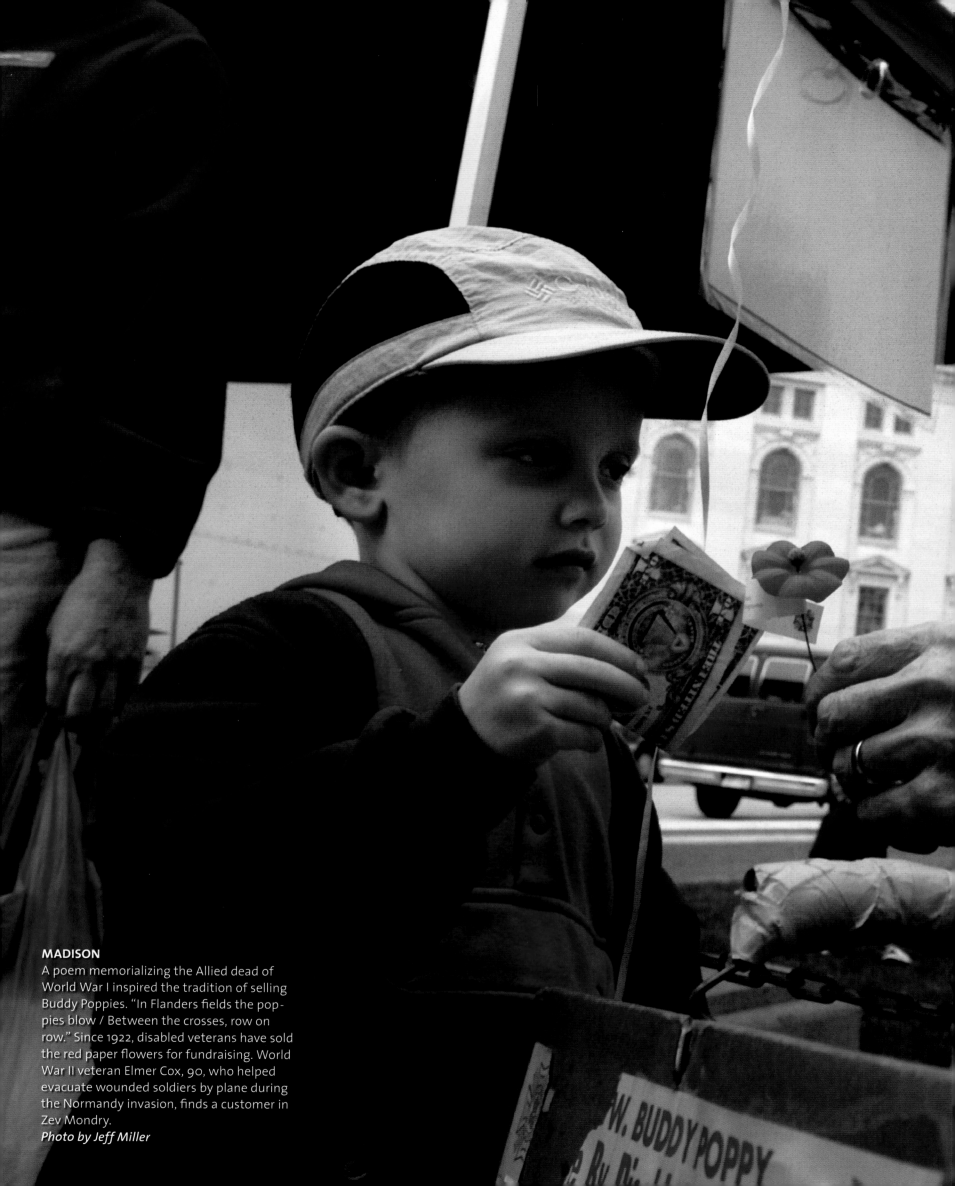

MADISON

A poem memorializing the Allied dead of World War I inspired the tradition of selling Buddy Poppies. "In Flanders fields the poppies blow / Between the crosses, row on row." Since 1922, disabled veterans have sold the red paper flowers for fundraising. World War II veteran Elmer Cox, 90, who helped evacuate wounded soldiers by plane during the Normandy invasion, finds a customer in Zev Mondry.
Photo by Jeff Miller

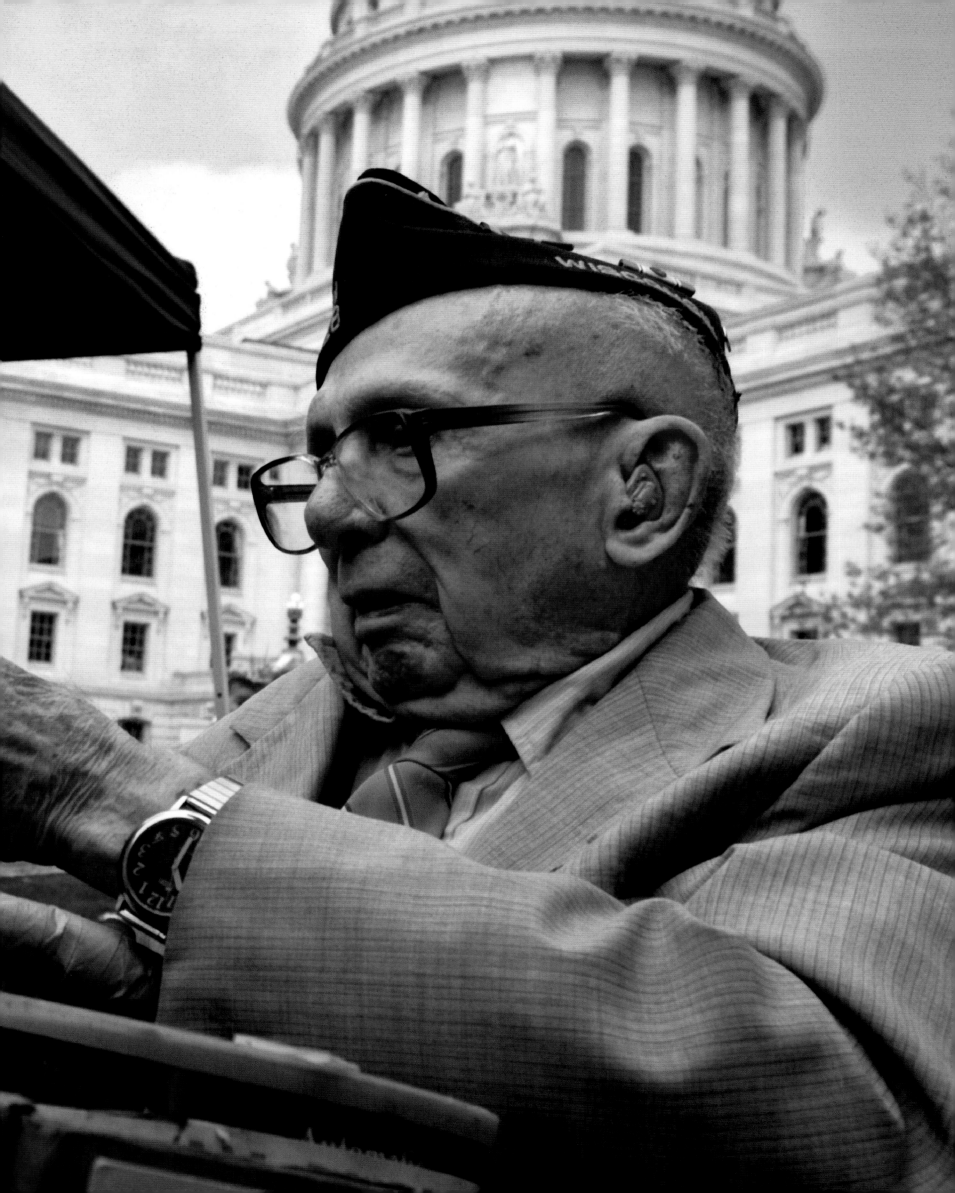

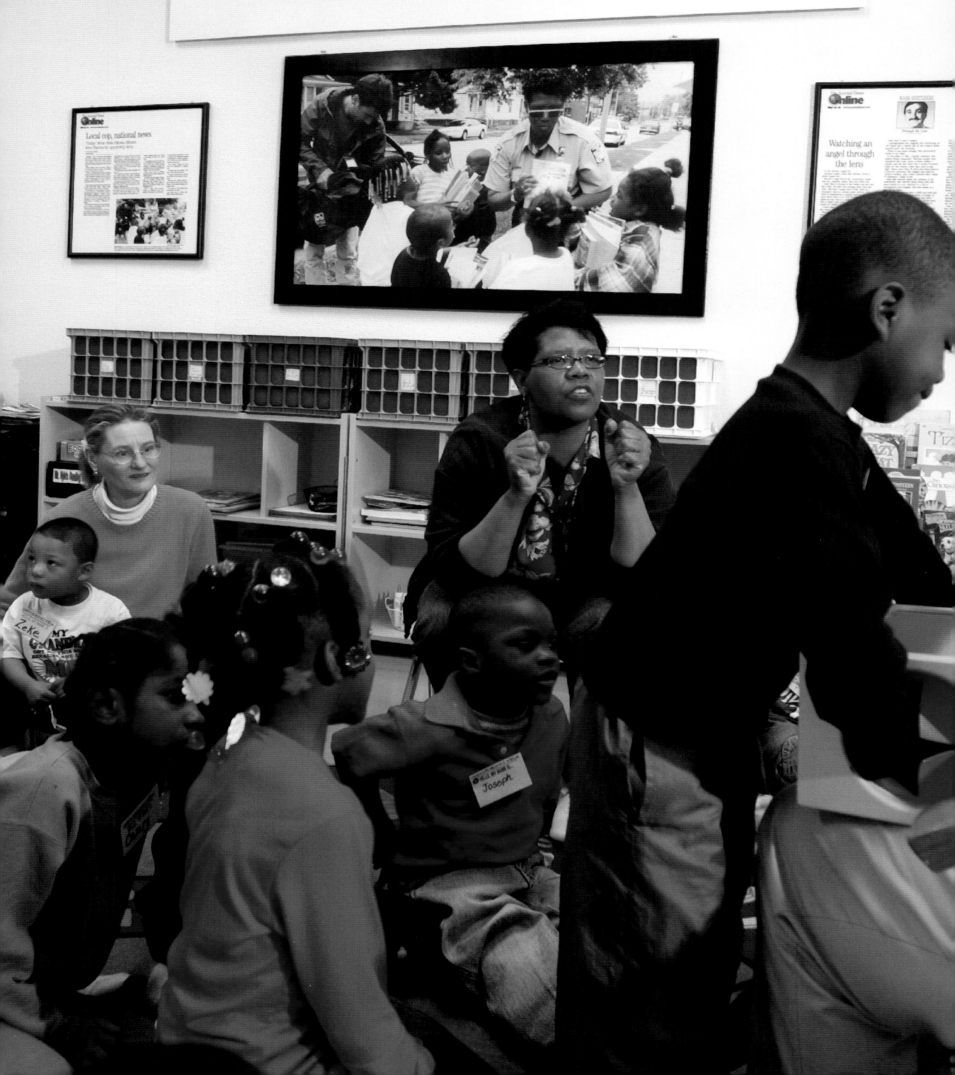

"Tell the kids I love them"
- GOD

RACINE

Retired police officer Julia Burney parlayed a gift of 10,000 books into her Cops-N-Kids Reading Program. The program operates out of a refurbished storefront with 12 new computers, and offers 30 school kids a safe place to improve their reading skills and finish their homework. "When we teach our kids to read, we all win," says Burney.

Photo by Mark Hertzberg, The Journal Times

BAILEYS HARBOR

Budding entrepreneurs Taylor Schultz (left) and Troy Tauber peddle hot drinks, sodas, and bratwurst from their makeshift stand at the Door County Festival of Blossoms Lighthouse Tour. Boy Scout Troop 1120 used its grip on the snack market to raise $850 for its camp fund.

Photo by Jeffery Foss Davis

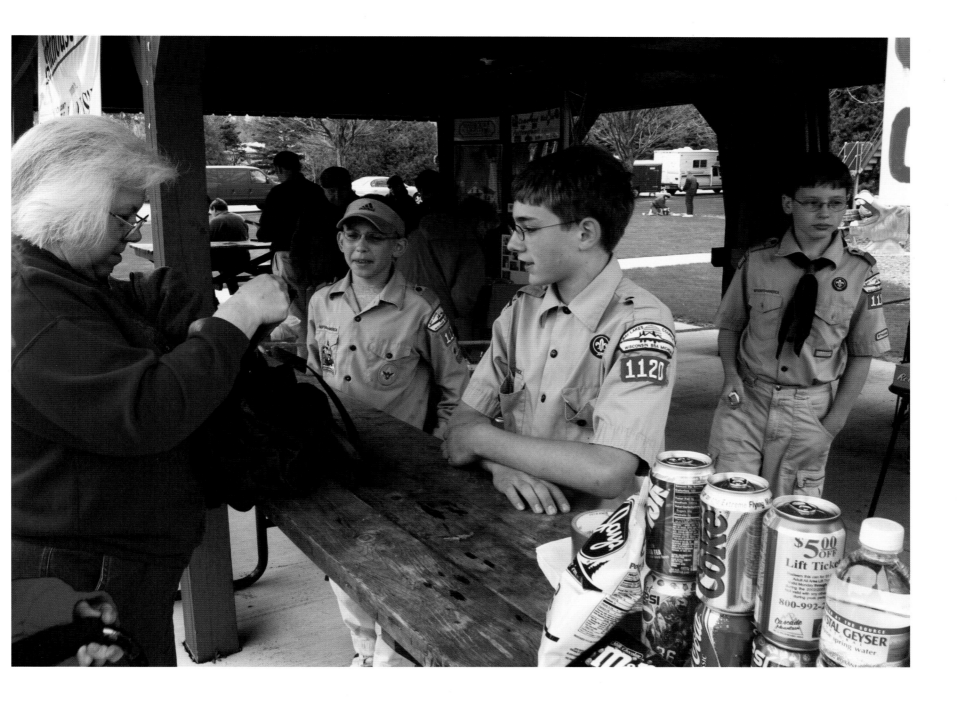

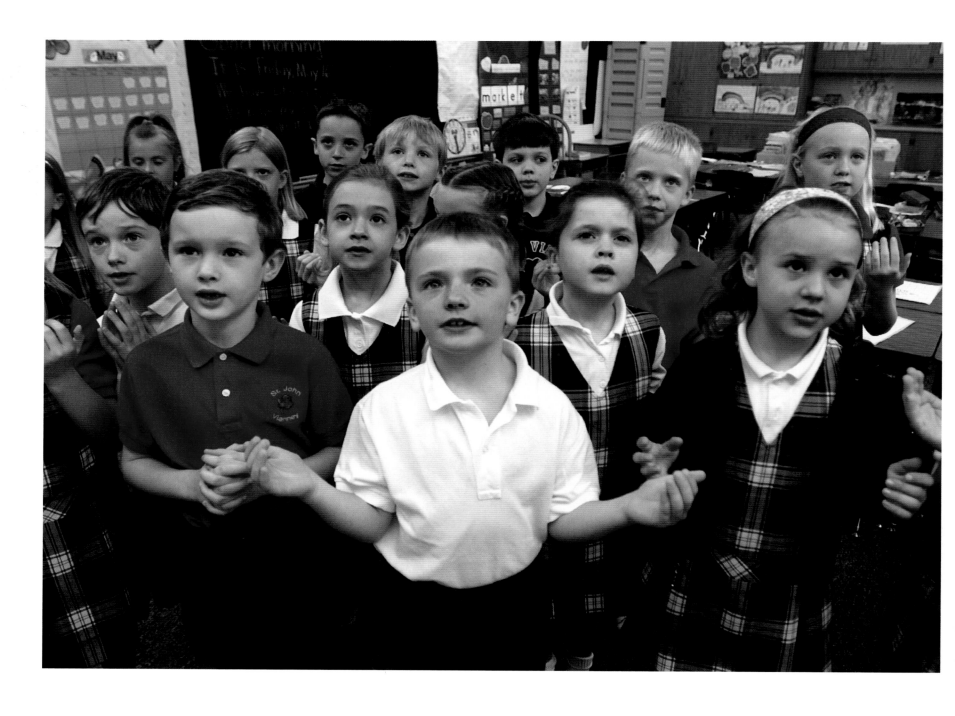

HUBERTUS

The National Shrine of Mary, Help of Christians, receives visitors of all faiths. Run by friars, the shrine sits atop 1,300-foot Holy Hill, the highest summit in the area. Stories of the shrine's origins vary and include one of a tormented French hermit, discovered living on the hilltop around 1862, who claimed he'd been cured of paralysis after praying there.

Photo by Antonio Garza

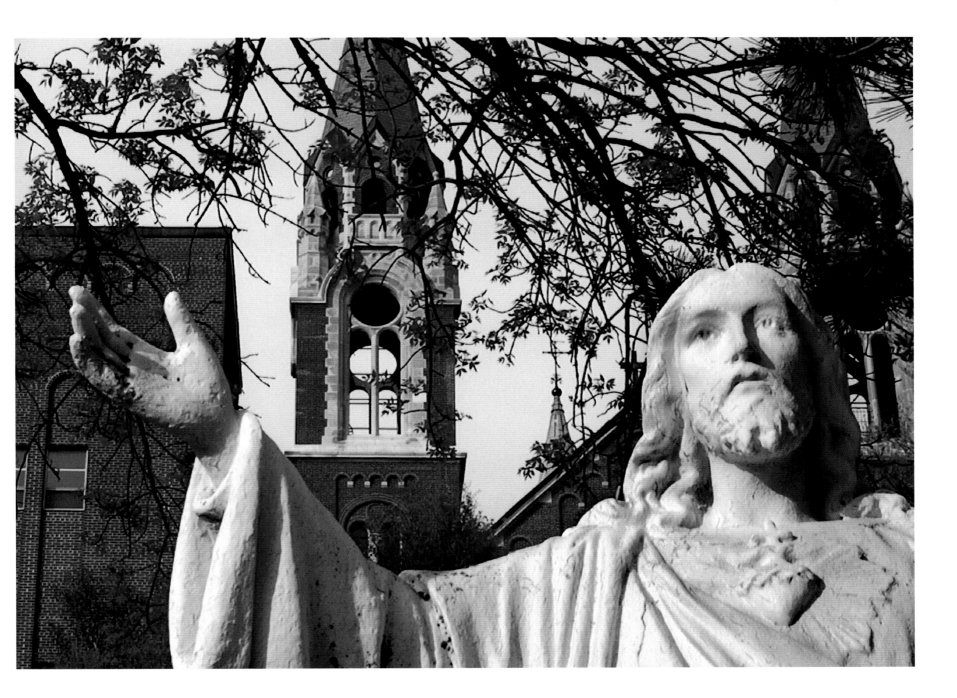

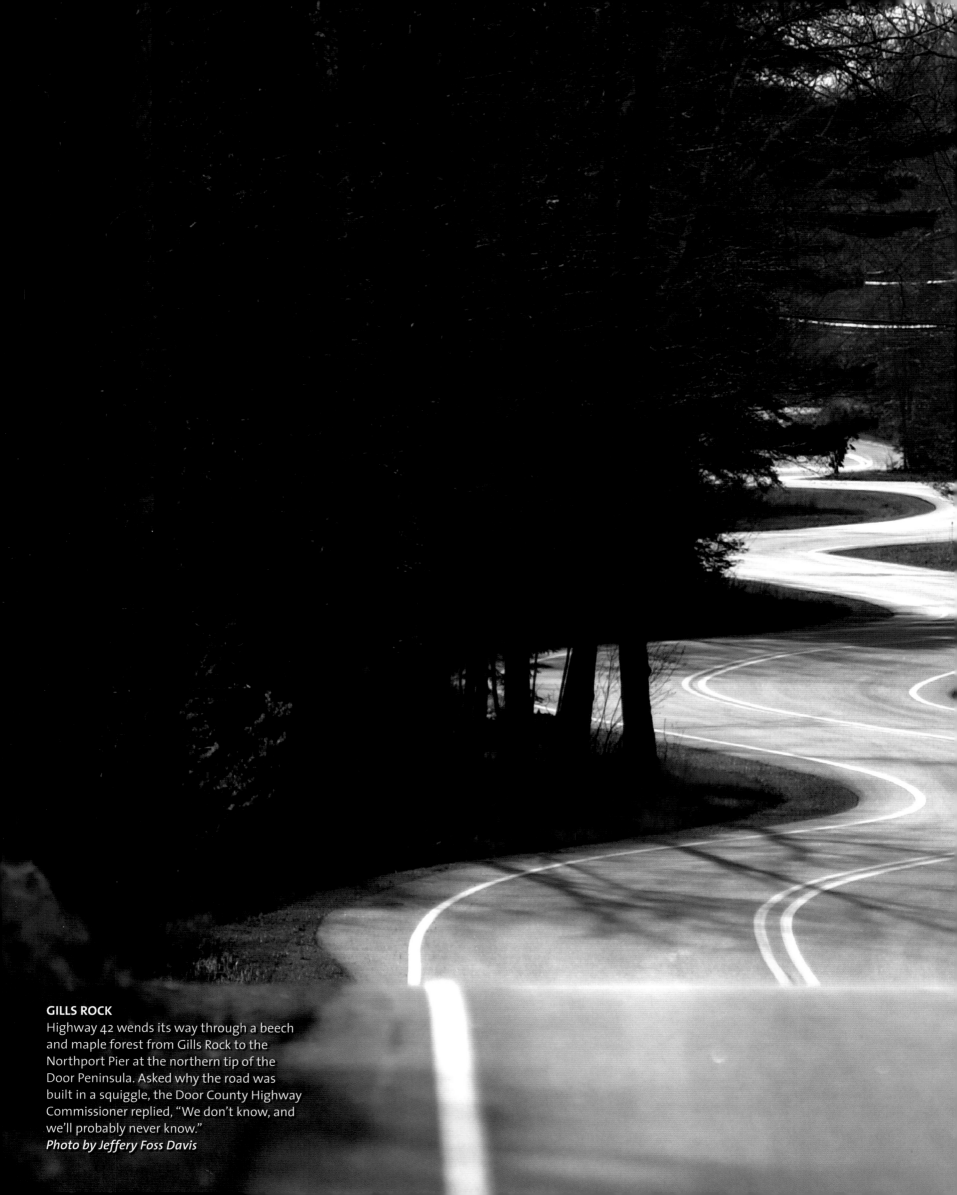

GILLS ROCK
Highway 42 wends its way through a beech and maple forest from Gills Rock to the Northport Pier at the northern tip of the Door Peninsula. Asked why the road was built in a squiggle, the Door County Highway Commissioner replied, "We don't know, and we'll probably never know."
Photo by Jeffery Foss Davis

Our Town

RACINE

The shores of Lake Michigan are studded with pier lights marking the mouths of rivers. The North Pier Light has stood at the entrance of the Root River since 1906.
Photo by Gregory Shaver

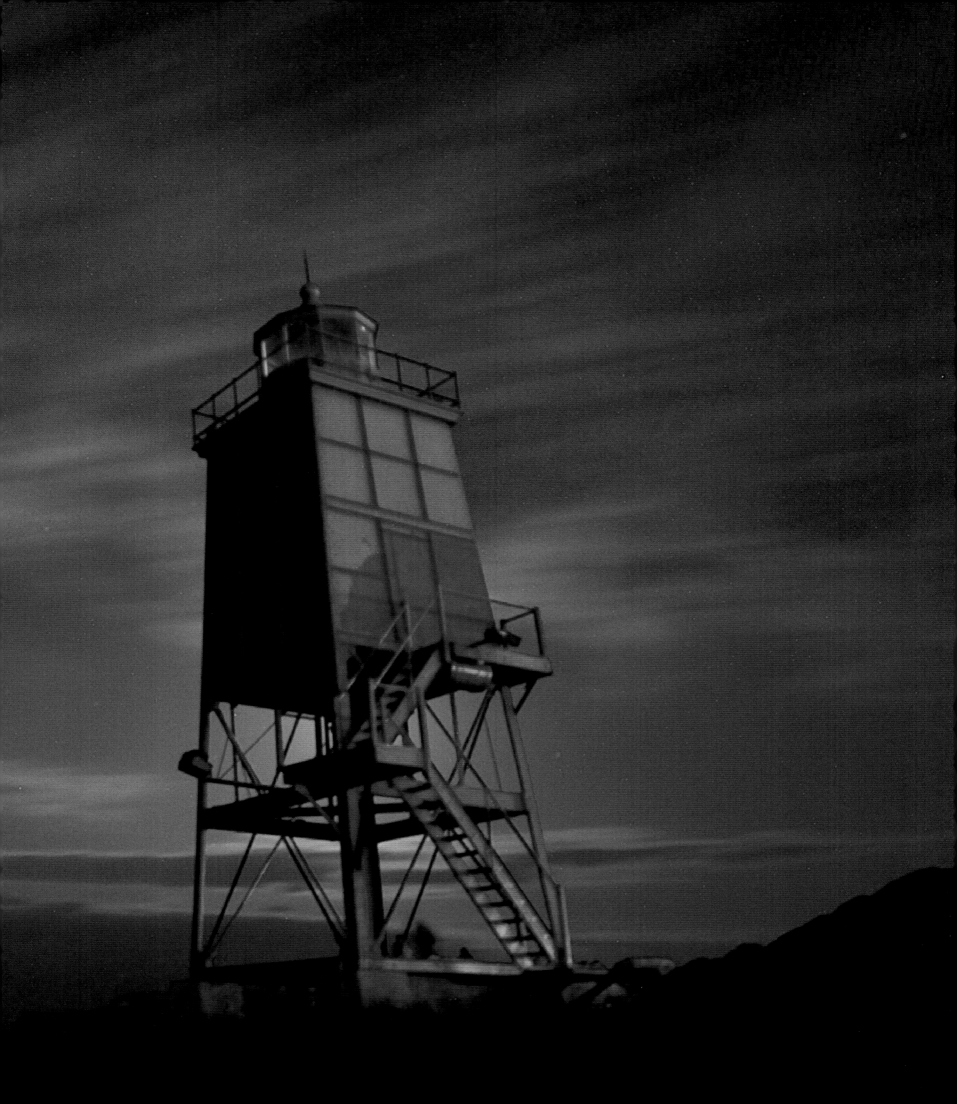

BROWN COUNTY

This farmer wears his politics on his silo. "No" in this case refers to a sales tax increase that, if passed, would pay for the renovation of Lambeau Field, the Green Bay Packers' home field.
Photo by Tim Dardis

MILWAUKEE

The Pabst Brewing Company shut the doors of its last plant in 1996 and outsourced its production to the Miller Brewing Company, but the neon lights of Milwaukee's most famous beer maker still hang over Juneau Avenue. In its late 19th and early 20th centuries heyday, Pabst was the largest brewer in the world and employed 20,000 workers in North America.
Photo by Scott C. Anderson

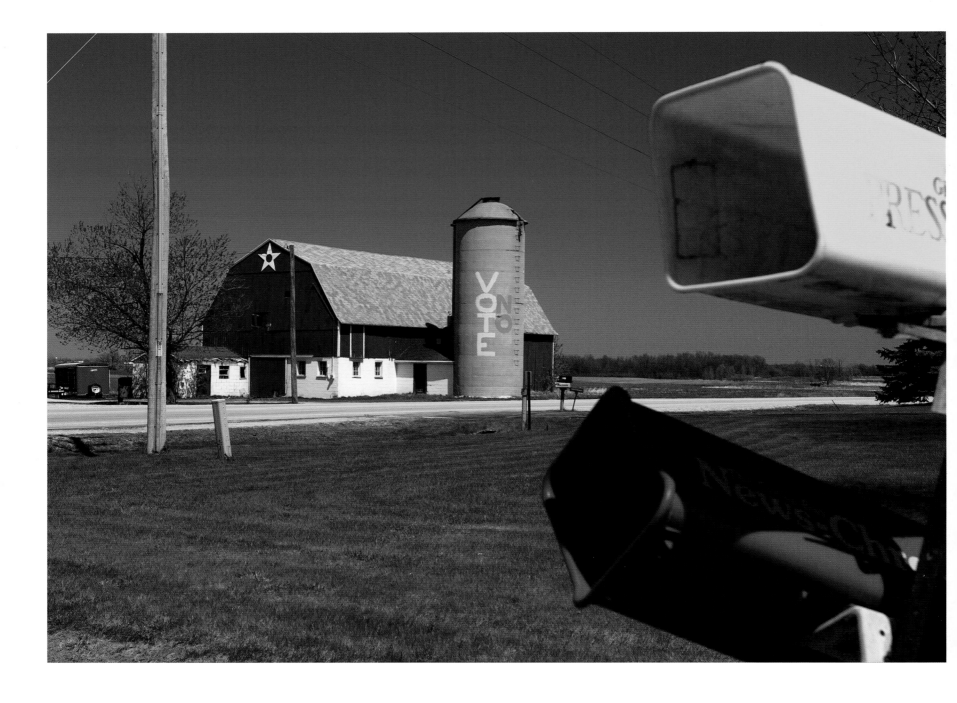

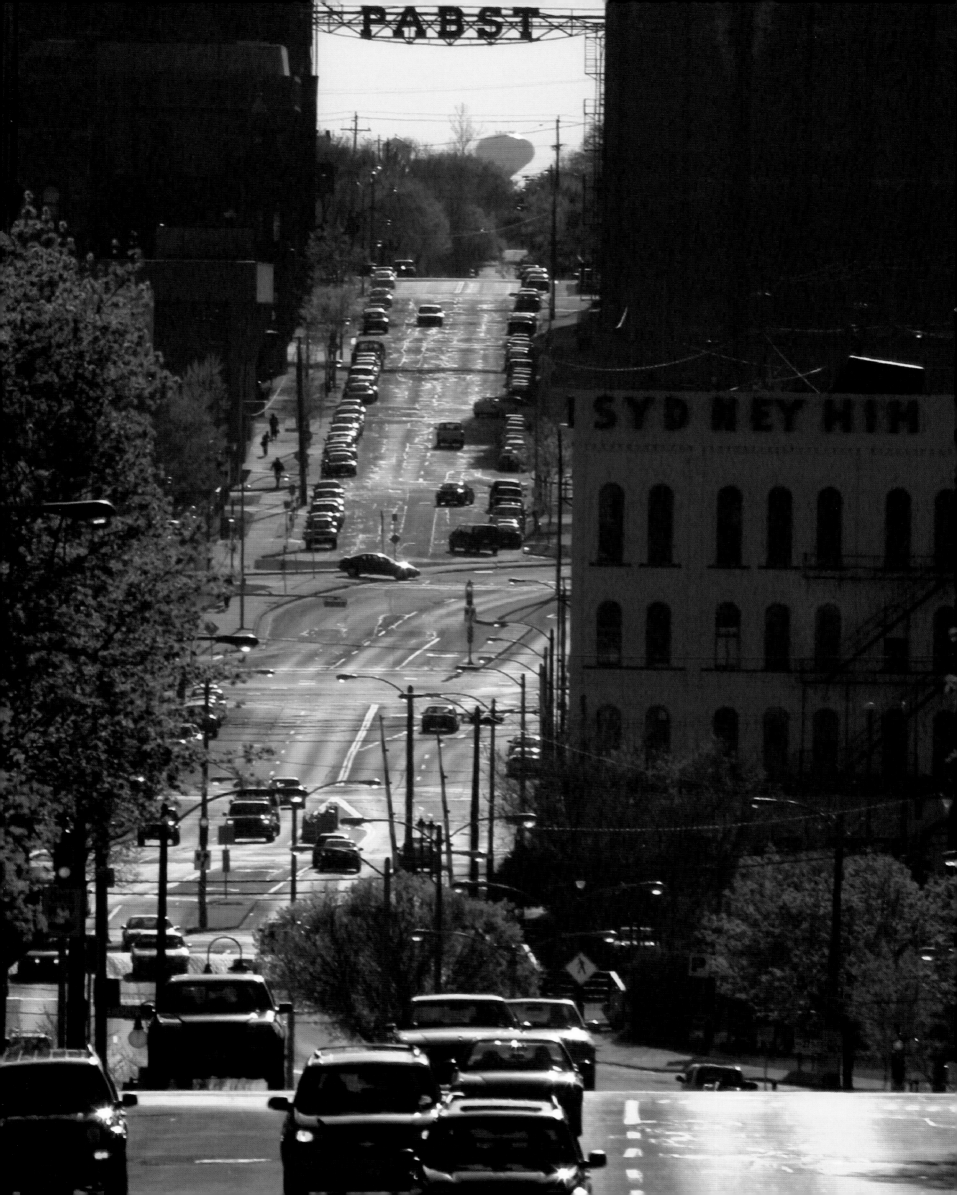

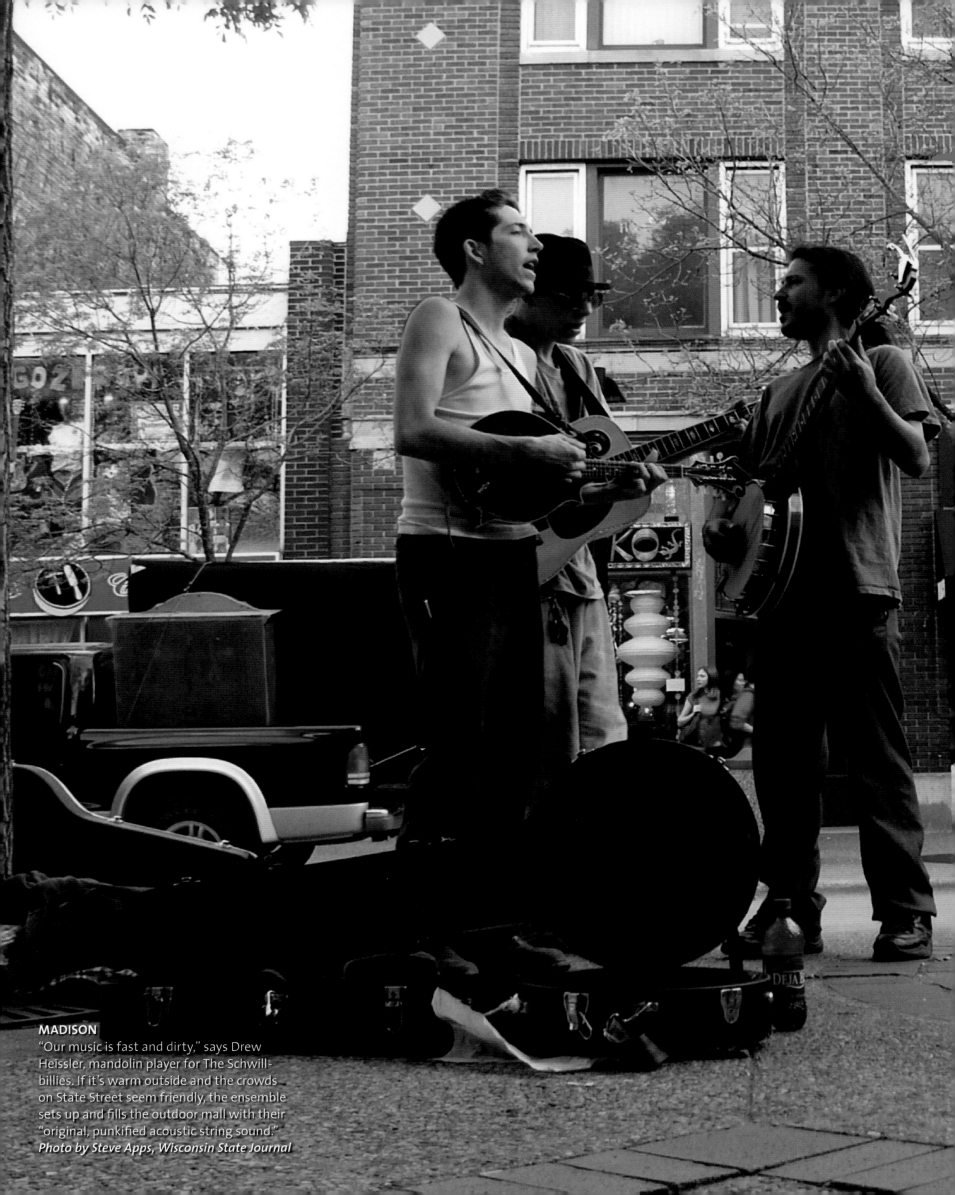

MADISON

"Our music is fast and dirty," says Drew Heissler, mandolin player for The Schwill-billies. If it's warm outside and the crowds on State Street seem friendly, the ensemble sets up and fills the outdoor mall with their "original, punkified acoustic string sound."
Photo by Steve Apps, Wisconsin State Journal

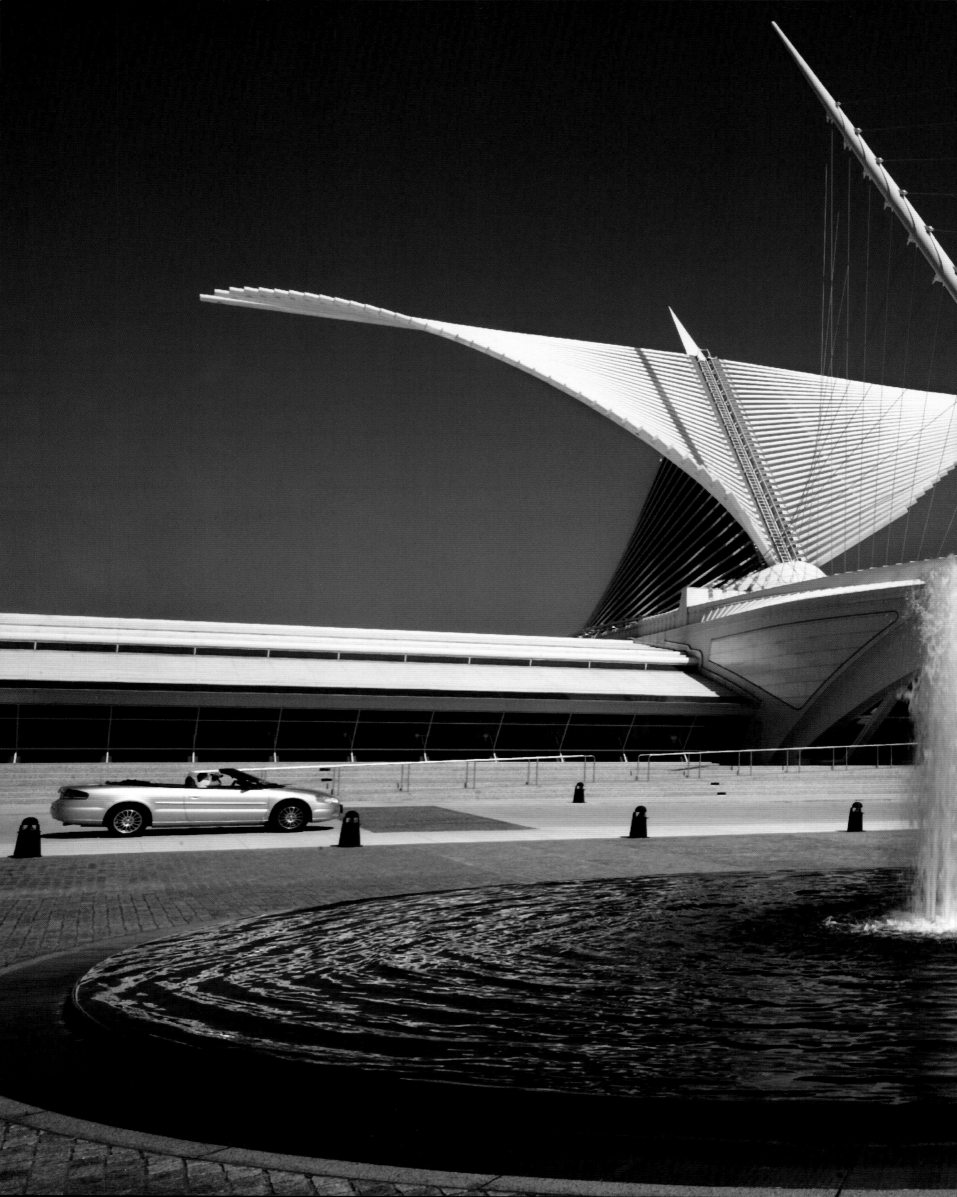

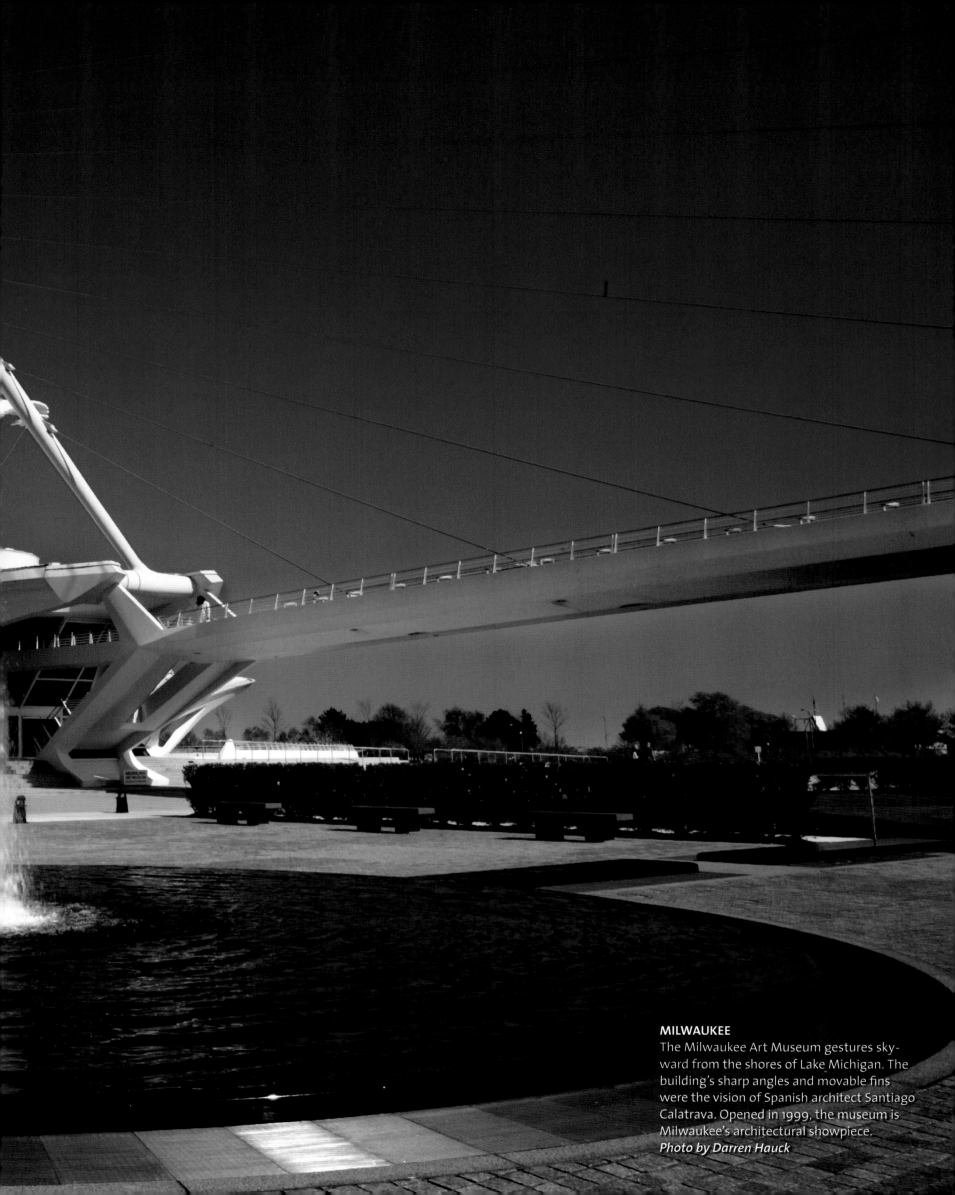

MILWAUKEE
The Milwaukee Art Museum gestures sky-ward from the shores of Lake Michigan. The building's sharp angles and movable fins were the vision of Spanish architect Santiago Calatrava. Opened in 1999, the museum is Milwaukee's architectural showpiece.
Photo by Darren Hauck

DOOR COUNTY
Separating Washington Island from the Door County peninsula is Death's Door Passage, named for the unpredictable currents and rocky shores that have wrecked dozens of ships over the past two centuries. Calm weather prevails on this day, making for a relaxing passage for those on two ferries crossing paths.
Photo by Jeffery Foss Davis

MAZOMANIE
One of many flags that appeared in Wisconsin after the terrorist attacks of September 11, 2001, this banner papers a garage.
Photo by Callen Harty

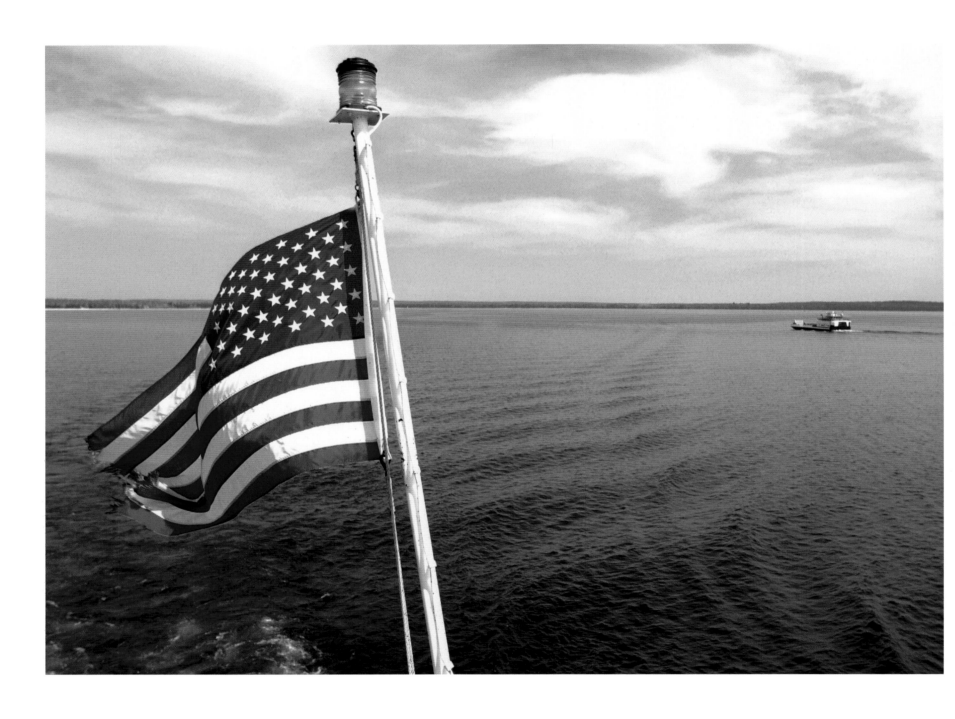

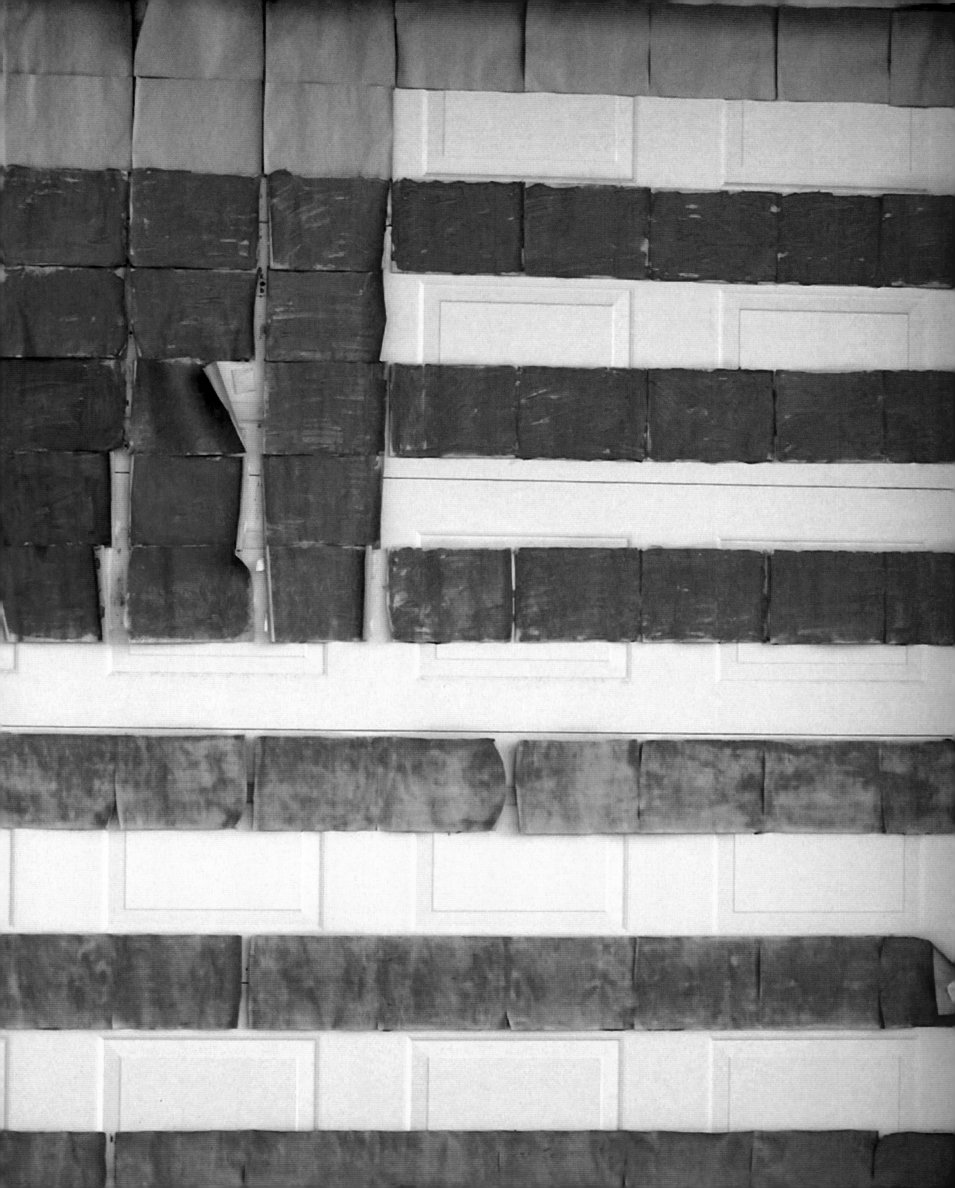

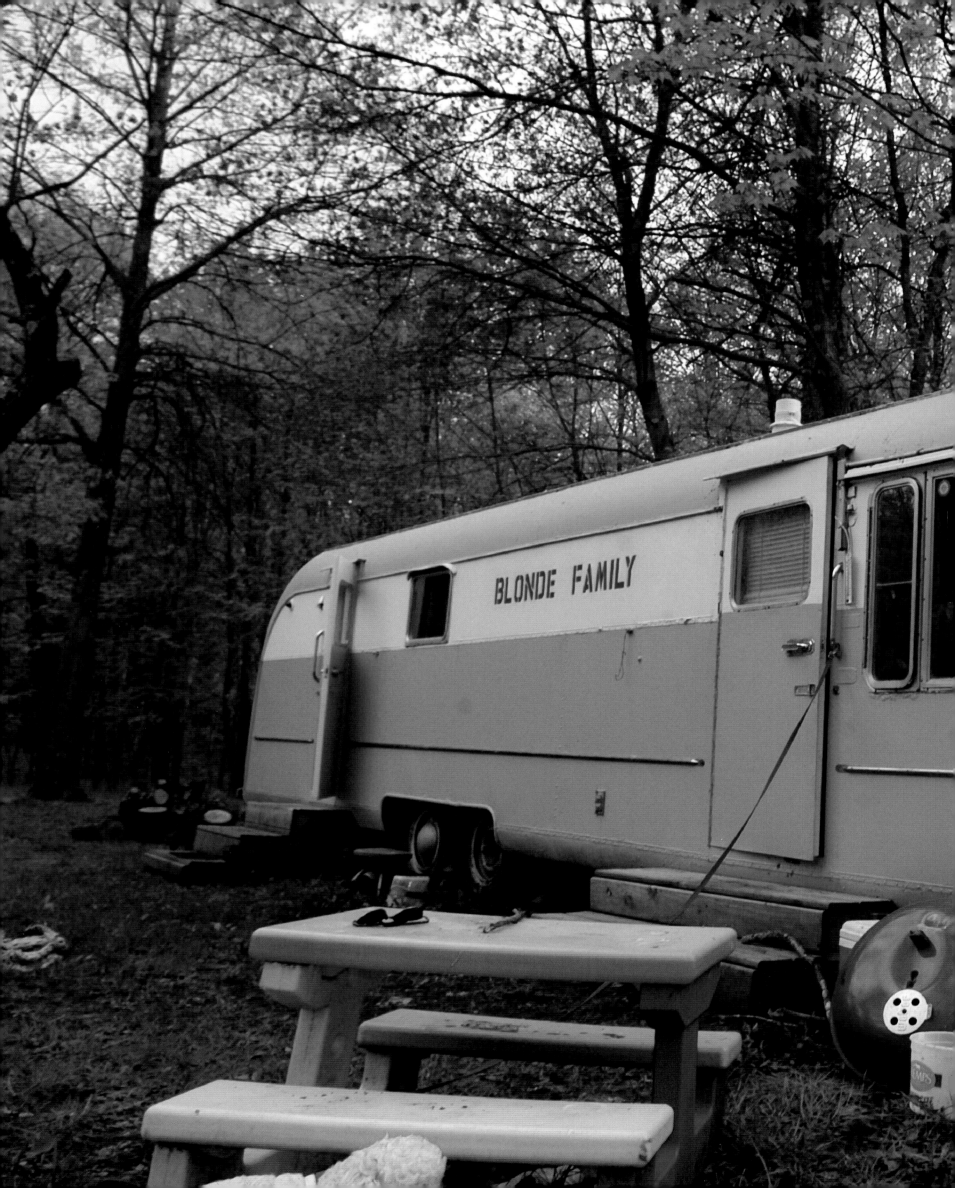

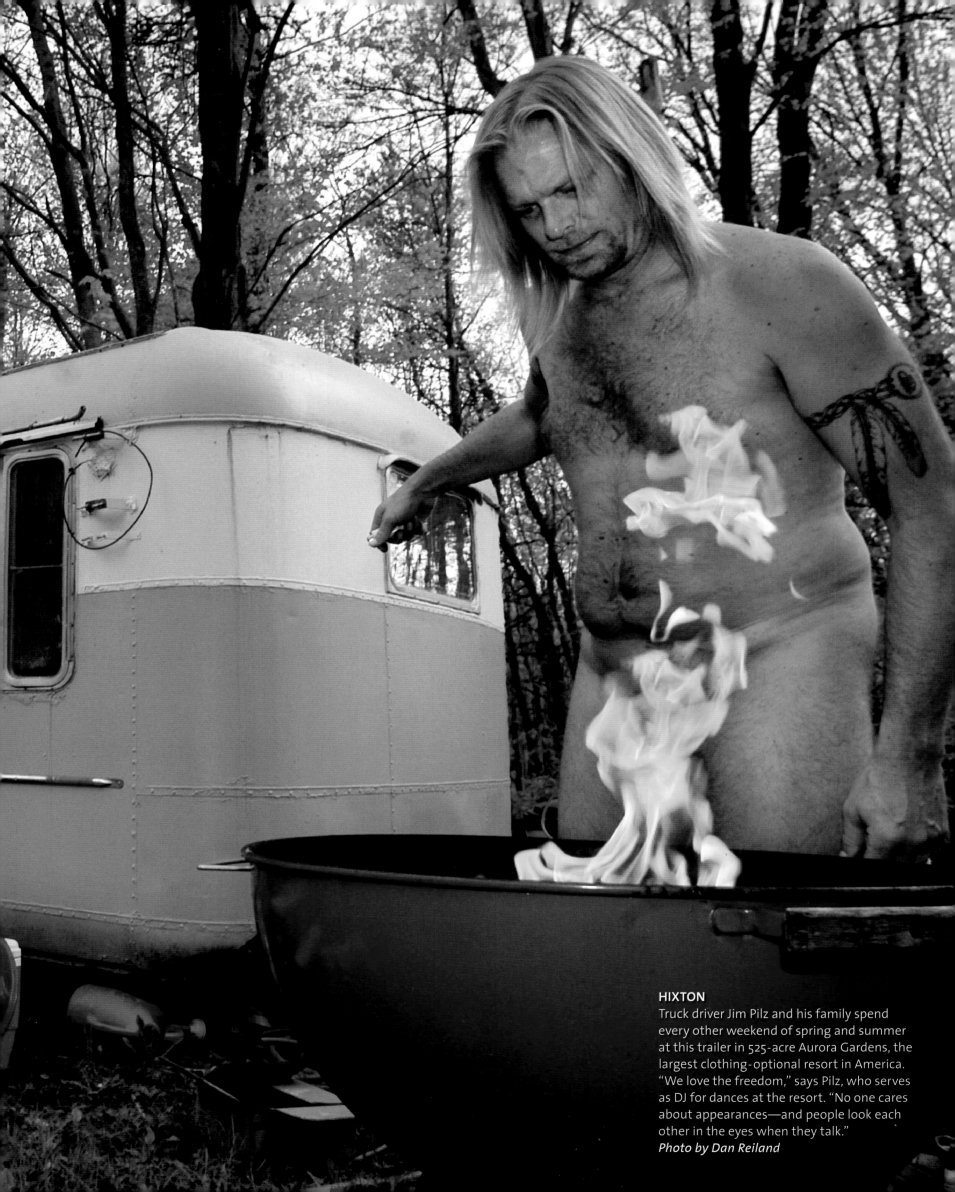

HIXTON
Truck driver Jim Pilz and his family spend every other weekend of spring and summer at this trailer in 525-acre Aurora Gardens, the largest clothing-optional resort in America. "We love the freedom," says Pilz, who serves as DJ for dances at the resort. "No one cares about appearances—and people look each other in the eyes when they talk."
Photo by Dan Reiland

HIXTON

Tom Stuckert cleans moss and debris off the roof of the women's outhouse. As resort manager, Stuckert is responsible for maintaining Aurora Gardens' grounds, which include 300 campsites, 25 miles of trails, a 5-acre lake, and a six-room bed and breakfast.

Photos by Dan Reiland

HIXTON

"People shouldn't be ashamed of their bodies. We're part of God's creation," says Sparky Beauchene, a nudist since 1972. Every weekend from April to November, the Milwaukee-based electrical contractor and his dog Bare stay at the resort, which was originally a Christian riding camp for boys.

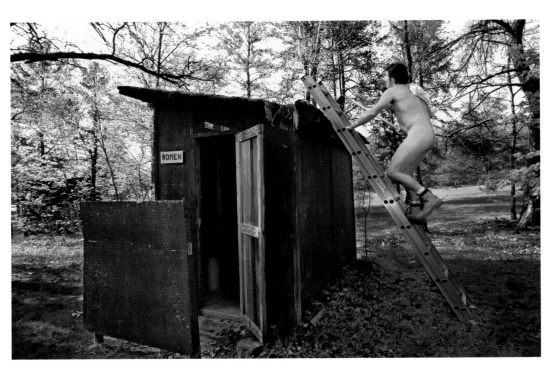

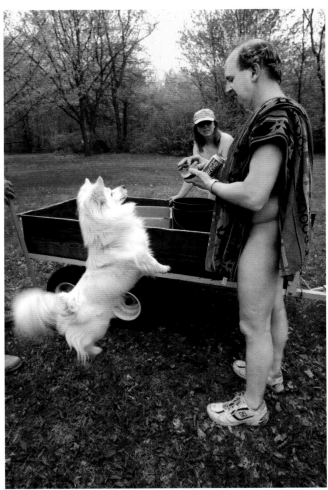

HIXTON

Owner Bob Reinke cautions, "Never use a weed whacker or a chain saw while nude." He and his wife Nancy bought the resort in 1996 and, after hosting a weekend nudist retreat, made the business clothing optional in 2001. Reinke claims nudists are the friendliest and cleanest campers.

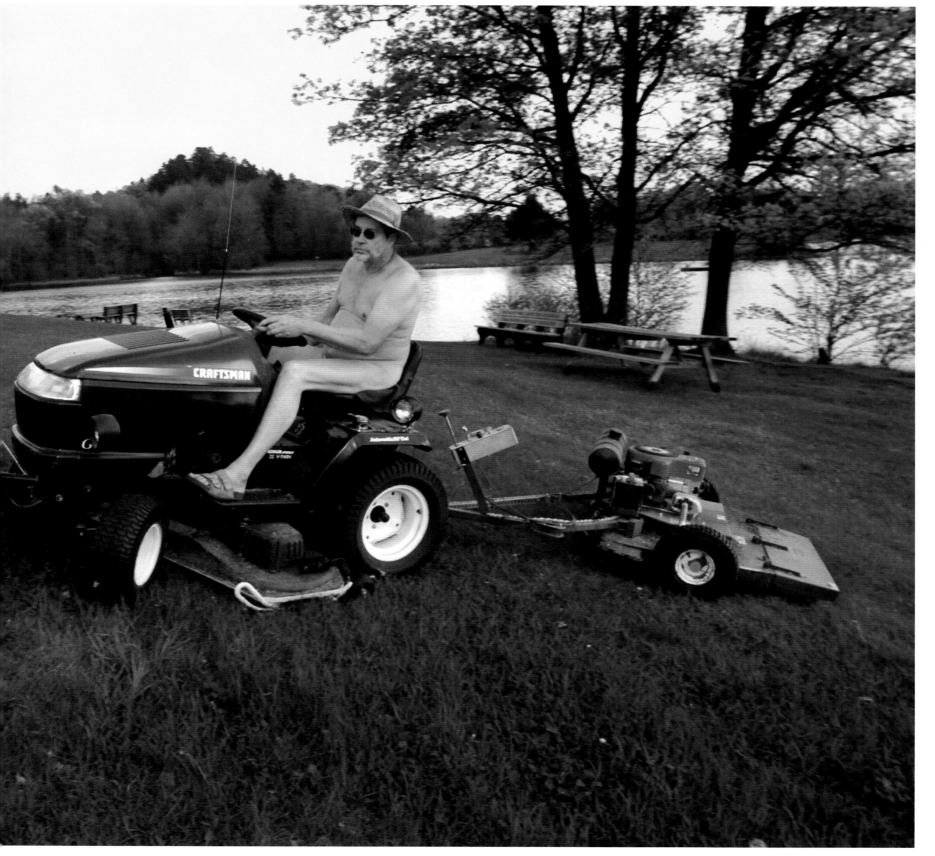

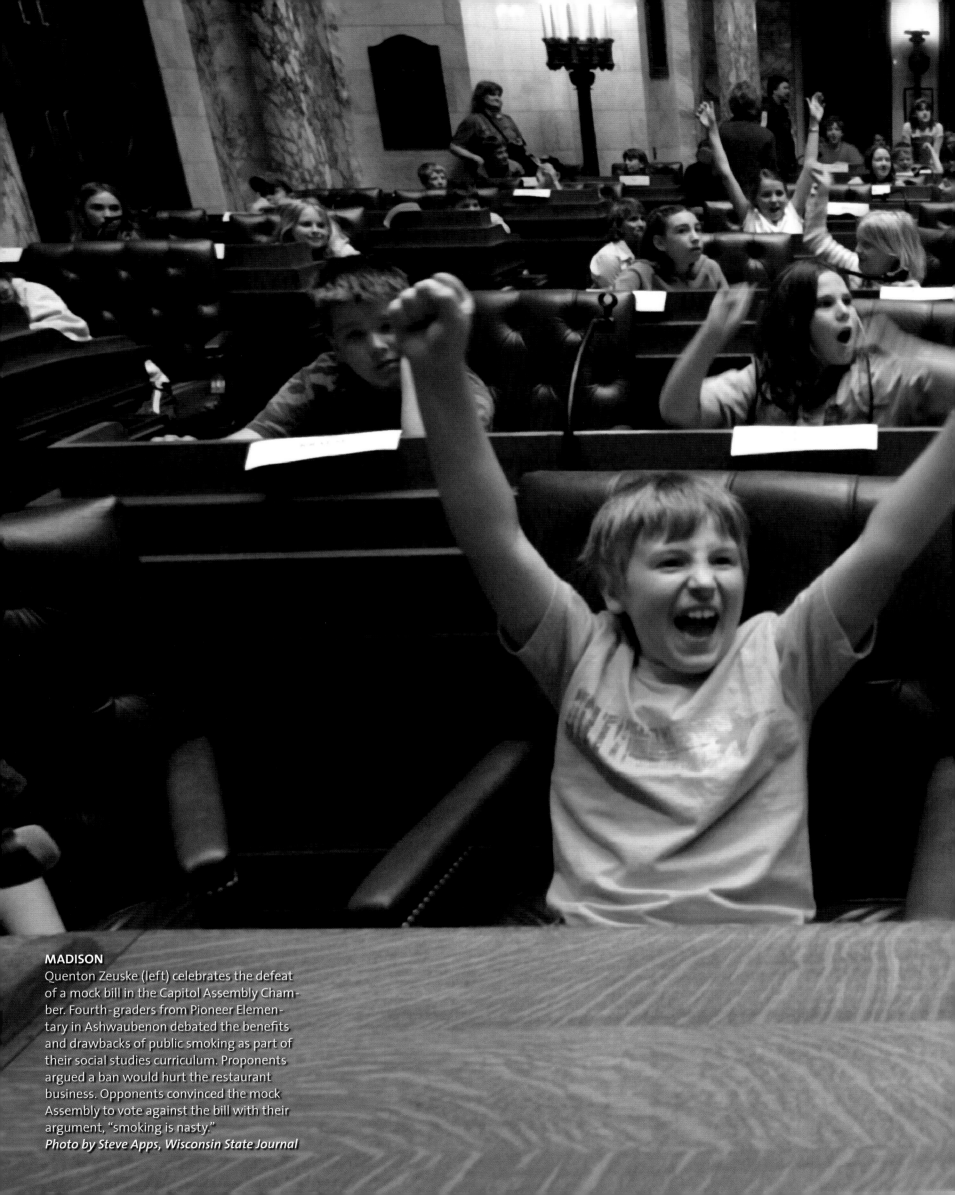

MADISON
Quenton Zeuske (left) celebrates the defeat of a mock bill in the Capitol Assembly Chamber. Fourth-graders from Pioneer Elementary in Ashwaubenon debated the benefits and drawbacks of public smoking as part of their social studies curriculum. Proponents argued a ban would hurt the restaurant business. Opponents convinced the mock Assembly to vote against the bill with their argument, "smoking is nasty."
Photo by Steve Apps, Wisconsin State Journal

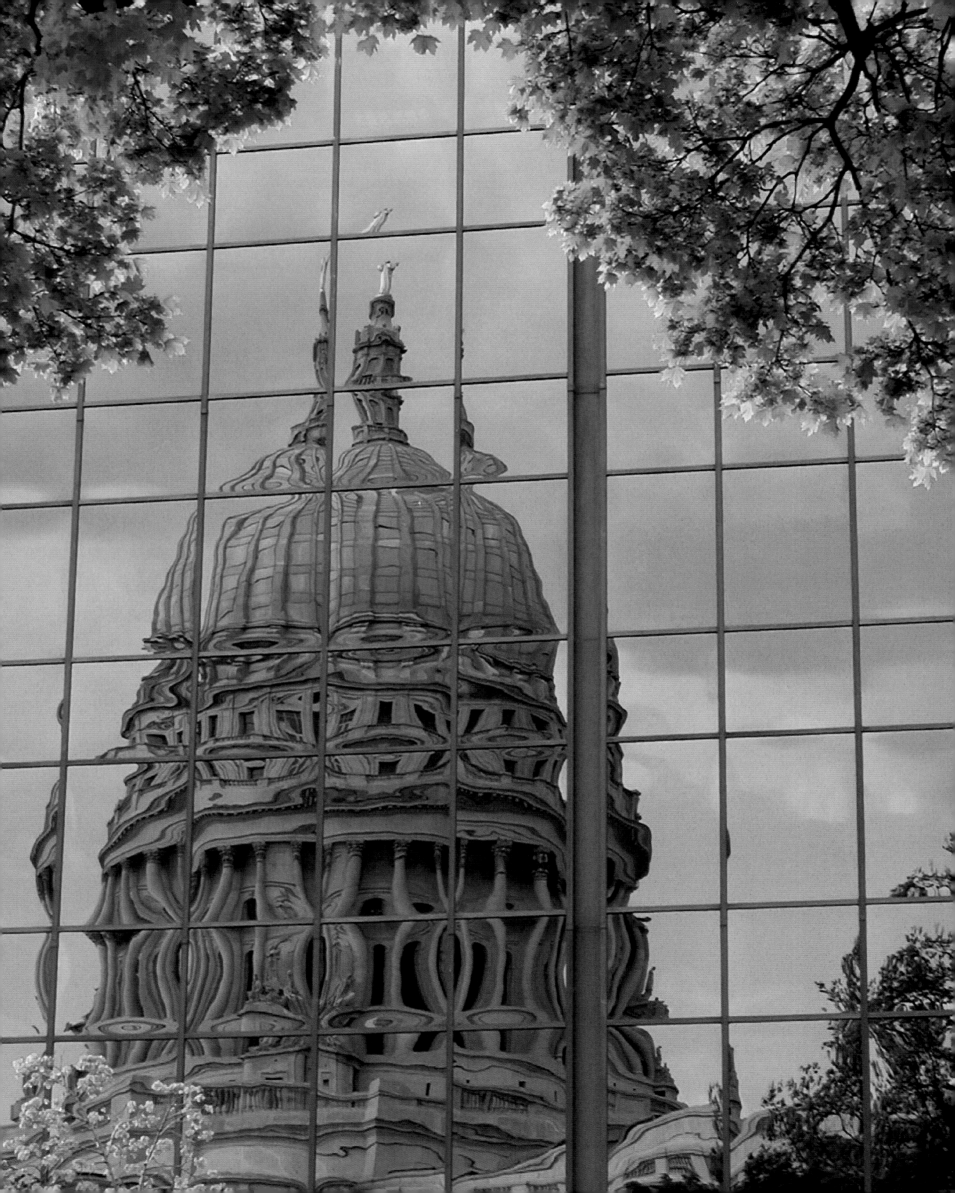

MADISON

Capitol ideas: Wisconsin's government still shimmers with the influence of Robert La Follette and his Progressive movement. Church and state are strictly separate, and the death penalty has been outlawed since 1851. In 1911 legislators established the nation's first progressive income tax, set maximum work hours for women and children, and created programs to aid farm cooperatives.
Photos by Callen Harty

MADISON

A woman symbolizing Wisconsin gazes from the capitol dome. She's part of Edwin Blashfield's painting *The Resources of Wisconsin.* At the time of its creation, about 90 years ago, those resources were grain, lead, copper, tobacco, fruit, fish, and freshwater pearls.

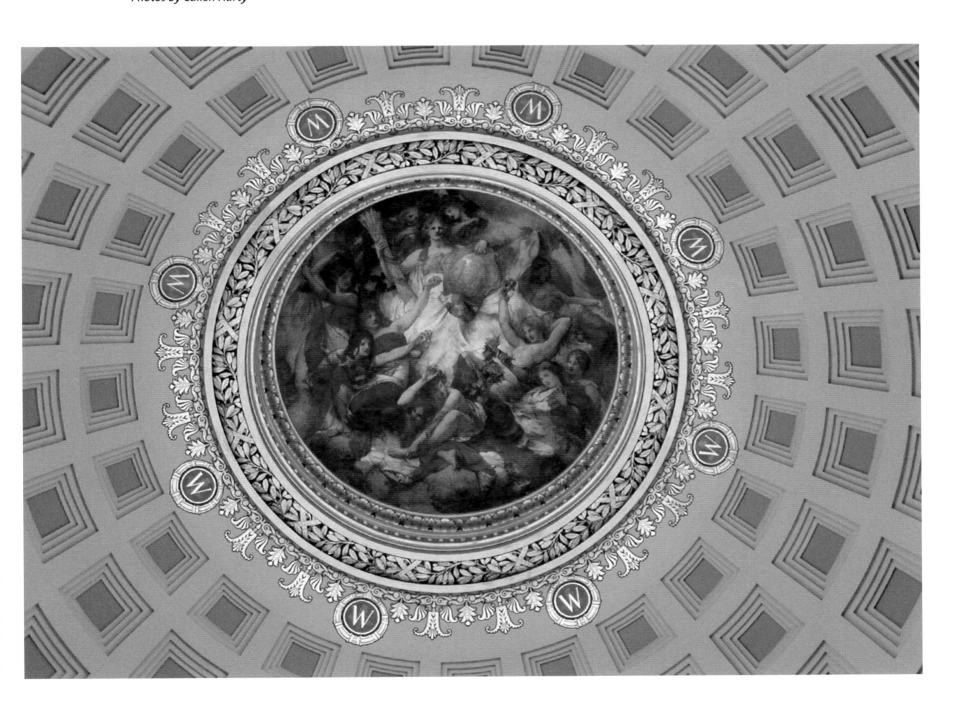

SUN PRAIRIE

Georgia O'Keeffe, best known for her modernist paintings of enormous flowers and sun-bleached desert bones, was born in Sun Prairie on November 15, 1887. As a small girl, she had her first art lessons from local watercolorist Sarah Mann. In the park next to city hall, a plaque is dedicated to the artist on the 100th anniversary of her departure from Wisconsin.
Photo by Andy Manis, manisphoto.com

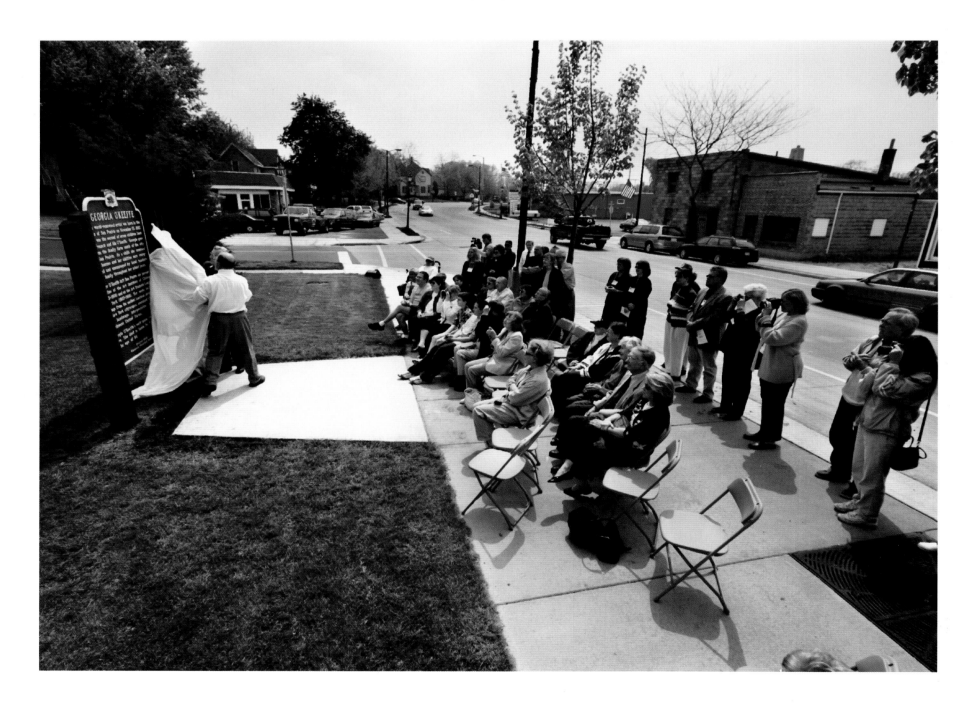

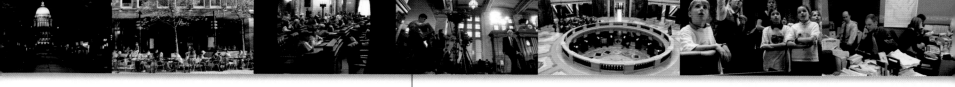

MILWAUKEE

News crews in Milwaukee City Hall await the star of a local scandal. Alderman Jeff Pawlinski (not shown) is about to make a resignation speech after pleading guilty to keeping campaign funds for himself and lying about it. He got eight months in prison.
Photo by Dale Guldan

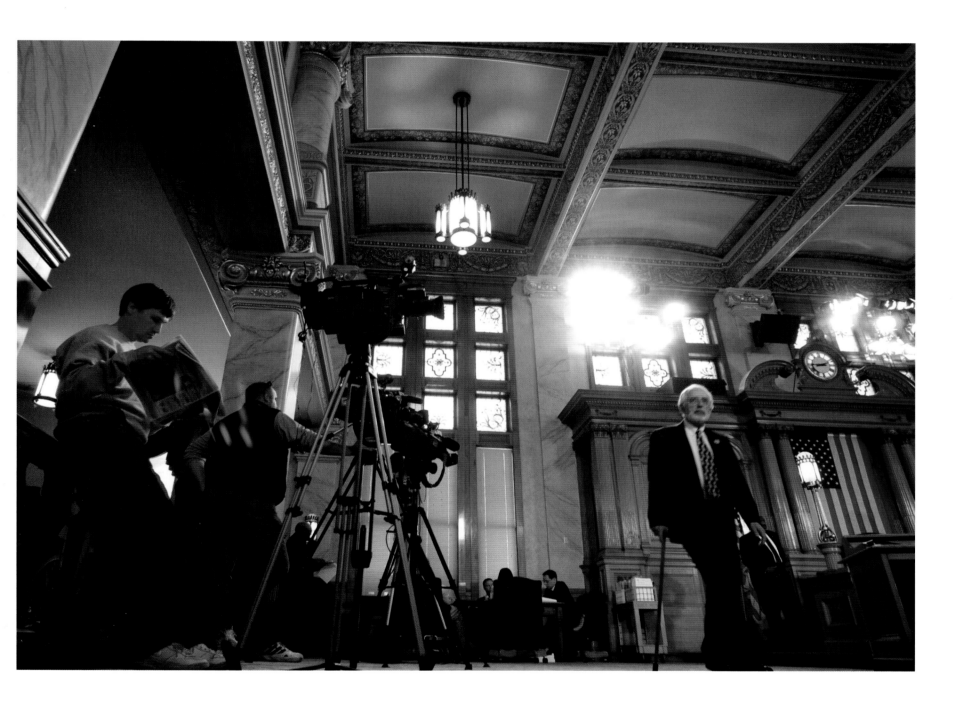

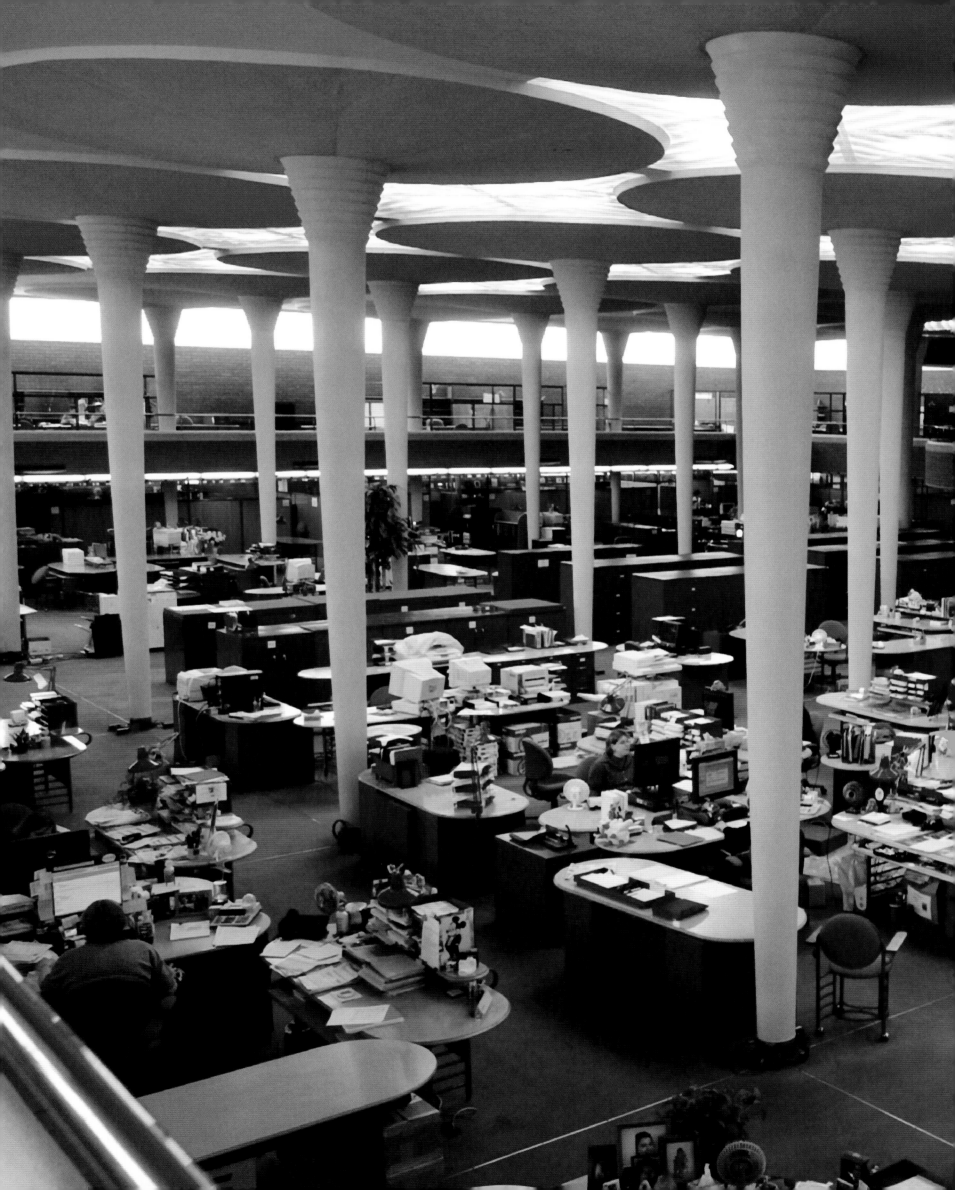

RACINE

The Great Workroom in the SC Johnson Administration Building was designed by Frank Lloyd Wright in 1936. In his own words, the architect aimed for "great simplicity." Wright attained his goal with flowing dendriform columns rising 25 feet in the air and spaced evenly across the half-acre floor.
Photo by Mark Hertzberg, The Journal Times

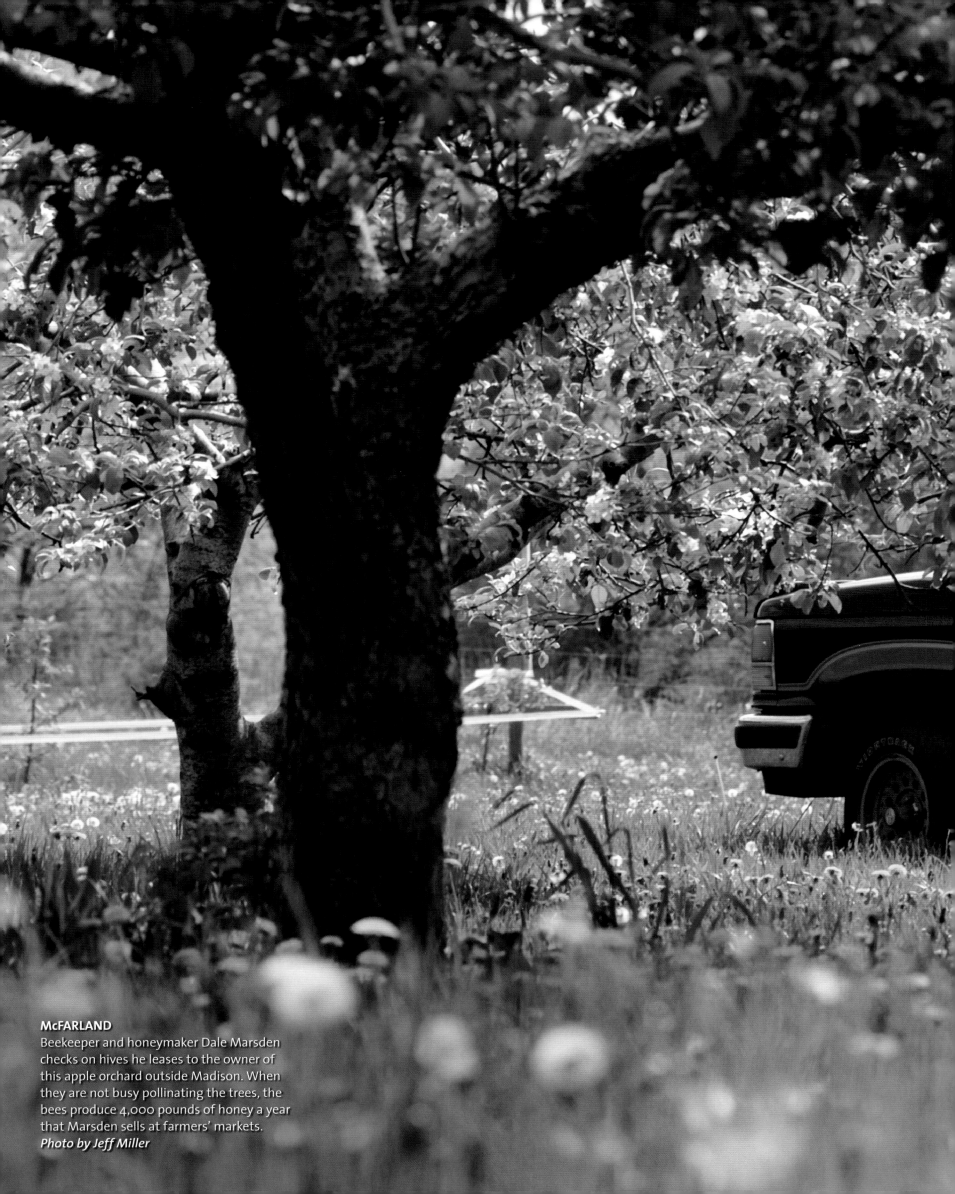

McFARLAND
Beekeeper and honeymaker Dale Marsden
checks on hives he leases to the owner of
this apple orchard outside Madison. When
they are not busy pollinating the trees, the
bees produce 4,000 pounds of honey a year
that Marsden sells at farmers' markets.
Photo by Jeff Miller

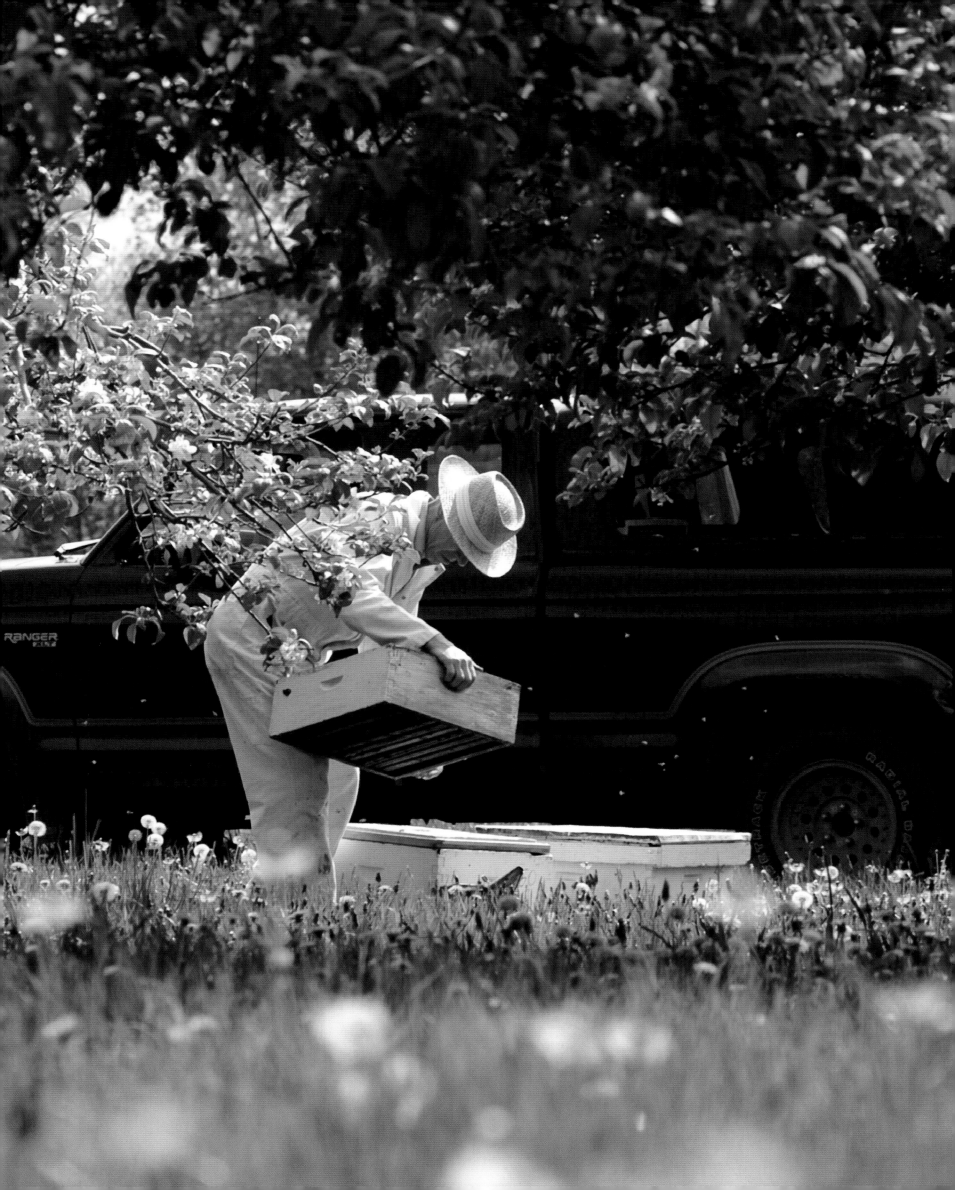

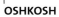

OSHKOSH
After six cold, dark months of winter, an ivy-laced window provides a pleasant distraction for students studying in Dempsey Hall at the University of Wisconsin.
Photo by Paul Stolen

FOUNTAIN CITY
Otis and Amelia keep an eye on their backyard domain, which slopes down to the Mississippi River and its barges heading for New Orleans.
Photo by Julie Geiger-Schutz

EGG HARBOR

Trilliums, the first voices in a symphony of color that arrives with spring, blanket a shaded lot. In a few weeks, starflower, bunchberry, jack-in-the-pulpit, wild columbine, and yellow lady's slipper will take center stage.
Photos by Jeffery Foss Davis

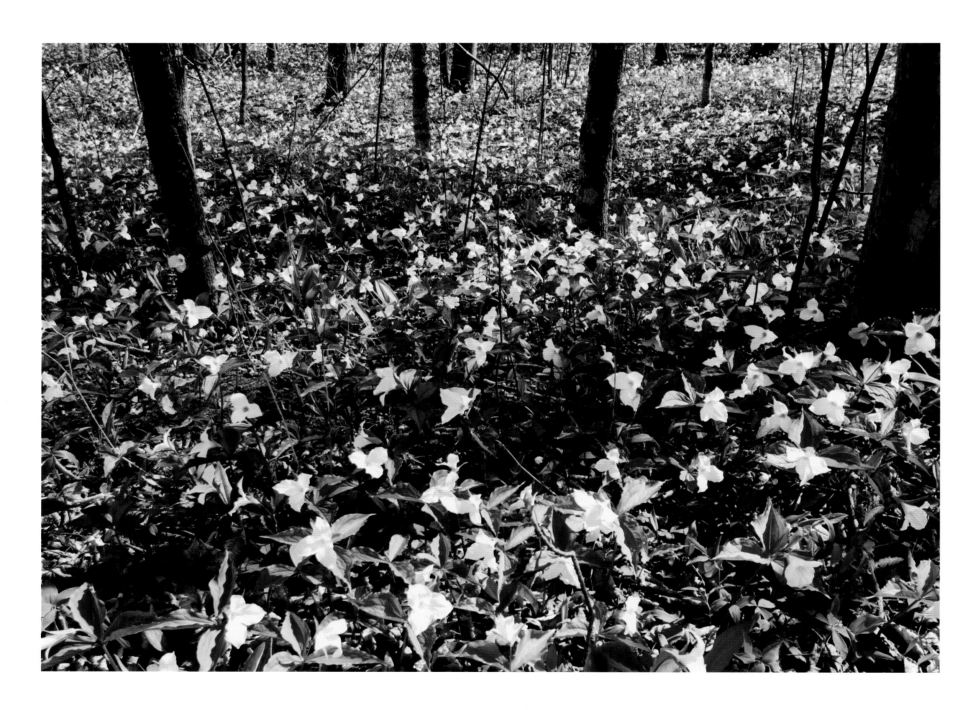

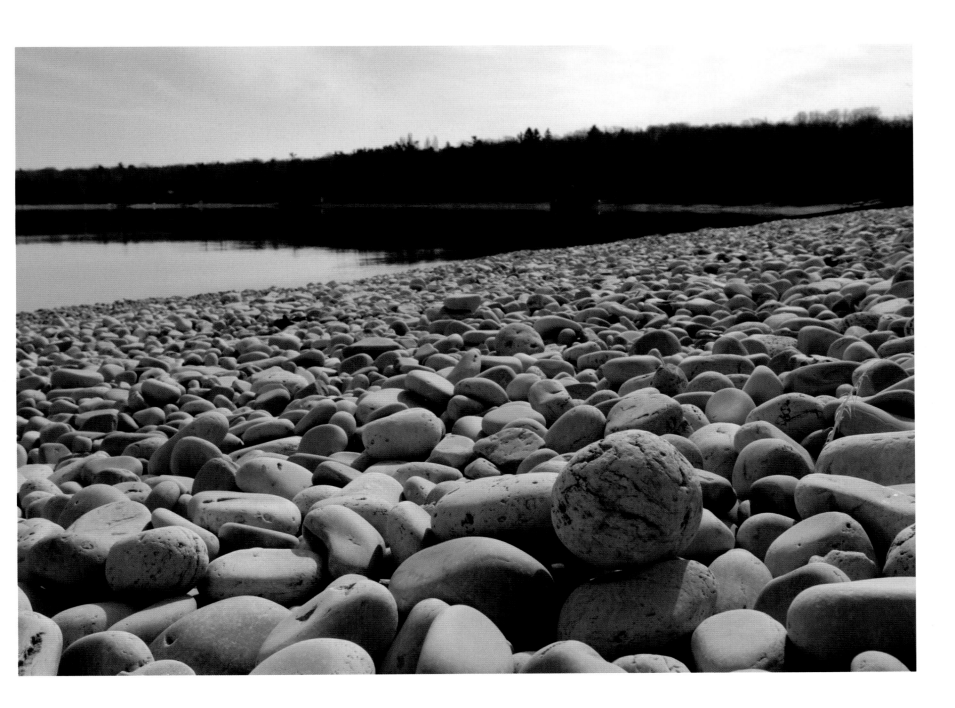

WASHINGTON ISLAND

An abrading glacier crumbled Door County's limestone bedrock into great boulders during its retreat 10,000 years ago. Lake Michigan's churning waters slowly ground the imposing rocks into tennis ball–size stones. Finally, a powerful current carried the rubble to Schoolhouse Beach, where slowly it continues to degrade. Someday it will become fine white sand.

WASHINGTON ISLAND
Lawyers may be considered bottom-feeders in some places, but only on Washington Island are they fried and eaten. Also known as eelpout or burbot, the Lake Michigan fish is served daily at the KK Fiske Restaurant.
Photo by Jeffery Foss Davis

MADISON
After decades as an industrial wrecker, Tom Every dubbed himself Dr. Evermor and started welding sculptures from the kinds of machinery he used to demolish. The *Dreamkeepers* contain, among other things, gears from Indiana Manufacturing (knees), tubing from a semi (legs), and springs from Overhead Door Springs of Chicago (eyelashes).
Photo by Callen Harty

MADISON
As locals know, that's not Myles Teddy-wedgers on drums. It's Mike Hess, who rented the unique apartment upstairs from Teddywedgers, a takeout place for meat-filled pastries.
Photo by Jeff Miller

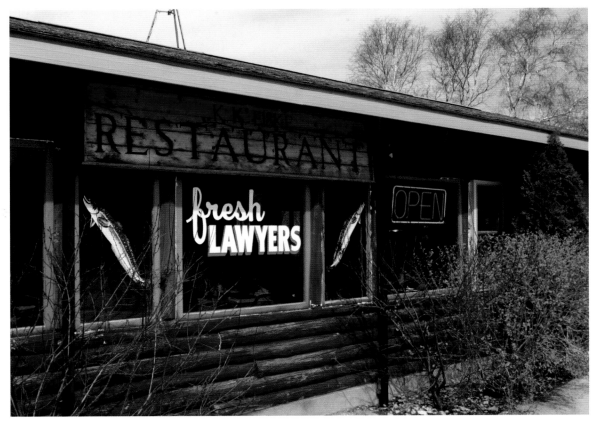

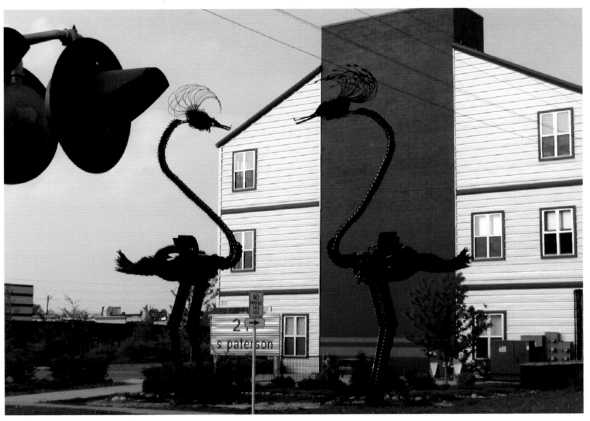

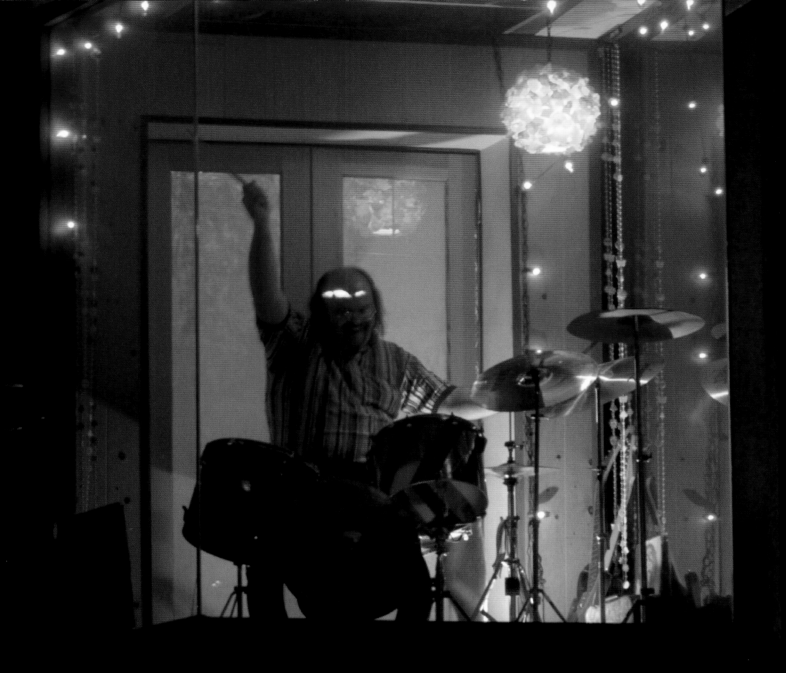

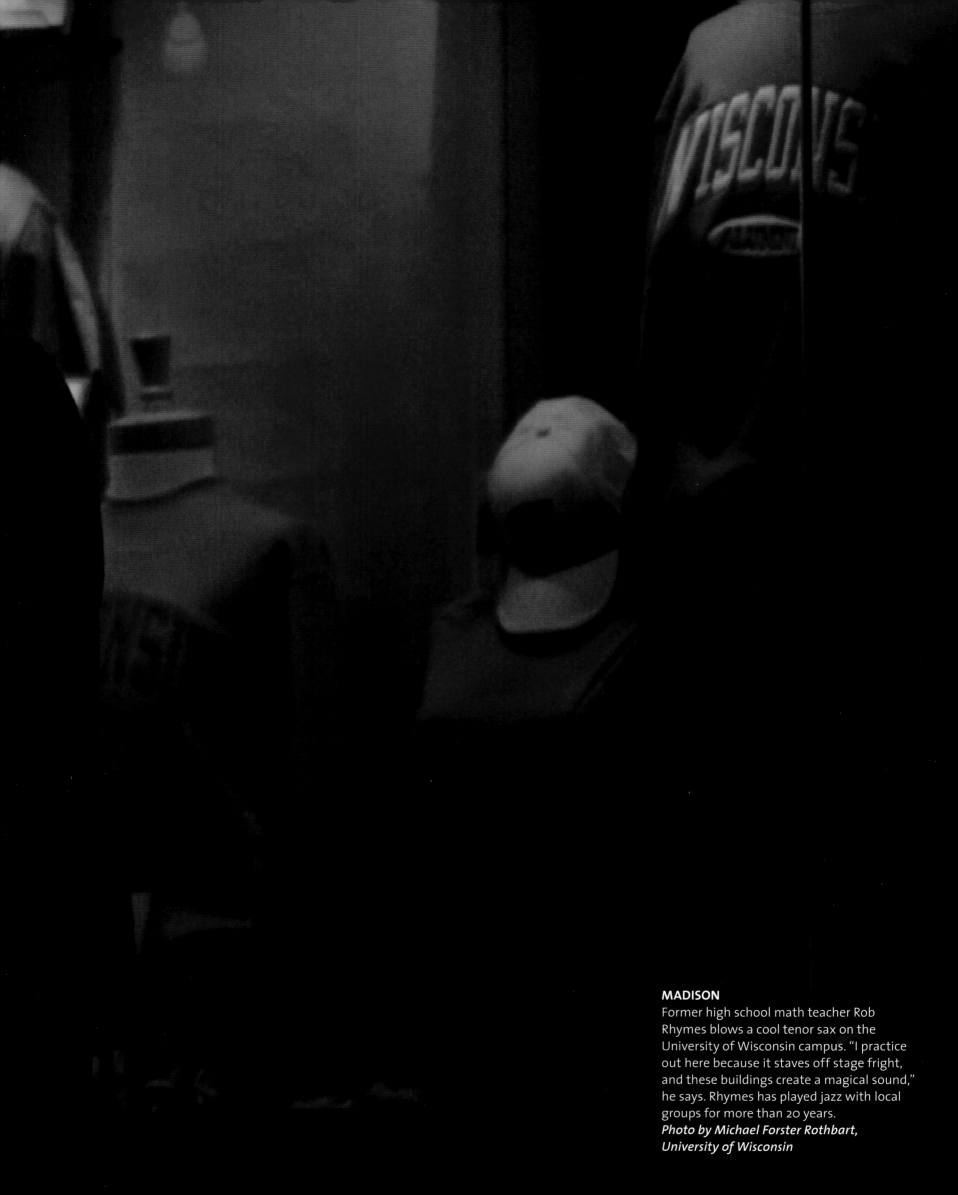

MADISON
Former high school math teacher Rob Rhymes blows a cool tenor sax on the University of Wisconsin campus. "I practice out here because it staves off stage fright, and these buildings create a magical sound," he says. Rhymes has played jazz with local groups for more than 20 years.
Photo by Michael Forster Rothbart, University of Wisconsin

LITTLE SAND BAY

One of the few remaining small commercial fishing boats on Lake Superior sits in dry dock. Finnish immigrants pioneered the industry in the 1890s. Since then, the lake's fish population has declined precipitously due to overfishing and the arrival of the parasitic sea lamprey.
Photo by Tom Lynn

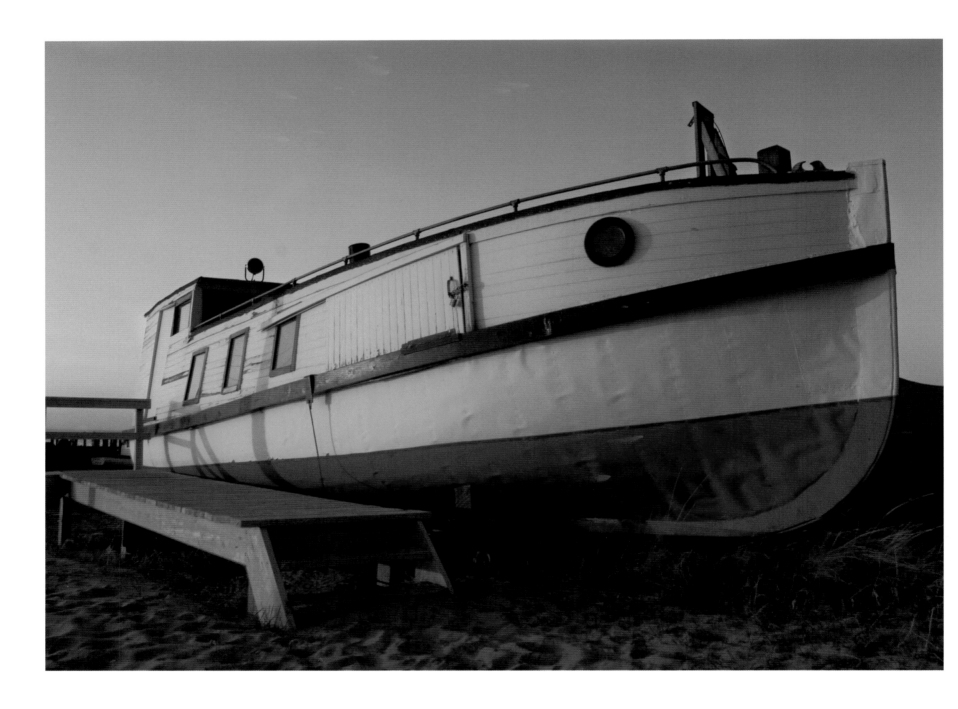

FISH CREEK

A peach sunset adjourns another day at the "Inland Cape Cod." By May, the storms, gale force winds, and snow flurries have subsided, and Peninsula State Park's seven miles of shoreline are once again a picture of tranquility.
Photo by Jeffery Foss Davis

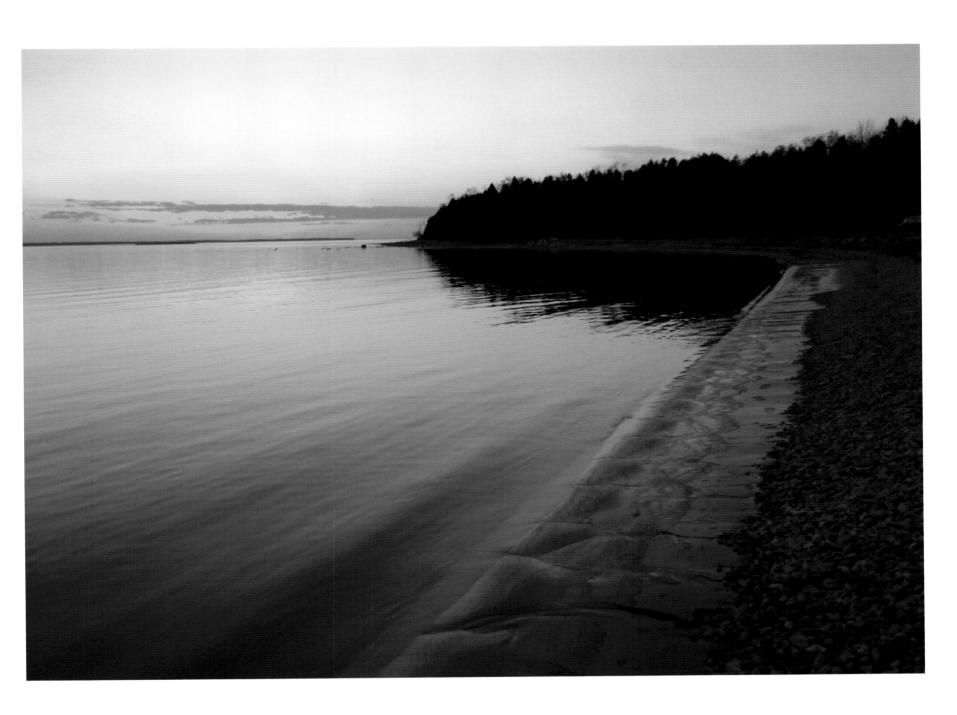

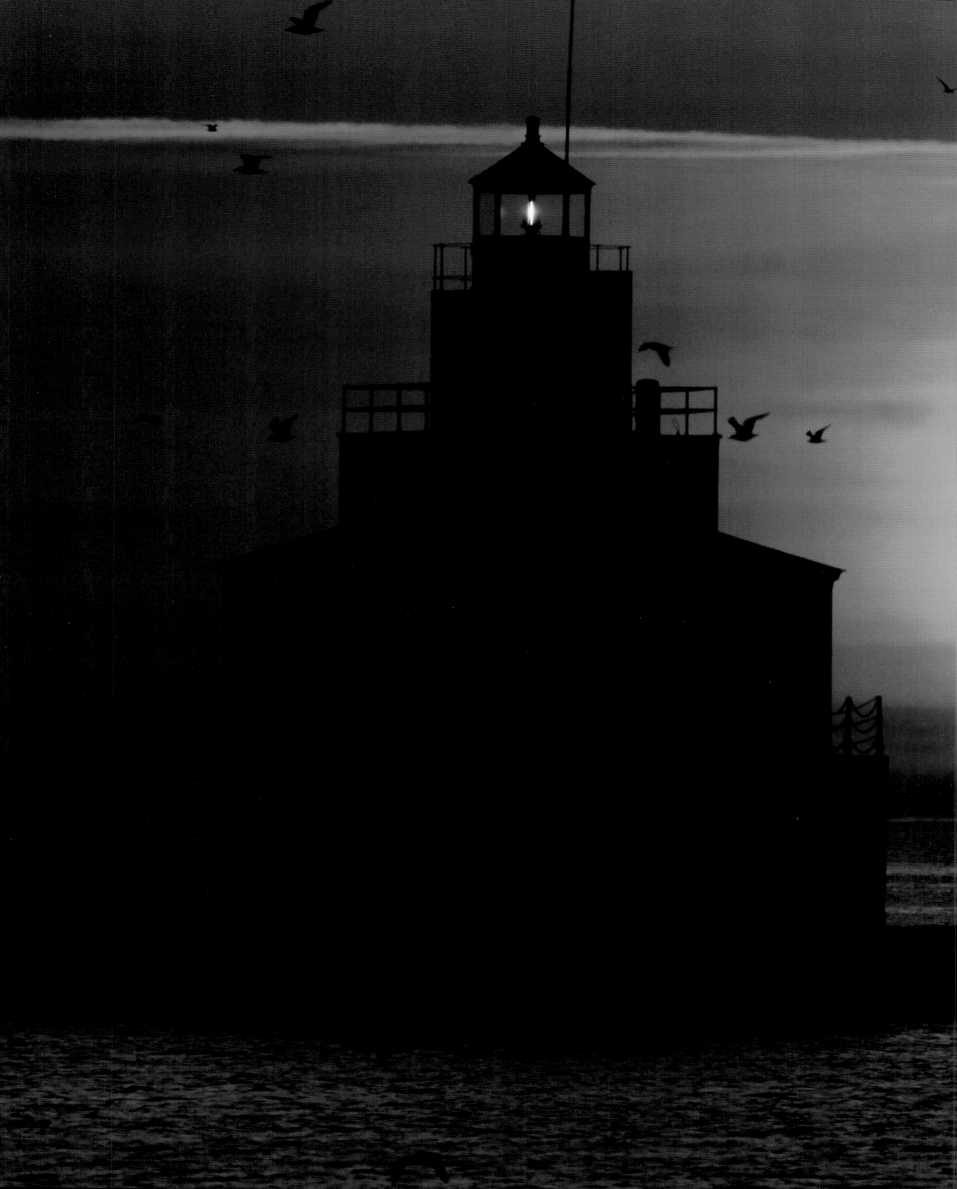

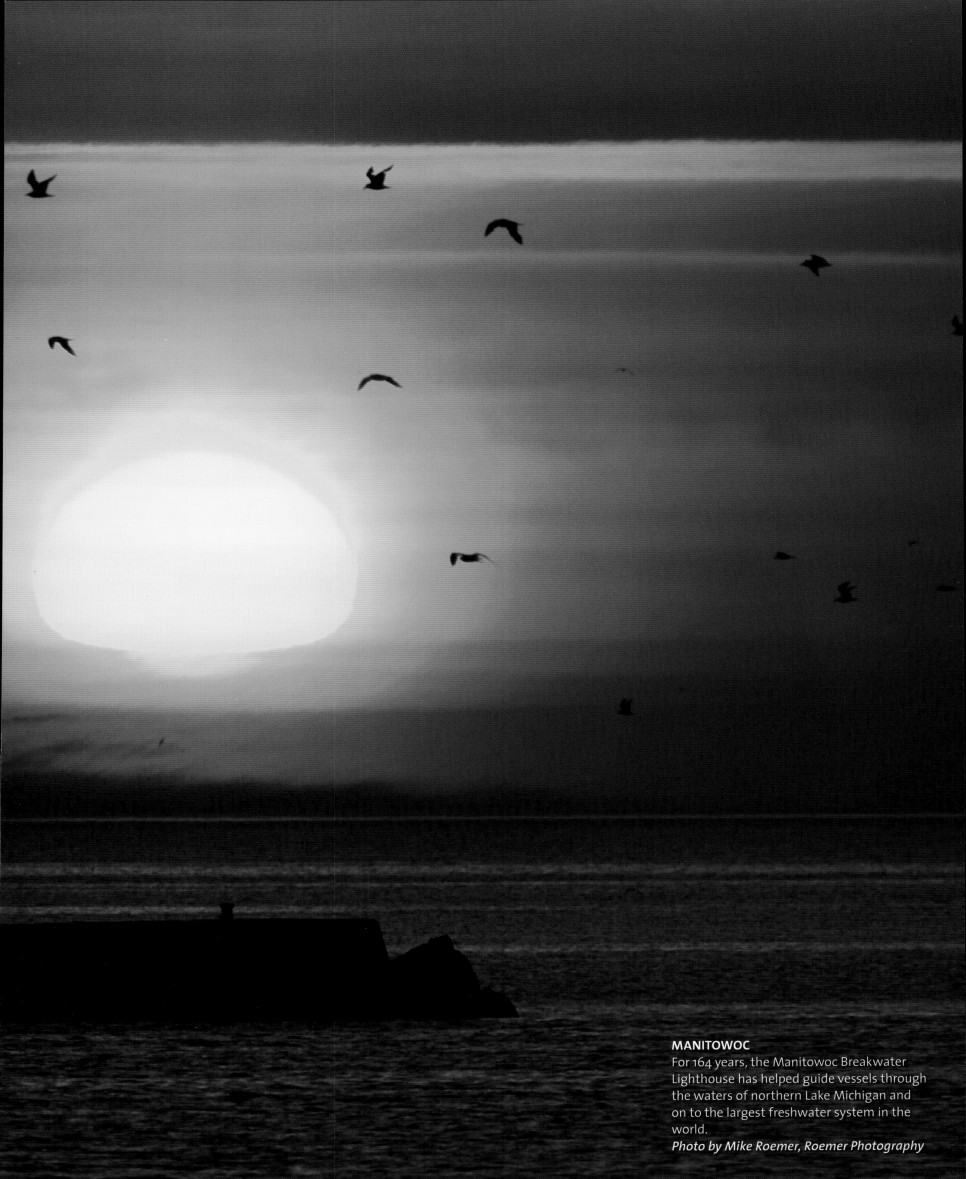

MANITOWOC
For 164 years, the Manitowoc Breakwater
Lighthouse has helped guide vessels through
the waters of northern Lake Michigan and
on to the largest freshwater system in the
world.
Photo by Mike Roemer, Roemer Photography

How It Worked

The week of May 12-18, 2003, more than 25,000 professional and amateur photographers spread out across the nation to shoot over a million digital photographs with the goal of capturing the essence of daily life in America.

The professional photographers were equipped with Adobe Photoshop and Adobe Album software, Olympus C-5050 digital cameras, and Lexar Media's high-speed compact flash cards.

The 1,000 professional contract photographers plus another 5,000 stringers and students sent their images via FTP (file transfer protocol) directly to the *America 24/7* website. Meanwhile, thousands of amateur photographers uploaded their images to Snapfish's servers.

At *America 24/7*'s Mission Control headquarters, located at CNET in San Francisco, dozens of picture editors from the nation's most prestigious publications culled the images down to 25,000 of the very best, using Photo Mechanic by Camera Bits. These photos were transferred into Webware's ActiveMedia Digital Asset Management (DAM) system, which served as a central image library and enabled the designers to track, search, distribute, and reformat the images for the creation of the 51 books, foreign language editions, web and magazine syndication, posters, and exhibitions.

Once in the DAM, images were optimized (and in some cases resampled to increase image resolution) using Adobe Photoshop. Adobe InDesign and Adobe InCopy were used to design and produce the 51 books, which were edited and reviewed in multiple locations around the world in the form of Adobe Acrobat PDFs. Epson Stylus printers were used for photo proofing and to produce large-format images for exhibitions. The companies providing support for the *America 24/7* project offer many of the essential components for anyone building a digital darkroom. We encourage you to read more on the following pages about their respective roles in making *America 24/7* possible.

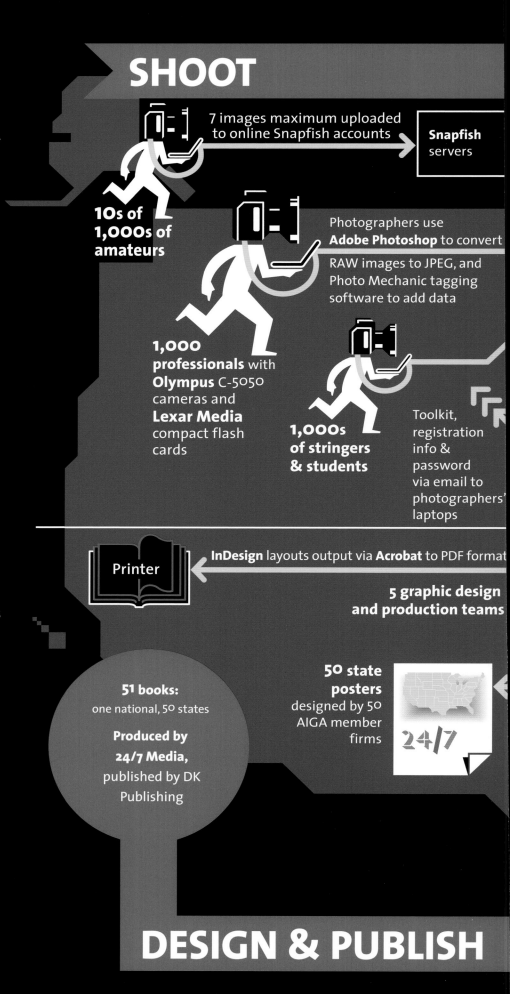

SHOOT

7 images maximum uploaded to online Snapfish accounts → **Snapfish** servers

10s of 1,000s of amateurs

Photographers use **Adobe Photoshop** to convert RAW images to JPEG, and Photo Mechanic tagging software to add data

1,000 professionals with **Olympus** C-5050 cameras and **Lexar Media** compact flash cards

1,000s of stringers & students

Toolkit, registration info & password via email to photographers' laptops

Printer

InDesign layouts output via **Acrobat** to PDF format

5 graphic design and production teams

51 books: one national, 50 states

Produced by 24/7 Media, published by DK Publishing

50 state posters designed by 50 AIGA member firms

24/7

DESIGN & PUBLISH

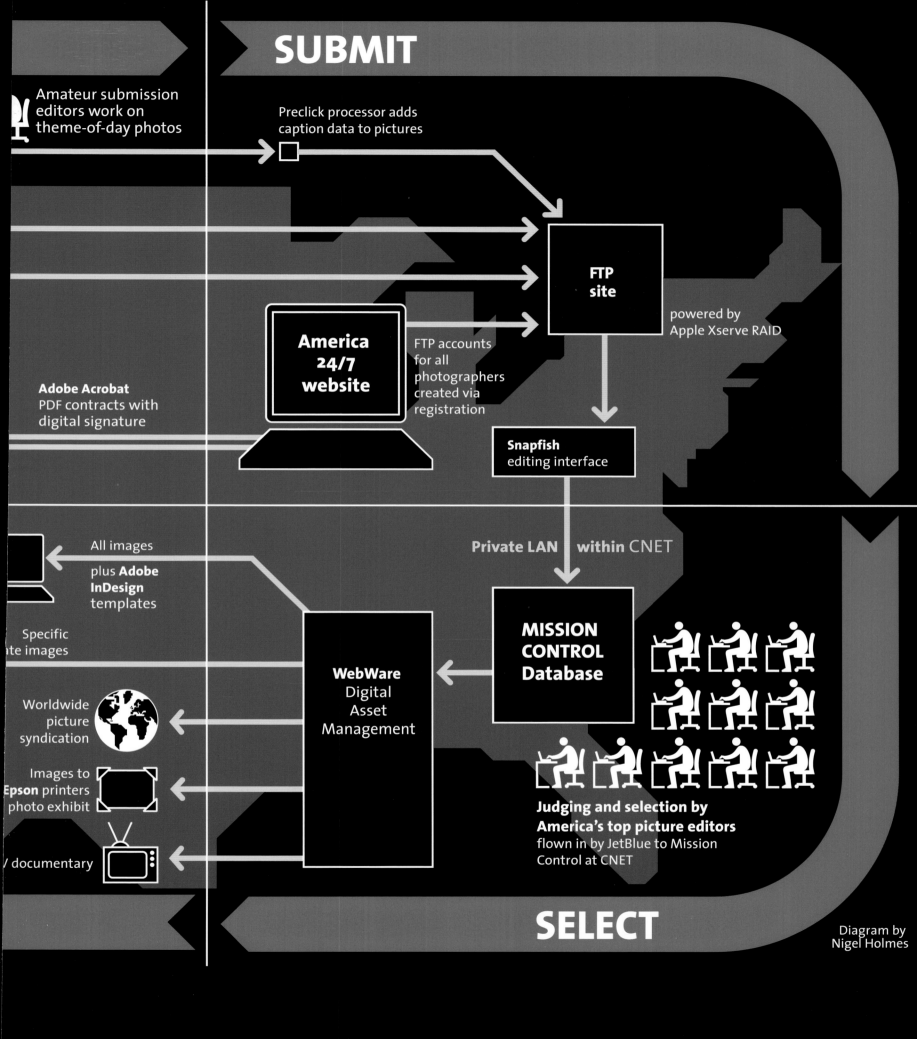

SUBMIT

Amateur submission editors work on theme-of-day photos

Preclick processor adds caption data to pictures

FTP site

powered by Apple Xserve RAID

America 24/7 website

FTP accounts for all photographers created via registration

Adobe Acrobat PDF contracts with digital signature

Snapfish editing interface

All images plus **Adobe InDesign** templates

Private LAN within CNET

Specific ate images

WebWare Digital Asset Management

MISSION CONTROL Database

Worldwide picture syndication

Images to **Epson** printers photo exhibit

/ documentary

Judging and selection by America's top picture editors flown in by JetBlue to Mission Control at CNET

SELECT

Diagram by Nigel Holmes

Wisconsin 24/7

About Our Sponsors

America 24/7 gave digital photographers of all levels the opportunity to share their visions of what it means to live in the United States. This project was made possible by a digital photography revolution that is dramatically changing and improving picture-taking for professionals and amateurs alike. And an Adobe product, Photoshop®, has been at the center of this sea change.

Adobe's products reflect our customers' passion for the creative process, be it the photographer, graphic designer, layout artist, or printer. Adobe is the Publishing and Imaging Software Partner for America 24/7 and products such as Adobe InDesign®, Photoshop, Acrobat®, and Illustrator® were used to produce this stunning book in a matter of weeks. We hope that our software has helped do justice to the mythic images, contributed by well-known photographers and the inspired hobbyist.

Adobe is proud to be a lead sponsor of America 24/7, a project that celebrates the vibrancy of the American spirit: the same spirit that helped found Adobe and inspires our employees and customers to deliver the very best.

Bruce Chizen
President and CEO
Adobe Systems Incorporated

Olympus, a global technology leader in designing precision healthcare solutions and innovative consumer electronics, is proud to be the official digital camera sponsor of America 24/7. The opportunity to introduce Americans from coast to coast to the thrill, excitement, and possibility of digital photography makes the vision behind this book a perfect fit for Olympus, a leader in digital cameras since 1996.

For most people, the essence of digital photography is best grasped through firsthand experience with the technology, which is precisely what America 24/7 is about. We understand that direct experience is the pathway to inspiration, and welcome opportunities like this sponsorship to bring the power of the digital experience into the lives of people everywhere. To Olympus, America 24/7 offers a platform to help realize a core mission: to deliver and make accessible the power of the digital experience to millions of American photographers, amateurs, and professionals alike.

The 1,000 professional photographers contracted to shoot on the America 24/7 project were all equipped with Olympus C-5050 digital cameras. Like all Olympus products, the C-5050 is offered by a company well known for designing, manufacturing, and servicing products used by professionals to perform their work, every day. Olympus is a customer-centric company committed to working one-to-one with a diverse group of professionals. From biomedical researchers who use our clinical microscopes, to doctors who perform life-saving procedures with our endoscopes, to professional photographers who use cameras in their daily work, Olympus is a trusted brand.

The digital imaging technology involved with America 24/7 has enabled the soul of America to be visually conveyed, not just by professional observers, but by the American public who participated in this project—the very people who collectively breath life into this country's existence each day.

We are proud to be enabling so many photographers to capture the pictures on these pages that tell the story of who we are as a nation. From sea to shining sea, digital imagery allows us to connect to one another in ways we never dreamed possible.

At Olympus, our ideas have proliferated as rapidly as technology has evolved. We have channeled these visions into breakthrough products and solutions to meet the demands of our changing world-products like microscopes, endoscopes, and digital voice recorders, supported by the highly regarded training, educational, and consulting services we offer our customers.

Today, 83 years after we introduced our first microscope, we remain as young, as curious, and as committed as ever.

Lexar Media has grown from the digital photography revolution, which is why we are proud to have supplied the digital memory cards used in the America 24/7 project. Lexar Media's high-performance memory cards utilize our unique and patented controller coupled with high-speed flash memory from Samsung, the world's largest flash memory supplier. This powerful combination brings out the ultimate performance of any digital camera.

Photographers who demand the most from their equipment choose our products for their advanced features like write speeds up to 40X, Write Acceleration technology for enabled cameras, and Image Rescue, which recovers previously deleted or lost images. Leading camera manufacturers bundle Lexar Media digital memory cards with their cameras because they value its performance and reliability.

Lexar Media is at the forefront of digital photography as it transforms picture-taking worldwide, and we will continue to be a leader with new and innovative solutions for professionals and amateurs alike.

Snapfish, which developed the technology behind the *America 24/7* amateur photo event, is a leading online photo service, with more than 5 million members and 100 million photos posted online. Snapfish enables both film and digital camera owners to share, print, and store their most important photo memories, at prices that cannot be equaled. Digital camera users upload photos into a password-protected online album for free. Users can also order film-quality prints on professional photographic paper for as low as 25¢. Film camera users get a full set of prints, plus online sharing and storage, for just $2.99 per roll.

Founded in 1995, eBay created a powerful platform for the sale of goods and services by a passionate community of individuals and businesses. On any given day, there are millions of items across thousands of categories for sale on eBay. eBay enables trade on a local, national and international basis with customized sites in markets around the world.

Through an array of services, such as its payment solution provider PayPal, eBay is enabling global e-commerce for an ever-growing online community.

JetBlue Airways is proud to be *America 24/7's* preferred carrier, flying photographers, photo editors, and organizers across the United States.

Winner of Condé Nast Traveler's Readers' Choice Awards for Best Domestic Airline 2002, JetBlue provides friendly service and low fares for travelers in 22 cities in nine states across America.

On behalf of JetBlue's 5,000 crew members, we're excited to be involved in this remarkable project, and for the opportunity to serve American travelers each and every day, coast to coast, 24/7.

DIGITAL POND

Digital Pond has been a leading creator of large graphic displays for museums, corporations, trade shows, retail environments and fine art since 1992.

We were proud to bring together our creative, print and display capabilities to produce signage and displays for mission control, critical retouching for numerous key images for the book, and art galleries for the New York Public Library and Bryant Park.

The Pond's team and SplashPic® Online service enabled us to nimbly design, produce and install over 200 large graphic panels in two NYC locations within the truly "24/7" production schedule of less than ten days.

WebWare Corporation is pleased to be a major sponsor of the America 24/7 project. We take pride in being part of a groundbreaking adventure that is stretching the boundaries—and the imagination—in digital photography, digital asset management, publishing, news, and global events.

Our ActiveMedia Enterprise™ digital asset management software is the "nerve center" of *America 24/7*, the central repository for managing, sharing, and collaborating on the project's photographs. From photo editors and book publishers to 24/7's media relations and marketing personnel, ActiveMedia provides the application support that links all facets of the project team to the content worldwide.

WebWare helps Global 2000 firms securely manage, reuse, and distribute media assets locally or globally. Its suite of ActiveMedia software products provide powerful media services platforms for integrating rich media into content management systems marketing and communication portals; web publishing systems; and e-commerce portals.

Google™

Google's mission is to organize the world's information and make it universally accessible and useful.

With our focus on plucking just the right answer from an ocean of data, we were naturally drawn to the America 24/7 project. The book you hold is a compendium of images of American life distilled from thousands of photographs and infinite possibilities. Are you looking for emotion? Narrative? Shadows? Light? It's all here, thanks to a multitude of photographers and writers creating links between you, the reader, and a sea of wonderful stories. We celebrate the connections that constitute the human experience and are pleased to help engender them. And we're pleased to have been a small part of this project, which captures the results of that interaction so vividly, so dynamically, and so dramatically.

Special thanks to additional contributors: FileMaker, Apple, Camera Bits, LaCie, Now Software, Preclick, Outpost Digital, Xerox, Microsoft, WoodWing Software, net-linx Publishing Solutions, and Radical Media. The Savoy Hotel, San Francisco; The Pan Pacific, San Francisco; Four Seasons Hotel, San Francisco; and The Queen Anne Hotel. Photography editing facilities were generously hosted by CNET Networks, Inc.

Participating Photographers

Wisconsin Coordinator: Mark Hertzberg, Director of Photography, *The Journal Times*

Brad Allen
Scott C. Anderson
Steve Apps, *Wisconsin State Journal*
James Benson
Eric Bertun
Janet Buckner
Bruce Caucutt
Tim Dardis
Jeffery Foss Davis
Mark Derse Photography
David Dunai
Michael Forster Rothbart,
University of Wisconsin
Antonio Garza
Julie Geiger-Schutz
Carol Glaman
Dale Guldan
Callen Harty
Darren Hauck
Mark Hertzberg, *The Journal Times*

Craig A. Irvine
Stephanie Judge
Ron Kuenstler
Jay Langhurst
Stephen D. Levin
Kris Lorentzsen
Michael Lutzenberger
Tom Lynn
Lisa Majkrzak
Andy Manis, manisphoto.com
Buck Miller
Jeff Miller
Mary Pollock
Gary W. Porter
Michelle Demian Powers
Dan Reiland
Mike Roemer, Roemer Photography
Gregory Shaver
Paul Stolen
Jill Stolt Photography

Thumbnail Picture Credits

Credits for thumbnail photographs are listed by the page number and are in order from left to right.

20 Gregory Shaver
Gregory Shaver
Jeff Miller
Buck Miller
Gregory Shaver
Mike Roemer, Roemer Photography
Gregory Shaver

21 David Dunai
Ron Kuenstler
Lynda D. Botez
Mike Roemer, Roemer Photography
Mike Roemer, Roemer Photography
Jeffery Foss Davis
Valerie Joy Hein

22 Gregory Shaver
Andy Manis, manisphoto.com
David Dunai
Dan Reiland
Gregory Shaver
Antonio Garza
Gregory Shaver

23 James G. Brey
Gary W. Porter
Gregory Shaver
R. Jacobson
Mike Roemer, Roemer Photography
Mark Hertzberg, *The Journal Times*
Ron Kuenstler

27 Julie Geiger-Schutz
Julie Geiger-Schutz
Gary W. Porter
Buck Miller
Julie Geiger-Schutz
Gregory Shaver
Buck Miller

30 Buck Miller
Jeff Miller
Buck Miller
Lynda D. Botez
Tim Dardis
Jeff Miller
Callen Harty

31 Gary W. Porter
Kris Lorentzsen
Jeffery Foss Davis
Tim Dardis
Jeff Miller
Buck Miller
Ron Kuenstler

32 Callen Harty
Jeff Miller
Callen Harty
Andy Manis, manisphoto.com
Jeff Miller
Daryl Frank
Dan Reiland

33 Mark Hertzberg, *The Journal Times*
Gregory Shaver
Jeff Miller
Jeff Miller
Jeff Miller
Jeffery Foss Davis
Michael Forster Rothbart,
University of Wisconsin

36 Andy Manis, manisphoto.com
Andy Manis, manisphoto.com
Michelle Demian Powers
Andy Manis, manisphoto.com
Andy Manis, manisphoto.com
Michelle Demian Powers
Michael Forster Rothbart,
University of Wisconsin

37 Andy Manis, manisphoto.com
Michael Forster Rothbart,
University of Wisconsin
Michael Forster Rothbart,
University of Wisconsin
Steve Apps, *Wisconsin State Journal*
Michael Forster Rothbart,
University of Wisconsin
Michael Forster Rothbart,
University of Wisconsin
Michael Forster Rothbart,
University of Wisconsin

40 David Dunai
Margaret M. Savino
Gregory Shaver
David Dunai
Gregory Shaver
David Dunai
Tom Lynn

41 David Dunai
Gregory Shaver
Gregory Shaver
Gregory Shaver
Gregory Shaver
Gregory Shaver
Heather Lim

42 Jill Stolt Photography
Jeff Miller
Mark Hertzberg, *The Journal Times*
Jeff Miller
Lynda D. Botez
Jeffery Foss Davis
Lynda D. Botez

43 Michael Forster Rothbart,
University of Wisconsin
Jeff Miller
Lynda D. Botez
Lynda D. Botez
Jeff Miller
Lynda D. Botez
Mark Hertzberg, *The Journal Times*

44 Brad Allen
Gregory Shaver
Matthew Adam Wensing
Gregory Shaver
Gary W. Porter
Brad Allen
Gregory Shaver

45 Jeffery Foss Davis
Jeff Miller
Jeffery Foss Davis
Kris Lorentzsen
Steve Apps, *Wisconsin State Journal*
David Dunai
Mark Derse Photography

54 Darren Hauck
Darren Hauck
Darren Hauck
David Dunai
David Dunai
David Dunai
David Dunai

56 Stephen D. Levin
Brad Allen

Brad Allen
Brad Allen
Brad Allen
Buck Miller
Buck Miller

57 Scott C. Anderson
Jill Stolt Photography
Mark Derse Photography
Mark Hertzberg, *The Journal Times*
Dan Reiland
Jill Stolt Photography
Scott C. Anderson

58 Julie Geiger-Schutz
Jeff Miller
Andy Manis, manisphoto.com
Andy Manis, manisphoto.com
Andy Manis, manisphoto.com
Dale Guldan
Julie Geiger-Schutz

59 Julie Geiger-Schutz
Lynda D. Botez
Mike Roemer, Roemer Photography
Mike Roemer, Roemer Photography
Mike Roemer, Roemer Photography
Stephen D. Levin
Mark Derse Photography

62 Darren Hauck
Christine A. Verstraete
Callen Harty
Mark Derse Photography
Mark Derse Photography
Jeffery Foss Davis
Dale Guldan

63 Mike Roemer, Roemer Photography
Jeffery Foss Davis
Steve Apps, *Wisconsin State Journal*
Mike Roemer, Roemer Photography
Jeffery Foss Davis
Steve Apps, *Wisconsin State Journal*
Jeffery Foss Davis

64 Michael Forster Rothbart,
University of Wisconsin
Michael Forster Rothbart,
University of Wisconsin
Callen Harty
Mark Derse Photography
Mark Derse Photography
Julie Geiger-Schutz
Mark Derse Photography

65 Mark Derse Photography
Brad Allen
Mark Derse Photography
Brad Allen
Heather Lim
Mark Derse Photography
Brad Allen

68 Darren Hauck
Jeff Miller
Dale Guldan
Darren Hauck
Dale Guldan
Darren Hauck
Dale Guldan

69 Darren Hauck
Jeffery Foss Davis
Jeff Miller
Darren Hauck
Darren Hauck
Jeffery Foss Davis
Jeff Miller

71 Buck Miller
Buck Miller
Buck Miller
Buck Miller
Gary W. Porter
Gary W. Porter
Gary W. Porter

74 Buck Miller
Buck Miller
Buck Miller
Buck Miller
Mike Roemer, Roemer Photography
Buck Miller
Mike Roemer, Roemer Photography

75 Mike Roemer, Roemer Photography
Buck Miller
Buck Miller
Mike Roemer, Roemer Photography
Mike Roemer, Roemer Photography
Mike Roemer, Roemer Photography
Mike Roemer, Roemer Photography

77 Mark Derse Photography
Mark Hertzberg, *The Journal Times*
Mark Hertzberg, *The Journal Times*
Mark Hertzberg, *The Journal Times*
Mark Derse Photography
Mark Hertzberg, *The Journal Times*
Steve Apps, *Wisconsin State Journal*

82 Mike Roemer, Roemer Photography
Callen Harty
Mark Hertzberg, *The Journal Times*
Buck Miller
Jeff Miller
Mike Roemer, Roemer Photography
Mike Roemer, Roemer Photography

83 Mike Roemer, Roemer Photography
Mike Roemer, Roemer Photography
Mike Roemer, Roemer Photography
Mike Roemer, Roemer Photography
Mike Roemer, Roemer Photography
Mike Roemer, Roemer Photography
Mark Hertzberg, *The Journal Times*

84 Buck Miller
Julie Geiger-Schutz
Ron Kuenstler
Ron Kuenstler
Jeffery Foss Davis
Jeffery Foss Davis
Stephen D. Levin

85 Heather Lim
Craig A. Irvine
Ron Kuenstler
Ron Kuenstler
Kris Lorentzsen
Ron Kuenstler
Ron Kuenstler

86 Andy Manis, manisphoto.com
Jed Carlson
Andy Manis, manisphoto.com
Andy Manis, manisphoto.com
Andy Manis, manisphoto.com
Heather Lim
Heather Lim

87 Jeffery Foss Davis
Brad Allen
Mike Roemer, Roemer Photography
Jeffery Foss Davis
Jeffery Foss Davis
Jeffery Foss Davis
Cory Morse, *Muskegon Chronicle*

90 Gregory Shaver
Gregory Shaver
Gregory Shaver
Gregory Shaver
Gregory Shaver
Joey Wallis
Mark Derse Photography

91 Ron Kuenstler
Mark Derse Photography
Mark Derse Photography
Mark Derse Photography
Mark Derse Photography
Gregory Shaver
Ron Kuenstler

92 Brad Allen
Brad Allen
Dale Guldan
Brad Allen
Stephen D. Levin
Mark Derse Photography
Mark Hertzberg, *The Journal Times*

93 Mark Derse Photography
Stephen D. Levin
Mark Derse Photography
Brad Allen
Brad Allen
Brad Allen
Tim Dardis

97 Michael Forster Rothbart,
University of Wisconsin
Dale Guldan
Dan Reiland
James G. Brey
Jeff Miller
Michael Forster Rothbart,
University of Wisconsin
Jeff Miller

100 Jeff Miller
Gregory Shaver
Jeff Miller
Scott C. Anderson
Jeff Miller
Jeff Miller
Jeff Miller

107 Mark Derse Photography
Mark Hertzberg, *The Journal Times*
Mark Derse Photography
Mark Derse Photography

Mark Derse Photography
Mark Derse Photography
Mark Hertzberg, *The Journal Times*

113 Jeffery Foss Davis
Mark Hertzberg, *The Journal Times*
Mike Roemer, Roemer Photography
Mark Hertzberg, *The Journal Times*
Jeffery Foss Davis
Mark Hertzberg, *The Journal Times*
Mark Hertzberg, *The Journal Times*

114 Jeffery Foss Davis
Antonio Garza
Jeff Miller
Dale Guldan
Jeff Miller
Margaret M. Savino
Jeff Miller

115 Margaret M. Savino
Margaret M. Savino
Antonio Garza
Margaret M. Savino
Jeff Miller
Margaret M. Savino
Antonio Garza

120 Andy Manis, manisphoto.com
Tim Dardis
Andy Manis, manisphoto.com
Lynda D. Botez
Scott C. Anderson
Buck Miller
Steve Apps, *Wisconsin State Journal*

126 Jill Stolt Photography
Jeffery Foss Davis
Callen Harty
Mark Hertzberg, *The Journal Times*
Callen Harty
Tim Dardis
Mary Langenfeld

130 Callen Harty
Dan Reiland
Dan Reiland
Margaret M. Savino
Dan Reiland
Tim Dardis
Julie Geiger-Schutz

131 Jeff Miller
Jeff Miller
Dan Reiland
Julie Geiger-Schutz
Dan Reiland
Jeffery Foss Davis
Mark Derse Photography

135 Callen Harty
Callen Harty
Callen Harty
Callen Harty
Callen Harty
Stephen D. Levin
Callen Harty

136 Andy Manis, manisphoto.com
Buck Miller
Jill Stolt Photography
Andy Manis, manisphoto.com

Michael Forster Rothbart,
University of Wisconsin
Lynda D. Botez
Mark Hertzberg, *The Journal Times*

137 Steve Apps, *Wisconsin State Journal*
Steve Apps, *Wisconsin State Journal*
Steve Apps, *Wisconsin State Journal*
Dale Guldan
Steve Apps, *Wisconsin State Journal*
Steve Apps, *Wisconsin State Journal*
Steve Apps, *Wisconsin State Journal*

143 Antonio Garza
Paul Stolen
Ron Kuenstler
Gregory Shaver
Julie Geiger-Schutz
Tom Lynn
Gregory Shaver

144 Dan Reiland
Callen Harty
Jeffery Foss Davis
Gregory Shaver
Julie Geiger-Schutz
Jeffery Foss Davis
Jeffery Foss Davis

145 Jeffery Foss Davis
Mike Roemer, Roemer Photography
Jeffery Foss Davis
Jeffery Foss Davis
Valerie Joy Hein
Mike Roemer, Roemer Photography
Jeffery Foss Davis

146 Callen Harty
Jeffery Foss Davis
Mike Roemer, Roemer Photography
Callen Harty
Steve Apps, *Wisconsin State Journal*
Jeff Miller
Jeffery Foss Davis

150 Jeffery Foss Davis
Jeffery Foss Davis
Scott C. Anderson
Tom Lynn
Mike Roemer, Roemer Photography
Stephen D. Levin
Tom Lynn

151 Tom Lynn
Mike Roemer, Roemer Photography
Stephen D. Levin
Jeffery Foss Davis
Stephen D. Levin
Mark Derse Photography
Scott C. Anderson

Staff

The *America 24/7* series was imagined years ago by our friend Oscar Dystel, a publishing legend whose vision and enthusiasm have been a source of great inspiration.

We also wish to express our gratitude to our truly visionary publisher, DK.

Rick Smolan, Project Director
David Elliot Cohen, Project Director

Administrative
Katya Able, Operations Director
Gina Privitere, Communications Director
Chuck Gathard, Technology Director
Kim Shannon, Photographer Relations Director
Erin O'Connor, Photographer Relations Intern
Leslie Hunter, Partnership Director
Annie Polk, Publicity Manager
John McAlester, Website Manager
Alex Notides, Office Manager
C. Thomas Hardin, State Photography Coordinator

Design
Brad Zucroff, Creative Director
Karen Mullarkey, Photography Director
Judy Zimola, Production Manager
David Simoni, Production Designer
Mary Dias, Production Designer
Heidi Madison, Associate Picture Editor
Don McCartney, Production Designer
Diane Dempsey Murray, Production Designer
Jan Rogers, Associate Picture Editor
Bill Shore, Production Designer and Image Artist
Larry Nighswander, Senior Picture Editor
Bill Marr, Sarah Leen, Senior Picture Editors
Peter Truskier, Workflow Consultant
Jim Birkenseer, Workflow Consultant

Editorial
Maggie Canon, Managing Editor
Curt Sanburn, Senior Editor
Teresa L. Trego, Production Editor
Lea Aschkenas, Writer
Olivia Boler, Writer
Korey Capozza, Writer
Beverly Hanly, Writer
Bridgett Novak, Writer
Alison Owings, Writer
Fred Raker, Writer
Joe Wolff, Writer
Elise O'Keefe, Copy Chief
Daisy Hernández, Copy Editor
Jennifer Wolfe, Copy Editor

Infographic Design
Nigel Holmes

Literary Agent
Carol Mann, The Carol Mann Agency

Legal Counsel
Barry Reder, Coblentz, Patch, Duffy & Bass, LLP
Phil Feldman, Coblentz, Patch, Duffy & Bass, LLP
Gabe Perle, Ohlandt, Greeley, Ruggiero & Perle, LLP
Jon Hart, Dow, Lohnes & Albertson, PLLC
Mike Hays, Dow, Lohnes & Albertson, PLLC
Stephen Pollen, Warshaw Burstein, Cohen, Schlesinger & Kuh, LLP
Rick Pappas

Accounting and Finance
Rita Dulebohn, Accountant
Robert Powers, Calegari, Morris & Co. Accountants
Eugene Blumberg, Blumberg & Associates
Arthur Langhaus, KLS Professional Advisors Group, Inc.

Picture Editors
J. David Ake, Associated Press
Caren Alpert, formerly *Health* magazine
Simon Barnett, *Newsweek*
Caroline Couig, *San Jose Mercury News*
Mike Davis, formerly *National Geographic*
Michel duCille, *Washington Post*
Deborah Dragon, *Rolling Stone*
Victor Fisher, formerly Associated Press
Frank Folwell, *USA Today*
MaryAnne Golon, *Time*
Liz Grady, formerly *National Geographic*
Randall Greenwell, *San Francisco Chronicle*
C. Thomas Hardin, formerly *Louisville Courier-Journal*
Kathleen Hennessy, *San Francisco Chronicle*
Scot Jahn, *U.S. News & World Report*
Steve Jessmore, *Flint Journal*
John Kaplan, University of Florida
Kim Komenich, *San Francisco Chronicle*
Eliane Laffont, *Hachette Filipacchi Media*
Jean-Pierre Laffont, *Hachette Filipacchi Media*
Andrew Locke, MSNBC
Jose Lopez, *The New York Times*
Maria Mann, formerly AFP
Bill Marr, formerly *National Geographic*
Michele McNally, *Fortune*
James Merithew, *San Francisco Chronicle*
Eric Meskauskas, *New York Daily News*
Maddy Miller, *People* magazine
Michelle Molloy, *Newsweek*
Dolores Morrison, *New York Daily News*
Karen Mullarkey, formerly *Newsweek, Rolling Stone, Sports Illustrated*
Larry Nighswander, Ohio University School of Visual Communication
Jim Preston, *Baltimore Sun*
Sarah Rozen, formerly *Entertainment Weekly*
Mike Smith, *The New York Times*
Neal Ulevich, formerly Associated Press

Website and Digital Systems
Jeff Burchell, Applications Engineer

Television Documentary
Sandy Smolan, Producer/Director
Rick King, Producer/Director
Bill Medsker, Producer

Video News Release
Mike Cerre, Producer/Director

Digital Pond
Peter Hogg
Kris Knight
Roger Graham
Philip Bond
Frank De Pace
Lisa Li

Senior Advisors
Jennifer Erwitt, Strategic Advisor
Tom Walker, Creative Advisor
Megan Smith, Technology Advisor
Jon Kamen, Media and Partnership Advisor
Mark Greenberg, Partnership Advisor
Patti Richards, Publicity Advisor
Cotton Coulson, Mission Control Advisor

Executive Advisors
Sonia Land
George Craig
Carole Bidnick

Advisors
Chris Anderson
Samir Arora
Russell Brown
Craig Cline
Gayle Cline
Harlan Felt
George Fisher
Phillip Moffitt
Clement Mok
Laureen Seeger
Richard Saul Wurman

DK Publishing
Bill Barry
Joanna Bull
Therese Burke
Sarah Coltman
Christopher Davis
Todd Fries
Dick Heffernan
Jay Henry
Stuart Jackman
Stephanie Jackson
Chuck Lang
Sharon Lucas
Cathy Melnicki
Nicola Munro
Eunice Paterson
Andrew Welham

Colourscan
Jimmy Tsao
Eddie Chia
Richard Law
Josephine Yam
Paul Koh
Chee Cheng Yeong
Dan Kang

Chief Morale Officer
Goose, the dog